Witness in Our Time

Witness in Our Time

Working Lives of Documentary Photographers

Ken Light

Introduction by
Kerry Tremain

SMITHSONIAN INSTITUTION PRESS • Washington and London

The text in this book is based on interviews conducted by Ken Light with support from an Erna and Victor Hasselblad Foundation grant.

The interviews were edited by Kerry Tremain.

COPY EDITOR: Robert A. Poarch

Library of Congress Cataloging-in-Publication Data
Witness in our time : working lives of documentary photographers / [edited by] Ken Light ; introduction by Kerry Tremain.
 p. cm.
 Includes bibliographical references and index.
 ISBN 1-56098-923-8 (cloth : alk. paper) — ISBN 1-56098-948-3 (paper : alk. paper)
 1. Photographers—Interviews. 2. Documentary photography. 3. Photo-journalism. I. Light, Ken.
TR139 W58 2000
070.4'9'0922—dc21 00-020889

British Library Cataloguing-in-Publication Data is available

Manufactured in the United States of America
06 05 04 03 02 01 00 5 4 3 2 1

♾ The paper used in this publication meets the minimum requirements of the American National Standard for Information Sciences—Permanence of Paper for Printed Library Materials ANSI Z39.48-1984.

For permission to reproduce illustrations appearing in this book, please correspond directly with the owners of the works, as listed in the individual captions. The Smithsonian Institution Press does not retain reproduction rights for these illustrations individually, or maintain a file of addresses for photo sources.

For Stanley Light, my father,

who gave me my first camera and taught me about the human condition,

and Melanie Light, my wife,

who has been patient, reassuring, and wise.

Contents

Photographers

Editors and Curators

Acknowledgments

My thanks to Susie Tompkins Buell, whose enthusiastic and generous support at the University of California, Berkeley, Graduate School of Journalism helped create a supportive environment for me to complete this book, and to Orville Schell, dean of the Graduate School, who appreciated my vision, ideas, and projects and allowed them to grow.

Without my colleague and coconspirator Kerry Tremain, this book would not be in its present form, nor would it be graced with his insightful introduction. Kerry's editing of each interview and, in a few cases, his reinterview of the photographers helped this book immensely. His additional research and collaboration on the biographies that introduce the interviews made each more readable. Our conversations and Kerry's editing skill, passion, and faith in the ideals of social documentary photography were a welcome breath of fresh air in the last year of the project and made a critical contribution to the book's final form.

A generous grant from the Erna and Victor Hasselblad Foundation supported my travel and my time to conduct the interviews with the photographers, and a grant from the National Press Photographers Research Foundation gave a much-needed boost. Without this support I might have never undertaken this project.

So many have given to this work. Amy Pastan, former acquisitions editor at the Smithsonian Institution Press, first agreed to the publication of this manuscript and nurtured it into draft form. She remained

available to listen to my ideas and problems long after her official editorial duties ceased. My thanks to Mark Hirsch, senior editor at the Smithsonian Institution Press, on whose desk this project landed as a book without a home. His unwavering support restored it back to health and finally to its present form. Editor Robert Poarch's timely line-by-line editing of the manuscript and Janice Wheeler's design created a more dynamic book.

My thanks to the photographers who took their precious time to answer my questions and who were so very patient these many years. Their faith, their graciousness, and their understanding that it would eventually see the light of day are honored. My thanks goes especially to those who took time to support this project in its moments of crisis: Jim McNay, Frank Rehak, and Susan Meiselas, and also to Brian Taylor, Reed Esterbrook, and Robin Lasser, who offered wise advice and support while I worked on my text.

The counsel of noted photography historian Naomi Rosenblum broadened my perspective, as did Ellen Handy, curator at the International Center for Photography. Joycelene Benzakin of the Sag Harbor Picture Gallery was generous with her contacts. Melissa Harris at the Aperture Foundation and Marcel Saba of Saba Press Photos generously shared their offices and telephones during the interviews I conducted in New York.

My students and assistants at University of California, Berkeley—Jill Davis, Sophia Ray, Christina Koenig, Doreen Bowens, Kimberley Lisagor, and Matt Golec—helped with the tedious transcription of the recorded interviews and Matt McClesky assisted with the indexing. For translating my conversation with Graciela Iturbide, I must gratefully thank Almundena Ortiz. My colleagues Jon Else and Tom Leonard at the Graduate School of Journalism offered important advice, and Roy Baril helped open numerous computer attachments that would have languished on my desktop, thereby saving the day.

This book originally started with my colleague and friend Kim Komenich, as we bemoaned the lack of a text for our students from which they could gain insight into the lives and work of documentary photographers. Long after we took separate paths toward this goal, he remained a steadfast supporter and cheerleader for its completion. Thank you.

Ken Light

Thanks to Valerie McGuire for researching the biographies. For reading and commenting on the edits and introduction, thanks to Mike Feeback, Carl Fleischhauer, Melanie Light, Joe Loya, Brad Matsen, Susan Meiselas, Joshua Phillips, Jon Polansky, Barbara Ramsey, Fred Ritchin, Bill Smock, Marilyn Snell, Patti Wolter, and especially to Jane Melnick, who first ignited my interest in documentary photography, and Peter Solomon, master wordsmith.

Kerry Tremain

Introduction

Seeing and Believing

KERRY TREMAIN

I

When mujahedin soldiers captured Antonin Kratochvil in Afghanistan, where he traveled in 1978 to photograph their war with the Russians, one of them pressed the barrel of an AK-47 rifle into Kratochvil's temple, read his passport, and shouted to the others that their prisoner was born in Czechoslovakia. The mujahedin knew Czechoslovakia. Czechs manufactured Russian guns. The soldier told the photographer he was going to blow his brains out.

Ironically, Kratochvil had risked his life to escape communist Czechoslovakia eleven years earlier. While still a teenager, he had walked to the Czech-Austrian border, a coil of barbed wire in a swath of fine gravel raked to allow the police patrol to track trespassers' footsteps. A friend of his had been killed nearby. In the dark he crawled under the barbed wire on his belly. Upright, euphoric, he spit on the Czech side of a stone that marked the border.

In Afghanistan Kratochvil sat silently while a guide he had hired just a few hours before pleaded furiously with them to spare the photographer. "He is not a spy; he hates the Soviets. He will tell the world about your revolution. You know my cousin who fixed your truck."

For two hours, the guide begged. Finally, the mujahedin fighter lowered his rifle and freed Kratochvil.

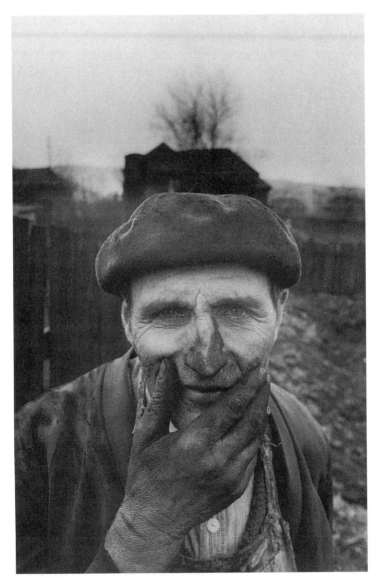

Polluted Garden, Romania, 1995
(© Antonin Kratochvil)

I met him in 1989, the year the Velvet Revolution liberated Czecho-slovakia, the year he returned to Prague, where his parents had died after decades of persecution by communist authorities. While the TV broadcast only happy celebrants, he photographed a hysterical boy covered in Vaclav Havel placards screaming to a large, empty plaza.

Like the best documentary photographs, Kratochvil's images conveyed an invaluable, if imperfect, truth. His natural elation about the liberation was chastened by an angry knowledge that the century's tragedies—the ethnic hatreds, the political recriminations, and environmental disasters—had not yet fully played out in Eastern Europe.

I published these photographs, and later we became friends. On trips to New York City I would visit the one-room apartment near the Lincoln Tunnel he shared with his wife and young son and piles of prints. There, he once showed me his pictures from Afghanistan and more recent photographs from a prison in Venezuela, one of which was a group of starving prisoners huddled in the dark behind a door nearly rusted shut.

In the movies the photographer is often a romantic action figure—James Bond with a Nikon. But there was no gold or glory to be gained from those prison photographs. Instead, they made me ask: Why would you spend your savings to go to a hellhole near Caracas where the guards and the prison gangs, both armed, would just as soon kill you and trade your camera for food? I found part of an answer to this and similar questions in the stories recorded in this book.

As a child, Jill Freedman would sneak into her parents' attic each day and cry over pictures of Auschwitz and Dachau that she found in magazines stored there. When she grew older, she saw parallels to those pictures in magazine photographs of civil rights activists set upon by dogs in the American South. Outraged when Martin Luther King Jr. was shot and killed in 1968, she quit her job to camp in a plywood lean-to on the Washington Mall and photograph the Poor Peoples' March, which King had conceived before his death.

Donna Ferrato was shooting a feature on "love" for Japanese *Play-boy* when a man began beating his wife in front of her. Stunned, unable to respond, Ferrato threw the film in a drawer the next day. But she found the courage to develop and print those pictures, then devoted her work in the years that followed to photographing victims of domestic violence and establishing an organization to help them.

Joe Rodriguez, who kicked a heroin habit as a young man, spent months gaining the trust of East Los Angeles gang members before asking to photograph them. Then LAPD officers, for unknown reasons, lied to the gang. They said that Rodriguez was helping them on drug busts. Although his life was now in grave danger, he went back to the neighborhood and slowly started to rebuild trust.

Like Kratochvil, Rodriguez risks his life to plea furiously, through photographs, for others to escape a future he once faced.

Documentary photographers often see things that do not officially exist. Indignities. Cruelties. People pinned to a wall with fire hoses because they want to vote.

During the Civil Rights movement, Klansmen ran Eugene Richards out of Arkansas for taking their pictures. Earl Dotter made portraits of miners dying from black-lung disease, while both the coal companies and corrupt union officials denied the problem. Susan Meiselas photographed the corpses of villagers in El Mozote after they were shot and burned by the Salvadoran army. It took ten years before a congressional inquiry and an exhumation forced authorities to admit the massacre had happened.

A transformation occurs when you see something important that is denied by those who have not or will not see it.

"Look. I've got a picture," you say. "I was there." Excuses are made: pictures can lie.

"But I don't."

The first time it happens, you become enraged. You dig in. You get better at shooting in low light and at developing a relationship with your subjects.

The camera gives you entry, but you don't shoot at first. You put it away. You stick around. You come back again and again. You explain yourself. Eventually you think: I've earned it.

No way.

"You just grit your teeth and bitch and moan and call home all the time and complain and try to keep away from the alcohol and don't get too depressed and go back the next day," said Richards.

In Red Hook, in Brooklyn, the crack addicts he had gone to photograph in the early nineties figured that he and the writer working with

him were cops. "Then about the fourth week we had a breakthrough moment. We witnessed a violent chase and people recognized we were journalists instead of cops. The doors opened."

If intense engagement with your subjects is the first requirement, keeping your head is the second. You can be too involved, or not involved enough.

The only thing to do is to get it right. The only way to get it right is to keep asking yourself if it is.

"You attempt to tell the truth," is how Richards described it. "You try to find the tools, the metaphors, the shapes, the shadows to translate the event or personality as truthfully as possible."

When it is done, you hope the work is faithful to the people you have spent weeks or months or years with. You notice things you missed, nuances. The truth is not completely here; it is slightly out of the frame. In the darkroom, other truths are unexpectedly revealed.

Work on the story is done but the work to get it published, intact, is just beginning. Richards spent months in cocaine-ravaged neighborhoods, but black activists like Al Sharpton denounced him as a white interloper, and intimidated editors avoided the photographs.

Dayanita Singh documented the growing Indian upper middle class into which she was born, but her photographs did not show what the editors wanted: poor India, exotic India. "This is not India," Singh recalled one editor saying. "This is Indians in London or Indians in New York."

"Look. I've got the pictures. I was there."

<div align="center">II</div>

Social documentary photographers have rarely had a secure home.

The American tradition was first encouraged by late nineteenth-century Progressives. To remedy a problem, they reasoned, we must first see it. And people of goodwill, once they see it, will work to correct it.

Jacob Riis, proud of the artlessness of his photographs, campaigned to improve immigrant ghettos with Teddy Roosevelt's support. Lewis Hine, on the other hand, proved that beautifully crafted images of ugly conditions could move the nation. His tireless work eventually helped create child labor laws.

Franklin Roosevelt's New Dealers, successor to the Progressives, offered documentary photographers a new and more spacious home. The Farm Security Administration established the country's first national documentary project and hired photographers like Dorothea Lange, whose images of California field hands helped influence Congress to legislate rural reform.

Life, founded in 1936, together with magazines like *Vu* in France and the *Picture Post* in Britain, provided the richest home yet. During World War II, these new magazines turned documentary photographers into photojournalists and photojournalists like Robert Capa, Margaret Bourke-White, and W. Eugene Smith into heroes. The photographers' politics were antifascist, the magazines their bread and butter.

After the war, even as political consensus frayed, photo-essays by photographers like Smith and Gordon Parks in *Life* helped stoke the "can-do" energy of the times. In the decades that followed, photographers alerted the country to the viciousness of racial bigotry and, in Vietnam, to the contradictions of the cold war.

Documentary photographs from the dust bowl to Da Nang changed our perceptions and remain lodged in our memories. By the seventies, however, television was king; the big-picture magazines were dying. The liberal Left entered a grim period of division and decay when the reform political coalition FDR had built forty years earlier shattered, preparing the way for Ronald Reagan and Margaret Thatcher.

The eventual decline of photo magazines and the sixties' social movements dealt documentary photographers a triple blow—a loss of revenue, influence, and a secure political home.

Ironically, at the same time the art world's interest was growing, along with the prices of vintage Depression-era photographs. Galleries and small publishers expanded, offering photographers the display space and editorial control they had lost in magazines.

To offer documentary photography a warm home, however, art's driving forces—formal innovation tied to celebrity genius tied to big money—would have had to undergo a fundamental renovation toward community engagement around controversial social issues. Except for a handful of sympathetic curators, documentary photography struck most as a dowdy interloper in the house of high culture—a house that underwent a renovation, but toward conceptual purity, not the nitty-gritty necessities brought in the back door by documentarians.

Contemporary art proved no more hospitable a home than did contemporary media, its middlebrow cultural rival. Documentary photographers have moved between them like resilient foster children, grabbing what they could from each. Astonishingly, they managed to produce a body of work that in its depth, breadth, intelligence, and pictorial inventiveness equals that of any previous era.

The documentarians' move into the art world also brought their work under the stern gaze of high-culture critics who did not always like what they saw. Documentary photographers, severe critics said, are voyeurs who profit from the misery of the poor by stealing and prettifying their visages, then parading them in exhibitions for the privileged. And photographic realism, they argued, perpetuates the myth that photographs are objective, rather than projections of the cultural values of those who make and distribute them.

This criticism, as we have seen, misconstrues why and how documentary photographers work. These photographers reject the quick, sensational pulse of news pictures in favor of long-term engagement with the people they photograph. Some have recently made more explicit this moral contract with their subjects, like Fazal Sheikh, who makes collaborative portraits of refugees. And just as there is a difference between a lecherous and a friendly look, the gaze of the voyeur and that of the witness are not the same.

Still, without a secure home—without a connection to an influential progressive movement or the financial support and power of popular media—documentary photographers were vulnerable to the sting of the art critics. They are aware that the truths they frame are fragile and tentative. Some, like Eugene Richards, devise pictorial strategies to make their own subjectivity transparent. Most, like Dayanita Singh, know firsthand how the media can distort meaning.

They have experienced, even in mundane ways, the difficulties of trespassing borders of language and culture with people they photograph. And they hold only a slender hope that they can prevent the sort of tragedies they witness.

A friend, who spent years documenting the lives of Andean people, told me, "My photographs changed nothing for them. In the end, the images had more to do with me." This widely shared sentiment draws on two truths—that photographs are always the product of personal

concerns and that photographs alone are rarely capable of radical social change—to imply a false conclusion, that acts of witness are unimportant.

We all see others by seeing our different selves in others. That is why Joe Rodriguez returned to the barrio, Donna Ferrato to those living rooms, and Antonin Kratochvil to places where people are trapped. Their own suffering, their memories of their suffering, made them seek the suffering of others.

Their pictures did not end drive-by shootings nor domestic or ideological violence. Photographs will not end centuries of oppression. Human tragedy requires many acts of empathy. Each of us is only capable of our own.

"A photograph that brings news of some unsuspected zone of misery cannot make a dent in public opinion unless there is an appropriate context of feeling and attitude," wrote Susan Sontag in *On Photography*. But what creates "an appropriate context of feeling and attitude"? Some remain convinced that historical forces like class conflict or nationalism will set us free, but the last century bears a tortured testimony to the results of those convictions.

Many documentary photographers, as do I, maintain a faith in the force of our collective acts of empathy and witness.

III

Airplanes, televisions, satellites, and computers have so intensified cross-cultural contact that we share our foods and our viruses, our music and our hatreds.

Engineers from Bangalore, India, educated at Stanford University now discuss software design at French bistros in Dublin. Serbian nationalists wear T-shirts adorned with multicultural cartoon creatures from *The Lion King*.

Culture clash and assimilation are ancient. What is new is the speed at which we perceive it, transmit it, turn it over, devour it. And this development, in large part, depends on images—on photographs.

The Kayapo people of the Amazon rain forest make videos with rock star Sting to extend their "traditional" culture, a way of life now as dependent on European environmentalists as on the forest itself. Mexi-

can photographer Graciela Iturbide shoots images of muscular Zapotec matriarchs in an ancient pueblo, which suddenly becomes a pilgrimage site for feminists who have seen the photographs in North American magazines.

Inevitably, intensified intercultural contact has made us question the old truths and spawned new ones that are more fluid and temporal. We are exhilarated to experience a world of cultural options to choose from, but terrified because the comforting certainties of any single tradition are ripped apart.

An explosion of global words and images has made us question how truths are made—and why. In photographs there is more to see, but our trust in what we see has been shaken. "We began the twentieth century by believing what we saw in a photograph was true and ended the twentieth century by distrusting every document," says curator Ann Wilkes Tucker of Houston's Museum of Fine Arts.

Faced with this confusion, many turn to imagined pasts. Perhaps the most notorious are the religious fundamentalists, such as the Talibans, but there are also those who long for a return to pre-Stalinist communism or to a world of hunters and gatherers attuned to nature. Some photographers also long for a more heroic era, like the one in which Robert Capa and W. Eugene Smith confronted fascism and traveled around the world for *Life*.

Although theoretically committed to the new, even so-called "postmodern" photographers and artists have, in practice, recoiled from the future. Instead, they have sought security in derivative theories of representation that they are as certain of as Rome's bishops once were of the Ptolemaic universe, and that are argued in a cultural equivalent of Latin. Given the complexities of representing the "other," many urge photographers to stick to their own kind, often a racial or gender category that they defend with the vigor of nineteenth-century Spencerians. Confronted with the myriad difficulties of accurately reporting, for example, the carnage of the Rwandan holocaust, they prefer to condemn Western media hegemony from their studios.

Believing that reality is hidden from us by the powerful, these artists implicate documentary photographers for promulgating a lie that photographs are true. But paranoia is just another way to give the truth a unity it does not really possess. Suspicious, ironic art seeks disengage-

ment from an impure world, not immersion in the cross-cultural tumult so richly available to the more daring.

The world is both a promising place to make photographs and a broad stage for self-discovery. The alternative to narrowing our vision to the studio is widening it to include more varied international participants. As cultural encounter intensifies, the globe becomes the important and visually inexhaustible arena for understanding our times. And with new modes of communication, there are opportunities to be seized.

Sebastião Salgado, who believes that "there is no person in the world that must be protected from pictures," sees the documentary photographer as a vector connecting the different realities of people around the world. This could double as a vision for the Internet, perhaps the most powerful media tool ever invented. At the very least, the Internet gives international photographers a way to share their interests and debate their concerns.

The World Wide Web also offers documentary photographers a place among media and reform organizations. They can work as part of creative teams of writers and video and audio documentarians to create compelling issue-based experiences.

While sensible about the difficulties of adapting to the Internet, thoughtful producers like Susan Meiselas understand that "We have to find ways of taking people someplace they don't expect to go." Her web site, www.akaKurdistan.com, posts images of Kurdish culture from diverse contributors, contemporary and historical, for visitors to view and discuss. In effect, the site hosts public debates about ways of representing truths.

In public forums communities of photographers, like those of writers and scientists, can examine the evidence and censure those who deliberately lie, digitally or otherwise. In this way, as curator Ann Wilkes Tucker described, "Photographers are liberated from trust being inherent in their medium. Our acceptance or rejection of the information they present will have to do with the reputation of the photographer, the declared intentions of the maker, and what else we know about that subject. In some ways it's probably the best thing that's happened in documentary."

Meiselas's www.akaKurdistan.com also suggests that accelerated cultural interaction need not imply the wholesale abandonment of cultural

and political traditions—it may instead be an occasion for their renewal.

Certainly, we can appreciate traditions like democracy and humanism that promote commonality amid difference, mutual respect, and lawful resolution of conflict. Each shares a cultural genealogy that is traceable through Ashoka, Gandhi, and King as well as Erasmus, Jefferson, and Mandela. They are neither natural nor inherent in human societies, as Hitler and Pol Pot have surely taught us. Democratic values urge us to resist the false comfort of utopias but encourage our better selves. For over a hundred years they have guided documentary photographers.

As they evolve and mature, democratic and humanistic traditions recognize that our commonality lies not just in our similarities, but in our multiplicity, and that this multiplicity cannot be contained within any one country, culture, or ideology. We can value each other although we are not the same. We can experience one another through one or another aspect of our own multifaceted selves.

Good photographs are complex records of this exchange between photographer and subject. They give us access to the experience of both and evoke and widen feelings within the viewer.

A widened consciousness of other human beings and cultures invites compassion and yields some working truths: there is no final conflict, no shelter from tragedy, no release from suffering, and no end of history. It is the perfect theories and the dreams of a perfect state that deceive us.

During the communist occupation in Czechoslovakia, writers won our admiration by courageously passing around copies of samizdat books of literature and social criticism. Others, like Antonin Kratochvil's father, a filmmaker and "class enemy" of the regime, made photographs on paper smuggled into the country. By witnessing a lie, these writers and photographers gave us glimpses of truth. They kept alive their human feeling, their sense of humor, and their sense of purpose.

"We've got pictures," they told us. "We were there."

Photographers

Hansel Mieth

The Depression and the Early Days of *Life*

In 1937 Hansel Mieth began work as a photojournalist for *Life*, only the second woman, after Margaret Bourke-White, to be hired full-time by the magazine.

Born in Germany in 1909, Mieth began photography as an amateur while traveling through Yugoslavia, Austria, Bosnia, Bulgaria, Romania, and Hungary with her boyfriend, Otto Hagel. After migrating to the United States in 1929, the couple worked among migrant farm laborers and photographed the extreme poverty of the Depression. These photographs were the basis of their book, *The Great Hunger*. In 1934 Mieth and Hagel made a film about the California Central Valley cotton strike, ironically titled *A Century of Progress*.

At *Life* Mieth photographed hundreds of stories, including Texas cowboys, the Meninger clinic, young railroad hoboes, the census, and unwed mothers. In 1941 Mieth left *Life* magazine and, with Hagel, returned to the West Coast to resume work on social documentary projects. During the 1950s, they were unable to work as photographers after being blacklisted, and many of their friends were afraid to be seen with them.

Mieth's last major project was on post–World War II Germany. Mieth and Hagel returned to their hometown to photograph the devastation and broken people. Their collaborative effort, *We Return to Fellbach*, was published in 1950. After her husband's death in 1973, Mieth remained on their ranch in Northern California where she painted, photographed, and wrote until she died in 1998.

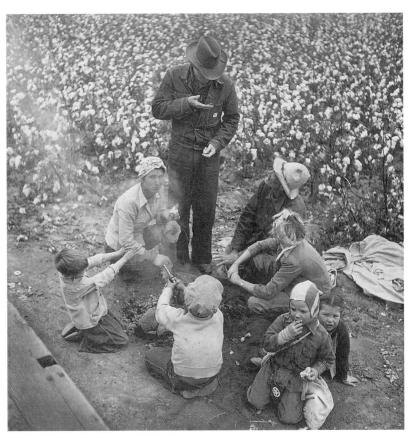

Cotton pickers around fire, 1934
(Hansel Mieth/Otto Hagel)

Otto and I had started photography in Germany in the late 1920s. Otto had a little camera. The first photographs he took were of his grandfather's funeral when he was twelve years old. He took a whole series of him dying and then being buried and the people bringing him to the cemetery. To see from these that eventually we would become photographers, you would have had to have a good imagination.

In Yugoslavia we took some pictures here and there and sent them in with little articles to newspapers. We hardly made anything. I don't even know if and how they were used, because we were traveling. We made ourselves a little booklet where we wrote our credo and the things we were looking for in the world. When we went to these various countries and towns and villages, we found out whether there were any writers or known people living there. If we could befriend them they would write in their life's urges and credo in our little book.

But we couldn't stay in Germany anymore because of the growing conditions under the Nazis.

I was about eighteen or nineteen years old when I came to the United States in 1929. I worked in San Francisco factories, sewing or hat making, and they paid me by the piece. The girls next to me were also on piece labor. I made piece by piece the same amount of material as them, and the boss gave me six dollars a week. They made twelve dollars a week. Now I was not against them getting twelve dollars, but I was against me getting six dollars. So I told the boss that he made a mistake. He said he didn't make a mistake. I tried to tell him, "Yes you did, you counted only half." He told me that people like me don't get anywhere in life because they want to know too many things. So I said, "I guess I have to leave you. Good-bye." And that happened a few times. They were telling me I was a "green" woman. When you had just come from another country to a new country, you didn't get the same wages that somebody who was here a long time was getting.

The camera I brought with me from Germany was stolen right in the beginning. So, when Otto was cleaning up somebody's attic he found a very small camera that didn't work. He went to the lady he worked for and asked if she would sell it to him. She said he could have it because it wasn't working. So he fixed it up. He had started as a watchmaker at home, so he took it apart and fixed it up, and he used that little camera. All the North Sacramento Hooverville pictures were taken with it.

It was during the Depression that we came to America, and we knew that the Depression couldn't last forever. Otto was really the person who took the lead. He said we must record the situation now—all the people who have no homes, who have no roof over themselves, who have dishes and who have nothing to cook, and who are on the road.

We were in the same position as these people then. We couldn't buy the individual magazines of 35mm film, so we bought a hundred feet, or whatever length, they come in and rolled the film in the changing bag. We had our own cartridges then.

The thing that was a little hard was the developing and printing. You needed a stationary place and usually we had to come back for a week or two to San Francisco or Berkeley with some friends and borrow their darkroom. Or we rented a place in San Francisco, usually in the North Beach section, for $8.25 a month. There was a kitchen and a bedroom, and the bedroom we used as the darkroom. At the time they had flat roofs, and we could put a tent up there and sleep. Most of what we earned went to gasoline and film.

We got a job for a few weeks in North Sacramento from a Frenchman who had bought a place, and he wanted to get it cleaned up. We had to go by these Hoovervilles everyday. We started [photographing] Hoovervilles in 1931, 1932.

Otto and I, we went in and we talked to the men. We were all of one kind of language, I mean we could understand each other. We saw an Indian family there. We had cheap film and cheap paper, and everything came out pink, so we always call them the "pink Indians." We helped people if they had any construction problems. If a woman was not feeling well, I took care of the kids for her a bit. We just got acquainted, so the relationship was not just one way, it was many ways. It was quite a large Hooverville, I would think about three hundred families.

We looked upon it as a calling. The few cents we made, we did doing the hard work. We didn't have any money to pay out for rent or anything, sometimes only enough just to keep our car going. Nobody had anything in those days; they didn't save for the future. You just worked from day to day and hoped that someday it might get better. We thought the photographs could have a hand in it. People could see just how bad it was. Maybe they would build some camp or make it so that they could camp easier and not have to go to an outlying cemetery or a dump, that they could set a little piece aside where these homeless

people could set their tents or their wagons. The North Sacramento Hoovervilles eventually got wiped out. The city burned them up and chased the people away.

In the beginning there was no photo market anywhere. Even for two or three dollars you couldn't sell anything except on the California Central Valley cotton strike. Publications would have paid you anything for those photos, but we didn't sell them any. Actually, we didn't know what to do with the photographs we took. I said there might come a time when they would be useful. At the time that we took them there was really no use for them.

We didn't belong to any political organization necessarily. But our world was on one side, and the corporate world was on the other side. I don't know how to explain that. We belonged to the majority of people. We only knew the poor. We didn't have much to do with the rich. They didn't know anything of us, and we wanted nothing of them.

We worked in every valley, from the San Joaquin and Central Valley to whatever valley it was, wherever there was something growing and wherever they needed workers to pick their fruit, whether it was peaches, oranges, pears, apples, potatoes, or peas. There was very little difference. You just let yourself be hired.

Children then were with their parents in the cotton fields. But we had no children to take care of. Most people had a family. Often the children were in the car and had to wait for the parents to come back every so often to the car and give them a drink and let them out and play in the sandbox on the side of the road or on the side of the field.

We had a little car. It had a rumble seat, and out of that we made a grub box, like a kitchen, in the back. We had all the grub. Whatever you needed to put a measly meal together was with us in the car. It took us about fifteen minutes from the time when we opened up a campsite to have water boiling on the tin stove. The tin stove was an old five-gallon tin can cut out so you could make a fire down underneath and boil the water while you were boiling beans and bacon or biscuits.

So many times in the cotton-picking picture, you see me either picking cotton or Otto is doing the work amongst the other people. Or you see me standing out in a picture with the Rolleiflex up in the air to get a better view.

We were part of the people that were working in the fields; they

didn't have to give us permission to photograph. It was understood what we were doing and that we were trying to show with our photographs how bad the times were and that they shouldn't get any worse. That if the times ever get better, the photos would be a warning that at any time it could get bad again, and so we should stick together.

When the cotton strike was going on, people we knew were in the strike. Otto went to the field with a truck of strike organizers, and he said let's make a film of what's going on. He thought maybe a film could have given them a little presence and not them individually, but the whole idea, a movement, and show it a little better than in still pictures.

We came home one night, and there was no more camera. We had bought a 16mm camera, and it was missing, and the film was missing, and everything that you needed for the film, everything was missing. And since Otto had left Germany in a hurry when he came here, he did not have any papers. So he couldn't go to the police and ask about it, but I did. I said you took our film away, you smashed our things. The police said they didn't take the film, but we didn't believe them. For years we believed that they did it because they smashed places up, and we were taking pictures of the strike.

Maybe thirty years later we phoned an old colleague from this period in Los Angeles, where he lived, and he said, "My God. Sure. I had the film. I took it with me and all during the war. I had it in my baggage." He explained the whole thing. Because we belonged to the Film and Photo League and he belonged to the Film and Photo League, it was not a matter of swiping it. It was just a matter of if you were in the Film and Photo League, the Film and Photo League owned it. And so he kept it.

Little by little, I eventually got on the WPA [Works Progress Administration] in 1936. I went to the art department with whatever strike pictures I took.

I also had pictures of Chinatown. The young kids didn't have any money, so five or six or more Chinese kids usually rented a room, and the bed was in use twenty-four hours a day. It started with one or two men, and after eight hours they got out, and then the next two got to bed. The children didn't have any playgrounds. They played around the narrow Chinatown streets, and I had quite a number of, maybe thirty or forty, prints of that.

I went around with them to the WPA art department, and they looked at them and said, "No, we couldn't employ you. You should not have come to the art department, because what you have here is not art. It is propaganda, strictly propaganda, and we don't deal in that. It has to be art for art's sake. What you have is always dealing with a purpose, and art shouldn't have a purpose like this."

So I went home again and said, well, that was a bummer. But we needed a little extra money, and I had heard of the youth and recreation department, whose headquarters were in the San Francisco Mission district. I went to the director of the project, and he looked at the very same pictures, and he put his arms around me and said, "That's just what I was looking for. Sure you can work for us. But I don't have a photographic project. Why don't you start one?"

So I got three or four people, young photographers like me, and we had a project going. That's when I photographed the boys on the road. I was with all the nationalities in San Francisco who had their headquarters at various places. We did the unemployment situation in San Francisco and all of California. We had an open season. We could photograph what we wanted as far as the director was concerned. Through our project they got a few playgrounds built in Chinatown. They got things organized in the various nationalities, like the International School and the International House. So we really did something.

Time magazine wanted to get some of the pictures. They got to know me through Peter Stackpole [an early *Life* magazine photographer]. I developed some of my pictures in his darkroom, and he showed them to *Life* magazine. Joining up with them maybe wasn't the absolute best thing I did, because I felt I was forsaking my people.

The *Life* man asked me if I wouldn't want to work for them. I said he wouldn't want me because I was not of the very same opinion. He said, "We don't need a bunch of yes-men. I think you will do fine with us. You have a different opinion and don't worry. We'll get along all right." Finally I agreed to do some freelance stuff with them. And they sent me out the rest of the year. That was the end of 1936.

The rest of the year, 1936 and beginning of 1937, I did a number of stories for them. One was on sheep raising in California.

When Gene Smith came to *Life* magazine we understood each other very well. He came out to California a lot, and we talked and talked, and it turned out that what we subscribed to was this responsibility in

life. We were born, we have a place in life, and we felt we had a re-
sponsibility to give back, to help if we possibly could to move the world
a little closer to understanding—one person to the other, against wars
and the war industry. Still we were not firebrands of any sort or rush-
ing around rabble-rousing. We just understood our places.

Between Otto and Gene and me in the photo department at *Life* we
saw eye to eye. Except Gene had a completely different life. There was
no girl who'd live with Gene. He was a wonderful guy, and he was im-
possible. Even I got tired at times. I told Otto, "You are sitting up all
night long, talking, talking, talking, what does it get you?" But with
Gene it was all very important.

He had so many fights with *Life* magazine. With Gene, nothing mat-
tered but doing a job well, doing it the way he saw it. "If I can bring
just a little glimmer of understanding in the world," he always said,
"my job is not lost."

But then he lost their house, and they had to get a divorce. I knew
Carmen, his first wife, so well. She was a wonderful girl, a wonderful
mother. He didn't make a life for her. With the second wife, he had a
child out of wedlock. Some part of his life was completely unrealistic.
Not that my life was realistic, but at least I always went back again to
where I was born, to what my mother told me.

After a while at *Life,* I couldn't take it anymore. I felt that our mar-
riage—and we weren't really married—was falling apart. That was the
first thing. And I could point to so many other marriages that had fallen
apart because living had gotten so easy.

There were stories which I just loved doing, and there were stories
that I was no good at that I didn't like. But that was not the really bad
thing. The really bad thing is the big question of what was I doing?
Whom was I helping? You were on expense account; you flew around
and took a big room in a train and so on. Your whole life was upside
down from where it was before. You looked at the world through the
viewfinder lens instead of directly with people, talking with them. And
I wanted to go back to where I was before. I wanted to go back to Cali-
fornia.

We had come to know most of the West Coast photographers in
1933 and 1934. When you were at demonstrations or were running up
and down the sites looking for a picture, usually Dorothea Lange was
there with her camera. It was before she had a small camera. She had

a big Graflex. Dorothea usually was with a young man, like John Collier Jr., helping her.

Through Dorothea we came to know most of the other photographers. We came to know John, Peter Stackpole, Ansel Adams, and Edward Weston. We even lived with Dorothea and Paul Taylor, her husband, in Berkeley until we found a place of our own.

People like the very early stuff, but we didn't think we were really doing great things. They like that best of all because it came from the heart. The very early stuff I did counts more. It's not just the years; it's not just that collectors go for the thirties. No, it's a type of photograph that grows on you.

We didn't always have a very safe place for the work. While we kept them pretty well—the photographs, the negatives, and the few prints we could make with outdated paper—the thing is that we had to move so often, and Otto and I were not always home together in the same place. He was in Sacramento at one time, and another time he may have been down in the fields, and I was home and during the day I was out working.

I was a salesgirl in a five-and-ten or in a bakery store or in a sewing factory or in an office, and for a while I worked for the forestry department typing. I had so many jobs. Anybody could come in the apartment, so we don't have all the negatives anymore. Quite a few are missing, and I'm sorry about that. I'm looking for stuff that I know I would have wanted very badly that is not there anymore. And then when we moved from Telegraph Hill to another place, Otto had a bench made against the wall that you opened up and the bench was also a box. Somebody got in while we were moving and took quite a few papers, like citizen papers and my photographs. And that never came back.

We have come through so many chapters in my life. In your life you have quite a few chapters that turn what you did before upside down. So it's very hard to say if we were successful. What is success? You cannot buy a cup of coffee with it.

Walter Rosenblum

Lewis Hine, Paul Strand, and the Photo League

Walter Rosenblum's early involvement in photography began before he was twenty when he joined the Photo League, an organization for photographers founded in the Depression era. Later he would serve as its president. The organization nourished many of the generation's most famous photographers, notably Rosenblum's influential mentors Paul Strand and Lewis Hine. Strand contributed to Rosenblum's formal understanding of photography, while Hine opened up the world of social documentation. The Photo League was later accused of communist activity and destroyed during the McCarthyism era.

Rosenblum began work as a freelance photographer in the early 1940s, publishing his pictures in *Life*, *Survey Graphic*, and *Mademoiselle*, but it was his work as a combat photographer in World War II that brought him wider attention. Rosenblum was among the troops at Omaha Beach on D day; later, he was one of the first army cameramen to film the liberation at Dachau. After the war he photographed Spanish refugees in the south of France and Mexican migrant workers in the Southwest for the Unitarian Service Committee.

In 1948 Rosenblum began teaching photography at Brooklyn College, where he continues to hold the position of professor emeritus. In 1949 he married Naomi Baker, who, writing as Naomi Rosenblum, is the author of important surveys of American photography, including *A World History of Photography*.

Rosenblum has returned several times to the theme of urban New York

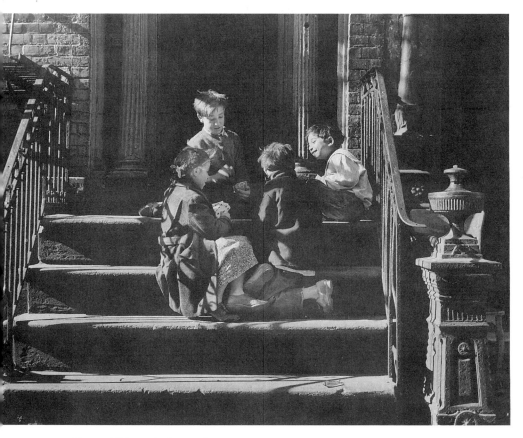

Gypsy children playing cards,
Pitt Street, New York, 1938
(© Walter Rosenblum)

City life, including *People of the South Bronx* (1979) and early work about his childhood neighborhood on the Lower East Side, *Pitt Street* (1938). In 1998 Rosenblum was given the Lifetime Achievement Award by the International Center for Photography in New York and was part of the Whitney Museum of American Art exhibition, "The American Century, Part 1, 1900–1950."

I was born on the Lower East Side of New York City in a neighborhood that provided sustenance for Jewish families recently arrived from Europe. Because my parents were orthodox Jews, my education at home was limited to the study of the Old Testament; art, music, and literature were never subjects for discussion. I knew the inside of my neighborhood synagogue at firsthand, but the Metropolitan Museum of Art was not part of my youthful experience. My introduction to photography was through Gus's Photography Studio, a small store that faced the building in which I lived. Gus used the sidewalk in front of his studio to expose his printing frames to the sun. Had I known how to use a camera then, it would have made for a fascinating photograph.

While in high school, I took a rudimentary photography class taught by a WPA [Works Progress Administration] teacher at the Boys Club of New York. It was a primitive affair. You developed your film by rolling it through a tray filled with developer and then made a contact print in a small printing frame. It was at that time that my mother, whom I dearly loved, died. My mother had been my protector who tried to provide a semblance of reason to my life, but now I was left alone with my father, whose life centered on religion. To assuage my grief, I went for long walks around the Lower East Side. For some reason, which I did not understand, I carried an old roll-film camera that my sister had borrowed from a friend; it turned out to be a true lifesaver. The camera forced me to look more deeply at my environment, and while the photographs I made were of little consequence, I discovered an interest that took me out of myself and into the world that surrounded me.

After graduating from high school I enrolled in the evening session at City College, but my interest in photography continued, so I joined the school's Camera Club. There I met Carroll Siskind, a young man who was sensitive to my needs and who suggested that I take a class

at an organization called the Photo League. Tuition was six dollars a semester, which seemed affordable, and there were darkrooms available to members. So one day I found my way to its headquarters at 31 East twenty-first Street in Manhattan. The League opened at noon, and, since I was half an hour early, I decided to sit on the outside stairway until the doors opened. Mike Ehrenberg, a member, quietly joined me, and, when we started to talk, I was impressed to learn that he had photographed the civil war in Spain. Recognizing a beginner, he made every effort to make me feel at home, informing me that the League not only had a school and darkrooms for members, but also sponsored a number of other activities. It issued a mimeographed newsletter called *Photo Notes,* held weekly meetings, and sponsored what were called "feature groups."

The Photo League was housed in a loft on the second floor of an old building of Civil War vintage. An old stone stoop led up to two long flights of rickety wooden stairs and then to a room with a worn wooden floor, an ancient tin ceiling, and decrepit folding chairs set out against the walls. The front of the loft served as an exhibition gallery. Dues at the League were five dollars a year. I later learned that shortly before I joined the Photo League in 1937, it had broken away from the Film and Photo League. The film section had split into two groups, one devoted to what was then called agit-prop film—which meant documenting union activities, strikes, and demonstrations—while the other section thought of itself as an educational study group, where the films of [D. W.] Griffith, [Sergei] Eisenstein, [Vsevolod Illarionovich] Pudovkin, and [Aleksandr] Dovzhenko could be discussed and analyzed. This group, which was first called NYKino, became Frontier Films after Paul Strand joined it as president. During the 1930s, it produced several documentaries including *Heart of Spain, People of the Cumberland, China Strikes Back,* and, lastly, *Native Land.*

As you entered the loft, you were in a narrow passageway facing the space for the office secretary. At the front was a large area where the school held its classes and the League its membership meetings. In the back were two darkrooms—one for developing film, the other housing five ancient Elwood enlargers. The darkroom fee for one-time use was ten cents, which paid for the developer and hypo, although I never recall paying the fee. The school consisted of three courses:

beginners, advanced, and workshop. On occasion, there was a special advanced class taught by Berenice Abbott. I paid my five-dollar dues and became a member.

Since the school was in midsession, I couldn't register for a class, and so without ever having been in an enlarging room before, I purchased a pack of paper, and decided to try to imitate what others were doing. When a member saw me put my paper into the hypo before the developer, she realized my predicament, and gently showed me how to make an enlargement. I later learned that this generous—and handsome—young woman was the daughter of Robert Flaherty of *Nanook of the North* fame. The members came from all walks of life. There were students, teachers, lawyers, accountants, plumbers, electricians—all interested in photography. It was immediately apparent that members were eager to help one another. I quickly realized that a course of instruction was imperative, and I registered for the beginner's class.

The major figure at the League was Sid Grossman. He was a remarkable person—very bright, mercurial, difficult to deal with on a personal level if he felt you were not serious. Sid was the chairman of the school committee, and the students who had studied with him were his greatest admirers. A few weeks after I joined the League the secretary resigned, and Sid, recognizing my interest in photography, offered me the job. I worked from twelve noon to seven at night, five days a week for ten dollars a week. The ten dollars permitted me to move out of my father's home to a small one-room apartment in New York City. Being secretary provided a wonderful learning experience, because I became involved in everything that was going on at the League. I acted as treasurer, collecting dues; I mailed meeting notices, typed *Photo Notes,* helped to organize and mount exhibitions, arranged for speakers for our weekly meetings, and collected work for the monthly print competitions. The prize was a twenty-five–sheet package of enlarging paper—an important gift in the Depression years.

It was at the League that I met Berenice Abbott, Lewis Hine, Paul Strand, the Newhalls, Ralph Steiner, Leo Hurwitz, Edward Weston, Ansel Adams, Elizabeth McCausland, and many others. I did not realize it at the time, but these individuals were the educational force that prepared me for the path that I was to follow for the rest of my life.

The League provided an environment where I learned about photography's history. When Hine and I were together, I discovered at first-

hand what he had contributed to photography as social documentation. From Strand, I learned about David Octavius Hill, Eugène Atget, and Alfred Stieglitz. The League was an exciting place not only because it provided a congenial place to work, but also because interesting people, deeply involved with photography, were happy to help young photographers understand in greater depth the meaning of photography as a fine art.

Aside from my office duties, I spent all of my free time at the League. It became my home. The beginners and advanced classes I attended were well taught and serious in intent, but it was Sid Grossman's workshop class that was of most importance to young photographers. While classes at the League were scheduled from 8 to 10 P.M., Sid held his classes at his home, which permitted us to remain together for a longer period of time. We not only looked at photographs and explored the projects we had chosen as class assignments, but we discussed the many problems that young photographers faced in the Depression years. One's personal growth, the influence of other art forms, our relationship to the world in which we lived—everything was open for discussion. We were free to explore all aspects of photography, as well as our own personal needs and desires. Each session was something to be treasured and remembered.

With the great numbers of photographic books available today, it may be difficult to realize that in 1938 only a handful of books on photography were available for the photographic educator. To fill this void, Sid prepared a series of mimeographed articles on photography that he had collected through the years. His workshop provided the finest training ground for the serious photographer that I have ever experienced. While he paid attention to the technical problems we faced, his primary purpose was to help us to develop as human beings. He recognized that many of us were severely limited by our background and that we would come to his class with little intellectual or aesthetic knowledge, so he endeavored to enlarge our vision and make us more sensitive to life in all of its manifestations.

Sid never received any financial recompense for the time, effort, and love that he gave to students. He worked as a photographer for the Works Progress Administration, which meant that he had to live on a weekly salary of twenty-three dollars. His teeth needed attention that he could not afford, and he suffered terribly from migraine headaches.

But the Photo League was his life and the students his emotional center. Sid was dedicated to photography as a serious means of personal expression, and he communicated this interest to all who studied with him. Besides teaching, he was also the primary guide in seeing that the League played a significant role in the development of photography during the time of its existence.

In 1938 photography was in a state of flux. Even though FSA [Farm Security Administration] documentation and photojournalism were beginning to make their presence felt, among those interested in personal expression, the pictorialist approach to photography seemed predominant. Pictorialist camera clubs throughout the United States were devoted to a kind of psuedoartistic photography, which was featured in many photographic magazines. Their members never seemed to find inspiration in the world in which they lived, but made soft-focus derivative images of nudes, misty landscapes, and individuals posturing in period costumes. In contrast, League members focused on their own environment and dealt with life on the streets in the various working-class and ethnic neighborhoods of New York City. We wanted our photographs to be considered as serious work, but pictorialists were derisively labeling us the "ash can" school of American photography.

A new kind of vitality, exemplified by photojournalists who were exploring the world for *Life, Look, Picture Post,* the *München Illustrierte Zeitung,* and *Vu,* in France, infused the work of League members. The Farm Security Administration group, notably Dorothea Lange, Walker Evans, Ben Shahn, Jack Delano, Russell Lee, and Marion Post Wolcott, also helped us understand a different role for photography.

The League organized a series of "feature groups" where photographers could join together to work on a specific project. Aaron Siskind, Morris Engel, Harold Corsini, Jack Manning, and others were involved in making the "Harlem Document"; Grossman, Sol Libsohn, and Arthur Leipzig worked on a documentation of "Chelsea." "Park Avenue, North and South" proceeded under the leadership of Consuelo Kanaga, while Lewis Hine, who had been brought to the League by Abbott and McCausland, joined with Eliot Elisofon in leading a "Men at Work" project. My self-assigned project for Sid's workshop class was to photograph on "Pitt Street," on New York's Lower East Side, very close to where I had been born.

All of this took place during the depths of the Depression, which

served as a motivating force for our work. The League had little income—rent was thirty-five dollars a month; the office secretary received ten dollars weekly salary—so all visiting speakers and the school faculty devoted their time without pay. When we ran short of money we organized fund-raising parties and film showings. In retrospect, we recognize that the League produced serious and talented photographers. Dan and Sandra Weiner came out of the League, as did Arthur Leipzig and Max Yavno; Morris Huberland, Rebecca Lepkoff, and Aaron Siskind were nurtured there, as were Sol Libsohn, Rosalie Gwathmey, Vivian Cherry, Elizabeth Timmerman, Harold Corsini, Morris Engel, and Jerry Liebling. Weegee [Arthur Fellig] was a member, and I remember meeting Robert Frank at the League when he had just arrived from Europe.

Unemployment was not easy to deal with in the late 1930s. On graduating high school I had answered an ad for an office boy. When I arrived at the address, there were more then a thousand people jamming the street in the hope of an interview. You learned to live on very little. I had a small one-room apartment; my bed was a mattress on the floor, and my furniture consisted of a table and chair. I ate lettuce-and-tomato sandwiches covered with mayonnaise to give the food some flavor. If I purchased film or enlarging paper it came out of my food budget.

Many of us were motivated also by our political allegiances. The Spanish civil war had ended with a victory for fascism. The Japanese had invaded Manchuria. I may have been about art and culture when I was a teenager, but not about politics, which seemed to be in the air we breathed during the Depression. A close friend, David Alman, whose parents were progressive thinkers, undertook to educate me about social ideas. Knowing of my dislike of my father's orthodox views, he had provided me with a series of pamphlets published by Ralph Ingersoll, which advocated an atheistic view toward religion. The pamphlets were so persuasive that when I was twelve, I felt it necessary to test his thesis by demanding that God end my life to demonstrate His presence. Fortunately nothing happened. As I followed David into new fields of social thought, I came to agree that socialism made much more sense then capitalism.

However, the policy at the League was to keep political beliefs out of official League matters. *Photo Notes*, which documented League ac-

tivities, bears witness to the fact that League members were never asked to subscribe to any specific political point of view, which were considered personal decisions. Certainly, many League members were politically involved; in the late 1940s they supported Henry Wallace when he ran for president on the Progressive Party ticket. Earlier, others had boycotted Japanese photographic equipment when Japan invaded Manchuria. They might even have wanted to join the Artists Union, but in the mid-1930s the graphic artists who had formed the union refused admission to photographers.

League members usually were called "documentary" photographers, as were the FSA contingent, but over the years I have come to believe that this term was an inaccurate description of what many of us were trying to do. Documentary, which I believe was first used by British filmmaker John Grierson, describes the kind of work done in the nineteenth century to record the buildings, bridges, and roadways and landscape that comprised the physical environment. Later, the term was used to describe work done by Jacob Riis and Lewis Hine, and eventually the Farm Security Administration, to show social conditions that required amelioration. Hine preferred to call his work "social photography," which I believe more accurately reflects our interests at the League.

Many members of the League felt that it was the responsibility of photographers to photograph the social evils that the Depression had brought into being. Elizabeth McCausland, who, as art critic for the newspaper *Springfield Republican,* often wrote about photography, supported this view. In her mind anything outside the range of "documentary photography" was a form of escapism that should not be condoned. Paul Strand presented a different outlook—one which was not always welcomed by members concerned with changing the social scene. As president of Frontier Films, Strand was then primarily involved with motion pictures, but he was on the League's advisory committee and often attended League meetings and joined in print critiques. He felt that so called "documentary photography" often had a tendency to consider only subject matter and pay little attention to basic aesthetic problems such as composition, tonal scale, and print quality—the formal elements important to all enduring works of art. Ignoring these considerations, he claimed, often produced photographs which "exhausted themselves on the first look."

He also felt that we were limiting ourselves in terms of subject mat-

ter. The entire visual world was waiting to be explored while we limited ourselves to social themes. Strand never denigrated the work of League members, and for *Photo Notes* he reviewed *An American Exodus* by Dorothea Lange, citing it as a vivid and fruitful influence upon the development of photography as a medium of expression. Nevertheless, there were those within the League who did not look kindly on such an aesthetic overview and let their feelings be known. Of what possible interest could a cobweb in the rain, a church in Taos, or a landscape in New England be to a society faced with the deprivations of a Depression and the horrors of the war in Spain and the rise of fascism in Germany and Italy?

Strand was a mythical figure to most of us. We had heard rumors that he was an important American photographer, but we knew little of his work. We were unfamiliar with the grand photographic tradition of which he had been a part, were ignorant about the Photo-Secession and Alfred Stieglitz, who had by then disappeared into the recesses of his gallery, An American Place. I came to realize that our education, as good as it was, also was limited. I took a class given by Strand, and he remained a friend for more than forty years.

In the late 1930s the photographic scene was enormously different from today. Few books were available; there was one monograph on David Octavius Hill, one book on [Eugène] Atget. *Camera Work* had been forgotten, so it was not available to us. Lewis Hine's *Men at Work* was aimed at young readers, so Margaret Bourke-White's *You Have Seen Their Faces* and Dorothea Lange's *An American Exodus* were considered pioneers in the field of picture books on social issues. The [Beaumont] Newhall history [*The History of Photography*] had just appeared. Picture magazines like *Life* and *Look* were starting to make their presence felt, but there were no commercial galleries devoted exclusively to photographs. An American Place still existed, but Stieglitz showed mainly paintings. I believe that there was a small show at the New York World's Fair of 1939, and in the early 1940s the Museum of Modern Art began to show individual photographers' works—I was part of a group show there called "New Workers One." In fact, aside from the Museum of Modern Art, in the late thirties and up through the forties, the Photo League had the only real photographic gallery in New York City where one could see a range of work by European as well as American photographers.

League photographers worked mostly for themselves, for there was little chance of having their work published. The work of the feature groups received little public attention. In my entire career, all of the work that I did was self-assigned, except for a small number of commissioned jobs for charity groups and a series of photographs of Spanish refugees in France for the Unitarian Service Committee. There were the Guggenheim and Carnegie Foundation grants and, after the Second World War, federal and state grants, which could be very helpful. I was awarded a New York State Fellowship, a National Endowment for the Arts Fellowship, and, later, a Guggenheim Fellowship.

Because there were no commercial assignments available to us, we at the League were able to choose our own way of working. We were fortunate in that there were many outside influences available to us through the speakers who were featured at our Friday-night meetings. We did not recognize it at the time, but a who's who of mainly American photographers appeared at League meetings during the late thirties and forties.

On December 4, 1947, an event occurred which came as a total surprise. The U.S. Attorney General, Tom C. Clark, released to the press a list of over three hundred organizations he deemed "totalitarian, fascist, communist, or subversive," and his list included the Photo League. Forty years later the listing was judged unconstitutional, but by then it had wrecked many lives and done unbelievable damage to the civil liberties of all Americans. None of our members had ever been interviewed or asked for information. Indeed, some of the organizations so listed no longer existed. The League fought back by organizing a meeting at which Strand denounced this unwarranted attack upon our civil liberties. We printed his talk in *Photo Notes*, and asked our membership for their support at this trying moment in the League's history.

W. Eugene Smith, who was a member of the League, was so disturbed by what had happened that he traveled to Washington to personally ask the attorney general why the League had been listed. Unable to gain an audience with Clark, he was shunted off to an assistant who told him that one simply had to trust the government when it listed an organization as being subversive. When Gene responded by saying that if someone called his wife a prostitute, he would like to know why, the young lawyer simply repeated, "You will just have to trust us."

While the listing aroused concern among League members, we went on with our usual affairs. By 1948 our membership list now comprised a very large list of important American photographers and historians. As a result, we had outgrown our small quarters and moved to new space in the basement of the Hotel Albert. Our members—students, plumbers, electricians, and accountants—built walls, installed electrical connections, and fashioned a fine exhibition gallery, classroom space, and an office, constructing a handsome headquarters from what had been a decrepit space.

However, the political temper in Washington had changed. At the trial of the leadership of the Communist Party for conspiring to overthrow the United States by force and violence, Angela Calomiris, a League member who proved to be an FBI spy, named Sid Grossman as a member of the Communist Party. In her book entitled *Red Masquerade,* she continually lied about the political nature of the League. Grossman's career was ruined, and the emotional trauma that resulted ended his relationship with the League. Other members recognized that being associated with a so-called subversive organization affected one's ability to earn a living, so League members had to think carefully about maintaining their membership.

Beaumont and Nancy Newhall, Barbara Morgan, and Ansel Adams were among the first to resign. At first, in answer to the original listing by the attorney general, Nancy Newhall, who had always been a strong supporter of the League, had prepared a booklet entitled "This Is the Photo League" in which she extolled the League's contribution to American photography. She cited the large numbers of lectures by significant photographers and art historians and the exhibitions held at the League, which she said would have done justice to a major museum, and she praised the League school for the way in which it had developed and supported young talent. Later, accepting the generally hysterical political tone of the time, she was quoted as saying that perhaps the attorney general had information proving that the League was subversive, but with which she was not familiar. In support of the League, Gene Smith took over the presidency, and Strand, who was later to have his passport confiscated, maintained his membership, as did Edward Weston, who wrote letters of strong support. We had a loyal contingent of members who tried to continue, but the financial burden became too difficult to bear. We closed our doors in 1952.

Although the League had ceased to exist, a group of us continued to hold meetings at the homes of various members, discussing work and talking about the photographic scene in general. My teaching job at Brooklyn College brought me into contact with many young photographers, whom I introduced to the League. I continued to urge them to attend the monthly meetings that were then taking place, and a group of us later started another organization called the Photographer's Forum, which met monthly at the New School for Social Research. That too dissolved some three years later, because some of us just ran out of steam.

The League played an important role in the history of photography. We rescued photography from the banalities of third-rate pictorialism. We lent support to the Farm Security Administration photographers as they explored the world of the agrarian poor and the dispossessed, and we portrayed the strengths and vitality of the urban poor. We paid homage to Lewis Hine, Paul Strand, and Henri Cartier-Bresson, among others, for their contributions to twentieth-century photography; and we helped many young photographers find their way in a very complicated world. We fought the McCarthyism that was threatening to destroy our democratic heritage.

I would sum up my beliefs and experience as follows: Lewis Hine came into my life when I was nineteen and, by friendship and example, showed me a road I might follow. And then came Paul Strand, who made me see how a simple sheet of photographic paper might become alive with the wonders of the world. From him I learned that anything in the world can be photographed if it has meaning for the photographer, that subject matter is inexhaustible if one is willing to explore its richness, that beauty can be found in a cobweb in the rain, in a bit of sand under a stormy sky, or in the face of someone you love. He made me see that photography must always be treated with respect and given one's best effort. In my philosophy the meaning of life derives from the people one has known and loved, who have made life inexhaustible in its richness. I have met my share of evil people and know what they are capable of—I was at the liberation of the camp in Dachau—but I have always held that evil is not inherent in men and women. Given a caring society, only the best in people will flourish. That is the spirit that has moved me to photograph.

Michelle Vignes

Magnum Photo Agency: The Early Years

Michelle Vignes's formative years were spent in Nazi-occupied France. After completing her education she worked as a secretary at Magnum, the legendary international photo cooperative that was organized at the end of World War II. At Magnum, Vignes was an assistant to Henri Cartier-Bresson and, after Robert Capa's untimely death in Indochina, she took over distribution and sales in Europe for all of Magnum's photographers.

In 1957 Vignes left Magnum and worked in the Paris headquarters of the United Nations Educational, Scientific, and Cultural Organization (UNESCO) as a picture editor assigning and editing stories. She moved to New York City and worked in the photography department at the UN and eventually moved to San Francisco during the height of the "Summer of Love," where she began working as a freelance photographer for the Gamma agency, where she did a series of short, local stories. Her coverage of the Black Panther Party in Oakland and San Francisco brought her a national reputation, and she began to collaborate with *Time, Life, Vogue, Newsweek, Ramparts,* and numerous international publications.

Vignes photographed the American Indian Movement (AIM) occupation of Alcatraz Island in 1969 and AIM's declaration of secession from the United States as an independent Oglala nation at Wounded Knee in 1973. At Wounded Knee the FBI set up roadblocks with tanks, and armed agents policed the area for over three months. Vignes was one of the few photographers to shoot from inside the standoff and created a lasting bond with

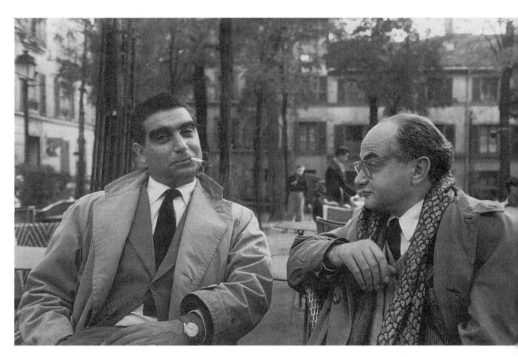

Robert Capa and David Seymour (Chim),
sidewalk café, Paris, 1953
(Collection of Michelle Vignes)

AIM members and the Native American community. Her work as a social documentarian began in earnest with this project.

In the mid-seventies Vignes started a long series on blues musicians, which culminated in the publication of three books: *Oakland Blues, Bay Area Blues,* and *The Blues.* Her more recent work, "The Gospel," flows from her interest in African American music and spiritual traditions in the San Francisco Bay Area.

As a cofounder of the International Fund for Documentary Photography and a respected teacher in the San Francisco Bay Area, she has helped to bridge photographers from different generations and continents. Recently she was presented the medal of Chevalier des Arts des Lettres by France's minister of culture.

Her early experiences at Magnum offer a rare look inside the workings of what they called the "Gypsy Factory."

I took a job at Magnum in 1953 not knowing much about photography, just names of well-known photographers like Henri Cartier-Bresson and Robert Capa.

As we had no darkroom, we sent everything to Pierre Gassman, a printer totally dedicated to each one of the photographers. Often I had to send a courier to take the negatives and to bring back the print. I would stay late to send the photos and try to make the deadlines and beat the other agencies.

Henri Cartier-Bresson, or HCB, was scared of keeping his negatives at Magnum because we all smoked, and he was afraid that we would set a fire. His negatives were stored in his studio, which was some distance from Magnum and four flights up. A friend who had been in prison with him in Germany, Claude LeFranc, would pick up the negatives, then bring them to me, and I would register them. Then I had a messenger send them to Gassman and back. I was always worried I'd lose his best negatives.

HCB just cut the frame out of the strip, and put it in a tiny envelope. His work was filed chronologically, in very tight envelopes containing his proofs. On each envelope, there was the list of its contents. In order to know what he had done, you had to have been through all of those, and there were quite a few. I happened to have a good visual memory of his work, and could find anything very fast. I loved it right away.

I put the photo packages together and got them out to the magazines

or to our correspondents in other countries. Things were not organized at all, so I created a system to send pictures, go to the train station, or the airport, and give the photos to someone and cable right away to the client that they would arrive via this stranger.

When I made the tour of magazines I would not only sell one story, I'd tell the picture editor, "Oh, listen, Ernst Haas is going to be in Thailand, or in Burma, for these coming weeks," trying to capture an assignment by mentioning a few stories that he could do.

Magnum was born because of the friendship of a few photographers who were involved around the Spanish War—Capa and Cartier-Bresson and George Rodger, who in his way was humanitarian more than political. We had some very political photographers. Magnum followed the intuitive talent of everybody; but each one had his or her different views.

Capa was a real businessman. If there hadn't been the war, he would have been great starting an enterprise of any kind. He was really a dynamo. He also gambled a lot on horses, and when he needed to borrow a little money to go on, he went to our accountant—who automatically would refuse any loan. But if he made a bundle she would accept the whole lot.

Capa had a wonderful sense of journalism. He always had ideas and was throwing people into the work. When I was there, he had started a story, "Generation X," that was the profile of one young person from each of several different countries. Each photographer chose a country. It was for *Holiday* magazine or another big one. After they did it, the magazine turned it down, so Capa recycled it to another one of the leading magazines.

Henri Cartier-Bresson could have become an art photographer. Capa, who had his feet on the earth, directed him, telling him, "No, don't do that mannered thing." Capa was the only one who could say to the photographers this is wrong or this is right. There were around twenty photographers. It was a centering point, where people were dispatched out, where photographers discussed, got the assignments.

Cartier-Bresson was a lot in Paris, but also, in 1954, he spent quite a few months photographing Russia. He was the first photographer to do stories in Russia. George Rodger came in and out, but around that time he had decided to leave *Life* to go and shoot in Africa. With George, we had a regular correspondence.

There were others. Erich Lessing started to photograph still lifes of opera and do portraits. Inge Morath followed Henri Cartier-Bresson on a trip in Europe as his assistant. Inge was married to the picture editor of *Picture Post* at that time.

[Werner] Bischof was a very shy, tall guy. Capa was always joking, and having fun, and drinking, and enjoying life. Bischof was a little straighter, and his sense of humor was so different that it made their communication difficult. The wife of Bischof, Rosellina, a wonderful woman, took care of his work and the work of others.

Magnum was really a turning point among photo agencies, because they had the photographers keep their negatives. They fought for that, that the photographer is the author and keeps his negatives.

After a year I became the picture editor in charge of all the sales in Europe. When Cartier-Bresson came back from Russia we sold his stories. They were divided into thirteen little stories, and I went to *Elle*, *Paris Match*, etc. We went very officially to see Madame and Monsieur Lazareff, the heads of a big chain of leading periodicals, including *Elle* magazine and the newspaper *Francesoir*. With Henri, I had discussed which stories we were going to bring. Those magazines were mostly women's fashion, and for those the editor was Michele Rosier, the daughter of the Lazareffs, a young woman in her twenties. We brought some things that had to do with women and fashion—maybe six of the thirteen stories. She looked at us, and said "Mr. Cartier-Bresson, you are leaving a few drops of your pee pee in each different magazine in Paris." (Laughs)

There was no precedent to establish a price on such a story, so out of the blue, really, I had to find a high price and be firm on it. It was scary. When we went to *Paris Match,* the leading magazine in France, we were asking a high price for each story. I gave them a day to make up their mind. They looked at them, and the next day, returned most of them to me. I think they kept two or three, and we were really disappointed, because we thought that would be our big sale. So right away, I rushed across the street to *Jours de France,* a direct competitor, but who didn't have that much money. They were very impressed, and they said, "Well, maybe yes. Let's consider, you know, the ones that were not chosen by *Match*." I couldn't ask for the same price. I asked a little bit lower.

That next night, around 11 P.M., I received a phone call from Henri Cartier-Bresson, who was at *Paris Match* working with the main editor. I heard the deep voice of the editor saying, "Michelle, we want to buy much more, and we want such and such a story by two days from now, by Wednesday, let's say."

So I said, "Yes, you'll have them," and I didn't sleep at all, because I didn't know if *Jours de France* was still considering them. I got really, really worried. When I called the next day, they said, "No, we're buying a story on Russia from another photographer." I thought, Whew!

The hardest thing was when we heard of the death of Capa, and then Bischof two days later. It was like being totally crushed. Capa didn't want to go on photographing wars, you know, and he wanted to print his new card: PHOTOGRAPHER OUT OF WORK (AU CHOMAGE). He died nonetheless on the last assignment he had accepted to do on war. He stepped on a land mine in Indochina.

Bischof was in a car accident in Peru, in the mountains. We were in shock, in total shock. I thought we were a family, a big loose family. But it wasn't that big, loose family, because right away there was a fight for power. Cartier-Bresson never wanted to have the power, but other people were jealous of him. So, once the magical alliance of HCB-Capa was broken, the others behaved like lost orphans.

After the volcanic and invulnerable Capa came the reign of the least aggressive of the founders: David Seymour or "Chim." He was kind and vulnerable. Here is his portrait by HCB: "He had the intelligence of a chess player with the look of a math teacher. He applied his vast culture to a wide range of subjects. He used his camera like a doctor would use a stethoscope in order to diagnose the state of the heart. He was vulnerable."

So he applied his stethoscope to the wounded Magnum, helping the agency's healing process. Unfortunately he was killed in 1957 in the Suez Canal.

When HCB's book, *The Decisive Moment,* came out, people were amazed with this different form of photography. That's where Cartier-Bresson made his mark. It was a stepping stone, and it has inspired a lot of people.

I think Magnum taught photographers to think in a way that they didn't before. They shot a bit straighter, and it suggested to photogra-

phers that you have to have a style, and you have to create an image from life. They taught how to believe in what you do and to live fully, live fully with your little camera. Don't do it just to record.

Magnum wanted everyone to know about the chaos that was going on in the world. George Rodger photographed the Bergen-Belsen concentration camp. Chim photographed prostitutes in Essen. There were Soviet war prisoners that were leaving Germany and many Jewish immigrants who escaped the camps and were never at home anymore. The ghettos where they had lived didn't exist anymore. Thousands went to Palestine, and Capa photographed them. Such was their work and the power of their lives. Their photographs continue to enrich, inform, and move us today.

Wayne Miller

World War II and the Family of Man

After a short stint in art school, Wayne Miller joined the navy and, a few months later, Edward Steichen's World War II photography unit. By the end of the war Miller was working as a freelance photographer for several national magazines and received two consecutive Guggenheim fellowships for the project, "The Way of Life of the Northern Negro," photographed in his hometown of Chicago.

Miller, his wife, Joan, and their three children moved in 1949 to Orinda, California, where he worked as a contract photographer for *Life*. In 1953 Edward Steichen, the director of photography at the Museum of Modern Art in New York City, enlisted him as an assistant curator for the historic "Family of Man" exhibition.

Miller created two books about childhood: *A Baby's First Year* with Dr. Benjamin Spock in 1955 and, after the family returned to California that year, *The World Is Young*. Elected to the Magnum photo agency in 1958, Miller served as its president from 1962 to 1966.

In 1958 he and Joan also purchased a redwood forest and, later, a vineyard, which they continue to manage. After retiring from Magnum and photography in 1977, Miller developed award-winning environmental education programs for the National Park Service. Recently, a book of his photographs on Chicago's South Side was published by the University of California Press.

I was born and raised in Chicago and attended the University of Illinois, where I became photographer for the university's yearbook and

Birth of David B. Miller delivered
by his grandfather, September 19, 1946
(© Wayne Miller/Magnum Photos)

newspaper, *The Daily Illini*. I went to the Art Center School in Los Angeles for nine months before I was asked to leave, because I didn't have the proper respect for their curriculum. When World War II came, I joined the navy and became a member of Captain Edward Steichen's special navy photographic unit.

In 1942 I married Joan Baker, which would prove to be the smartest decision I would ever make. In one bold move, I captured exclusive photo rights to her life and those of the four children she eventually produced. (Laughs)

Steichen was an exceptional man. He had been a painter of repute in the early 1900s and had introduced the works of Rodin, Cézanne, Brancusi, and others to the U.S. He was a lieutenant colonel in charge of aerial photography in World War I and, as chief photographer at Condé Nast, had created new standards for fashion and advertising photography between the wars.

I wasn't really a professional photographer. I learned on the job. By chance, I was the first one in the group, and I helped set up the conditions and space and equipment for the others, who came in shortly after I arrived.

I learned because Steichen encouraged me. If he saw something lousy in my work—and there was an awful lot of it—he ignored it and found things good to talk about. I don't ever remember him giving me an assignment, except to photograph the sailors—the "little guys" he felt would win the war. I followed the battle actions around in the Pacific, the Indian Ocean, and southern France. Much of my four years was spent aboard aircraft carriers, where action photography was limited to the occasional times we were attacked by air or torpedo. If you were on the wrong side of the ship, you missed the photograph.

I was excited, ambitious, and afraid all the time. Under similar conditions, anyone who says differently is a liar. Once a navy photographer asked if he could go in my place in a torpedo-bomber mission. When the plane returned, he had been killed by machine gun fire. His last photographs showed a Japanese Zero attacking his plane.

Often when I got into landing craft, I would get seasick. Off Italy, while waiting for the invasion of southern France, I went ashore out of boredom and photographed the children of Naples. Later I learned that these hungry, ragged children were not necessarily a reflection of the war, but of normal conditions in Naples. Gene Smith, who saw the

photos at *Life* with only the traditional credit line, "Photo by U.S. Navy," sent me a telegram that said, "Congratulations. I knew that these were yours."

Toward the end of the war in Japan, I traveled with a task force whose job was to liberate the prisoner-of-war camps. Unlike in Europe, the Japanese often put POWs in hotels. In one case, an American prisoner who had liberated himself was soaking in a bath while one of his former guards served him a cold beer.

I was also in Japan for the securing of Tokyo Bay harbor, then I left immediately with photographer Jay Eyerman of *Life* magazine for an eight-to-ten hour train ride to Hiroshima where the United States had dropped the atomic bomb. *Life* magazine had found us a nisei to act as an interpreter. He had been trapped in Tokyo at the beginning of the war and was a hot trumpet player at Radio Tokyo. Later I learned that—even though we were grimy and unshaven—he was passing us off as generals investigating the war damage.

The people with whom we had been at sword points for four years completely ignored us. They didn't push us or swear at us. They acted as though we weren't there. The emperor said the war was over and they were going home. We were in Hiroshima for only a day. We had no food or blankets. And we didn't know what we were walking into. Hiroshima was a horror, the ultimate denial of sanity.

I could have attended the surrender ceremonies, but I didn't. I was just tired of it all. During my four years, I'd seen an incredible waste of lives and resources. One evening toward the end, I drifted out on deck and joined a group of my shipmates. We swapped jokes for awhile, but then our mood shifted, and we began to discuss the blind futility of war. Many of us felt we were fighting in the dark against enemies we didn't know and who didn't know us. Guns and bombs might win the war, but ignorance would surely lose the peace.

I never forgot that conversation. It helped convince me to document the things that make the human race a family. We may differ in race, religion, language, wealth, and politics, but look what we have in common—dreams, the comforts of home, the hunger for love. With photographs, I thought I might help some of us better understand the strangers who live on the other side of the world—and on the other side of town.

Not long before the war ended I received a grant from the Guggenheim Foundation to photograph "The Way of Life of the Northern Negro." I went back to Chicago, where there was a large black population on the south side, many of whom moved there during the war.

Getting started was my biggest problem. After two months of stewing and stalling, I slung my Rollie around my neck and went to meet the people of south Chicago.

I had good luck almost from the start. At the South Parkway Community Center, I met Horace Cayton, the coauthor, with St. Clair Drake, of the sociological study, *Black Metropolis*. He knew everyone and was most generous in sharing his immense knowledge and contacts. Interracial groups of artists, activists, social service personnel, and society leaders often gathered at the center. It was always exciting. Once, I made a picture of a young white woman hanging a picture by hammering a nail into the wall with the butt of a revolver.

A struggling new magazine called *Ebony* occupied an office at the rear. Horace introduced me to its editor, Ben Burns, who promptly gave me photographic assignments, including stories I could never have discovered on my own.

While working on the grant, curious South Siders only challenged me a few times. So I'd cheat a little and answer, "Oh, I'm with *Ebony* magazine." As a rule, though, those black men and women of Chicago were gracious and generous. Conversation was easy; doors were opened and invitations offered.

When I spotted an interesting situation, I didn't hide my camera or myself. Instead, I often approached and said, "Please, pay no attention to me." I think that I somehow created good vibes. I was trying to tell their story. I was trying to respect their lives. That was my only reason for being in the streets and the homes of south Chicago.

I gravitated to places where people were having fun, raising hell, or trying to raise money. Once I photographed a veteran prostitute on the job with one of her regulars. Afterward, he asked me if I'd gotten the pictures I wanted, and, when I said it happened pretty fast, he invited me to come back next Tuesday for me to have more time.

One of my favorite haunts, a bar on Forty-fifth Street, had a lurid reputation. Its clientele were stockyard workers, day laborers, and a few unattached women. Some passersby would step into the street rather than stroll by its open door. True, the crowd was a bit noisy and

uninhibited. But, although I never saw another white face there, whenever I stopped in to make photographs or drink a beer, I was welcomed. Every summer the owners threw a big picnic for their friends and favored customers. I was invited, too, a gesture I'll never forget.

In addition to the thousands of photographs I made, there were thousands I didn't because my eyes and instincts weren't good enough. When I think of what I missed, it makes me want to cry. That I had the arrogance to even attempt such a grand concept now makes me uncomfortable.

It was a marvelous time. Magazines were hungry for photographers. I worked for *Life* on assignments, and for *Collier's,* and *Fortune.* I had more work than I could handle. I was also teaching at the Institute of Design in Chicago for one day a week. But after a while, it gets a little repetitious. I wanted bigger challenges.

I began to photograph my family in a documentary fashion. I did an assignment for *Ladies' Home Journal*—"Baby's First Year." I did two pages every month, photographing the changes within this baby's life. Later, with Dr. Spock, I made a book of these photographs.

In 1949 we decided to move either to the East Coast or the West Coast. The East seemed too much like Chicago. The sense of growth and movement in the West was more appealing, so I got a contract from *Life* in their San Francisco bureau and worked there four years.

I had met Dorothea Lange during World War II when I was going from Washington, D.C., to the Pacific—just an afternoon with her with warm pie and coffee in her garden. That was Dori. Dorothea was the reason I came out here. She was the only person I knew. She became a very close friend of the family, and she and Paul, her husband, invited us into their family lives. That quality she had was the quality she got in her photographs.

After the war Steichen had become director of photography for the Museum of Modern Art in New York. During the war, he told me of a dream that he had had in the 1930s of a massive photographic exhibition, a Walt Whitman–like hymn to America—photographs two or three stories high, to be hung in New York's Grand Central Station.

This dream was interrupted by the war. But Carl Sandburg, Steichen's brother-in-law and Lincoln's biographer, spoke during that time

of Lincoln's use of the phrase, "The Family of Man," and Steichen realized that his project should not be limited to America, but worldwide. In 1952 he traveled to eleven countries and twenty-nine cities in search of material.

He felt that people the world over had a lot in common. And he wanted to show there was more love than hate in the world, and more goodness than there was badness. He felt that without a greater amount of love in the world, we would destroy ourselves.

In 1953 he called to say he wanted to meet California photographers. Dorothea Lange, Joan, and I organized a meeting at our Orinda home. The next day Steichen asked me to assist him, and I couldn't say no. Joan and I and our four children moved from California to New York City.

The "Family of Man" was a big idea, and we needed to find the photographs to convey it. I looked through the Time-Life files, where there were three-and-a-half million pictures, all in different file cases. In addition to the work of *Life* photographers, the file contained pictures collected by Time-Life from photographers all over the world. I'd make a pile of selections and take them back to the Museum of Modern Art. Steichen and I looked through them again. I spent five months there, and I put my hands on every one of those prints.

We also announced what we were trying to do and asked photographers who were interested to send material to us. We received pictures from all over the world—bags of mail filled with both snapshots and large prints.

We got some from a Russian photographers' association in Moscow —great big prints, images of factories, and fellows wearing suits. From China we received pictures of farming successes. The farmers were nicely dressed in peasant costumes and invariably wearing medals. One of them is in the book.

In addition, I visited picture agencies, corporate collections, and looked at the personal collections of photographers in New York City. We must have looked at four million or more photographs. Steichen said, "No one will believe four million. Let's say two million."

Our workspace was a loft over a striptease joint in New York City. We gathered the photographs there, and a couple assistants would log them in. We were never concerned about who made the pictures. We

dealt with the pictures on the basis of their value to the core concept. We ended up with about ten thousand pictures. When we started working with these photographs they began to sort themselves out into certain categories. An obvious one would be "mother and child." Another would be "work." Another would be "play."

The assistants pinned them up on four-by-eight panels. We moved them around to relate one picture to another. As we got them up on these panels, obviously some of these things just didn't have any electricity to them. We continually questioned our values. Steichen also invited critics to come see the work in progress—photographers like Dorothea, some anthropologists and sociologists, the museum's director and his staff.

We created new categories, and we destroyed other ones, and, eventually, these categories began to create sequences. This is the way the exhibit was developed. I think you could say the photographs created the exhibit rather than Steichen and myself.

This was not an exhibit of fine photographs. This was an exhibit of photographs that expressed this common theme of the oneness of man. Most of the photographs had a relationship to another photograph. So the photograph itself was not necessarily complete in itself. It depended on the other member of the family to give it meaning. The idea of joining different photographers' work was unique. It was hard for some photographers to want to be involved in something like this because in the past it always had been the individual on the wall.

When it came to making of prints for the exhibition, we were dealing with concepts of communication that depended upon size, juxtapositions, and sequences. Some of the photographs were quite large—ceiling to floor. The largest one was of Mt. Williamson by Ansel Adams. It was about 10 feet high and 12 feet wide. We used an English paper that came in 40-inch-wide rolls. We had to make it in four panels, and it was quite a trick to match the quality of each panel.

Wherever the show went, it broke attendance records in major museums. The original exhibition made for the Museum of Modern Art in New York was hung on walls that were specially designed for them. Months later the U.S. Information Agency replicated the show and distributed it overseas. They were not involved in the creation of this show, but expressed their desire to distribute it. First it went to the

world's fair in Moscow. In all, ten copies of the show were seen in sixty-nine countries by more than nine million people. The book was a best-seller and is still being published.

There were criticisms. At the time, we were dealing with Senator Joe McCarthy's communist hearings. McCarthy suspected physicist Robert Oppenheimer of being a red sympathizer, and we had a picture in the show of Oppenheimer conducting a seminar with graduate students. We talked about it, and Steichen said the hell with it, this is a good picture. Let's use it.

After I returned to California from New York and the "Family of Man," I realized that not one of all the pictures I'd seen had photographed childhood. Sure, we all make pictures of kids, but no one had really made an in-depth effort to photograph that world of childhood. I decided I wanted to do that. I wanted to come back to what was me. I loved news stories, and I was pretty good at them. But those things were like a skyrocket. You'd grab hold of it and ride it to the top, and, after it was over with, you'd come back to earth.

I really enjoyed photographing those closest to me. Edward Weston photographed his backyard because it was as important to him as the migrant worker was to Dorothea. Well, that's what my family was. And is.

I got an advance from the publisher of the "Family of Man" book, and I did it. I photographed my own family, and as the children played with the neighborhood children, their own friends, neighborhood friends. Then they went to school, so I followed them to school, until they became young adults. I was trying to show how the world appeared to them.

They seemed to be pleased with the book when it was published. About seven or eight years later, when Jeanette was a beginning college student, she paid me a compliment that I shall never forget: "Dad, why don't you do another book about my age group? People don't understand who we are or how we feel."

The World Is Young sold about eighty thousand copies and was one of the first Reader's Digest Condensed Books. Unfortunately, it didn't go back to press. I don't know why. Publishers are timid souls. After the publication of *The World Is Young* in 1958, I returned to magazine

photography, then I retired from active photography in the mid-seventies.

I was asked, "Why did you quit?" For many years, I had been a spectator, an observer of other peoples' lives. I wanted to be a more active participant in the world, no longer just a fly on the wall watching the world through my viewfinder. When I mentioned this to my photographer friend Eve Arnold, she said, "I know exactly what you mean."

Peter Magubane

A Black Photographer in Apartheid South Africa

Born in Johannesburg in 1932, photojournalist Peter Magubane has helped expose South Africa's humanitarian crimes to the West. Magubane began at *Drum*, one of the only magazines dedicated to the anti-apartheid cause in the 1950s, first as a "tea-boy" and then a driver. He joined the photographic staff in 1954. The magazine was later syndicated, and, during the uprisings of the 1960s when other magazines such as *Time* and *Life* were forced to shut down, *Drum* was the world's primary source of photographs of apartheid.

Since Magubane is a black photographer, his work put his life in danger. The police broke his nose, and he has suffered multiple gunshot wounds. In 1970 he was accused by the government of being a communist and a terrorist. Imprisoned, he spent almost six hundred days in solitary confinement and was repeatedly and savagely beaten by guards. After his release the government "banned" Magubane, which prevented him from working as a photographer for five more years—a punishment he says was the most painful of all. In 1976, after the Soweto uprising, Magubane was able to resume work as a photojournalist for the *Rand Daily Mail* and covered the events that finally ended apartheid.

Magubane's work, much of which has been collected into the books *Magubane South Africa* (1978), *Soweto* (1979), *Black Child* (1982), *June 16, 1976* (1986), *Portrait of a City* (1990), and *Women of South Africa* (1993), provides a visual history of apartheid and the movement against it. With the end of apartheid and the election of his friend, Nelson Mandela, as presi-

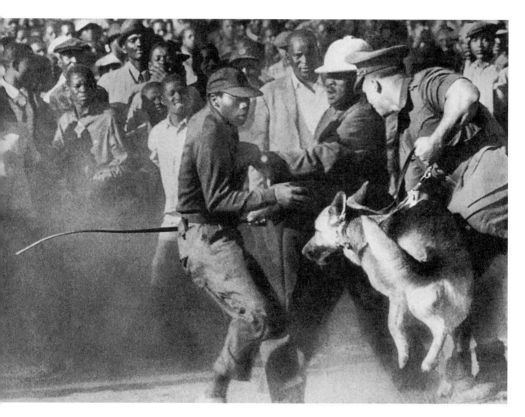

Soccer fans go wild and police use dogs
to control the crowd, South Africa
(© Peter Magubane)

dent, Magubane turned to documenting native South African culture and traditions. *Vanishing Cultures of South Africa*, published in 1998, celebrates the rituals of ten major South African ethnic groups and contains a preface by Mandela. Magubane was awarded with a Leica Medal of Excellence for Lifetime Achievement in 1997.

In 1956, when the "Family of Man" exhibition came to Johannesburg, I looked, and I said, "These are great pictures. If these photographers who took these pictures can do this, why shouldn't I?" I began working very, very hard to try and reach the standard of those pictures that I saw.

I was able to understand and make the world understand what was going on in South Africa because of *Drum,* a magazine that dealt with social issues affecting black people. I had to say to myself, "Here, I'm a black person. I have to liberate myself through the medium of the camera. I have to liberate the oppressor through the medium of the camera. I have to liberate my people through the medium of the camera." If you liberate yourself and you leave out the oppressor, you have not liberated your country at all.

I did all I could, truthfully. I recorded everything that happened, even if I found a white person being molested by black people. I would not turn around and face the other direction and say it has nothing to do with black people. I photographed that as well.

Drum magazine had a circulation of about 120,000 readers. Its audience was black people and liberal whites. It was a magazine that dealt with social issues—issues that were affecting black people. We did stories such as how prisoners were treated, how farm workers were treated, the prisoners that were sold to farmers who died while working—they would be buried on the same grounds, and the work force would carry on—child labor in South Africa, the Morality Act, the pass, the carrying of passes. You name it.

Anything that affected black people, we, as *Drum* magazine, were involved in. We were able to expose and show the world what South Africa was about. It was the only publication that told the truth about South Africa.

In the beginning there was no pressure from the outside. The authorities didn't deem it necessary that they should be raiding the paper. It was only in the 1960s and 1970s that you couldn't publish what you

wanted to publish. Especially, there was a story that we did in the 1960s on prisons. Newspapers were no longer allowed to photograph prisons or to say anything, whether good or bad, about prisons. Anything that involved police, you had to get it clarified first.

Of course, you know you would never be given permission to run it, but, in some cases, we did, hoping that we would not be prosecuted. When things began to be tougher is when the world put pressure on South Africa through the writings and photographs that were taken in the country about how black people were treated—what apartheid was about.

As a black person in South Africa in the fifties, sixties, and up to the seventies, it was a very difficult period. You had to carry a pass. Without a pass you did not exist. You could be stopped, arrested, and sent to prison. You couldn't even work. You couldn't even get a house. You couldn't be in a city. You had to be in a rural area. You could go into a camera store, and buy a camera, and photograph, but it would not be photographing, like an exposé. You would be probably doing portraits and have a studio.

But I said to myself, "You are here with a camera. Do you allow yourself to be dictated to by the system or by anybody?" Answering myself, I said no. That put me in a fix. I was arrested.

Before the arrest came, I was refused a press card, because I was black and because of the magazine that I was working for. No black person in that magazine had a press card, because the commissioner of the police signed the press card, and, therefore, you had to be very good to be able to get a press card. Well, I was one of the bad boys, but I didn't care at all, as long as my editors liked what I was doing, and the world was able to see what the oppression was like in South Africa.

In 1960, during the Sharpsville massacre, I had never seen so many people dead. There were about sixty-nine people who were shot by the police and over two hundred that were injured. I got to the scene. I was just shocked, didn't move for five minutes. When I moved, I took pictures from a distance. I was happy I had pictures. But my editor wasn't. He wanted a close-up picture, a picture that would make you cry if you looked at it, a picture that would sell the newspaper or magazine, as he put it to me.

I apologized profusely. I said, "I'm sorry. I got shocked." He said,

"In this game, you don't get shocked. If I didn't think you had a po-
tential of making a good photographer, I would fire you."

And the man was serious. I said to him, "Sir, thank you." I left the
office. I searched myself. I began to page through pages of *Life* maga-
zine and other magazines. The man was right. You know, here when
you deal with events like this, you really have to do long, middle, and
close-ups so that he has a choice. Then I said, "Well, I have to prove
myself now." From that day, I wasn't going to be shocked by anything.
I wasn't going to get emotionally involved. When I get into a scene, I
just have to think about me, think about the reader, and think about
the magazine.

That's exactly what I began doing. I knew very well that things might
be different in the future. One will probably have to lay his head on the
block whilst you're doing the work, but I would not be sorry if I died
doing this. I would be dying for the cause. I would be dying trying to
liberate my country and myself.

As a result, I had narrow escapes. I was detained for 586 days in soli-
tary confinement. I was banned for five years, which meant I lost seven
years of my photographic career.

In 1985 I was shot below my waist, seventeen buckshots, which are
still embedded in my body. The community looked after me. They
dragged me into the house. I could have died. The police would have
finished me up, but the people dragged me into the house and kept me
in the house until such time that things cooled down, and they took me
to the hospital. I must say I'm very grateful to the treatment that I've
gotten in all these years from my community. Because without them,
without their patience, I would not have operated freely. They did un-
derstand the work that I was doing. They knew that it was not for me
only, even though I was being paid for doing that. It was for the sake
of the country that I was doing this. Of course, you had to be with the
people who are demonstrating against the system. You could not be on
the other side. You couldn't be with the police. Now today, things have
changed. You don't have to be on this side. You can mingle with the
police, because the laws have changed.

In 1976 the police bashed my nose, and then I fell and got up. This cap-
tain said, "Take out the film."

I said, "no."

He said, "I repeat. Take out the film. If you don't, I'm going to hit you harder than I did."

I realized the man meant business. I took out the film, and he said, "Expose it."

The pain! The pain that I got with the hits on my nose was not as serious as the pain I got when I was made to pull out and expose these images that I knew I had. It was more painful to me to be made to destroy these images. I still say today that the policeman was a fool to have made me do that, because if he knew what photography was, he would have probably taken the film, and took it to the police archives. But he was a damn fool!

I was banned and not allowed to talk to more than one person at once or to attend gatherings. There's no way I could work as a newspaper photographer, because, if you have to photograph two people there's no way that you can do that. You can't go to a wedding. That's a group of people.

I broke my banning orders. I was arrested. I was sentenced to six months in prison, no fine. I went to prison, served the six months. I came back. In 1976 I was arrested again, detained for another 123 days. I had my nose fractured, and I was hospitalized for five days.

I was prepared to face the music. I did not use any pseudonyms. I used my own name under my pictures, and I had exhibitions all over the world. I wasn't afraid to speak out. They could not refuse me a passport, because I didn't apply personally. My first passport was through a mining magnate who was Anglo-American. They made the application. They had given me money to come overseas and exhibit my pictures.

What it meant was that when I came back, I had to return the passport. So, if I want another passport, I should reapply. The only other time I was able to leave the country was in 1977, when I won the major South African photographic prize for distinguished journalism. They couldn't refuse me a passport.

It would not have paid me had I left my country. I think I have gained more, because I have helped liberate my country with my pictures. It was more important to work in my country, to get as much material out of the country for the world to see, than to work in other parts of the world.

One time when I was in one of these farms, the police came and arrested us. I was with a writer. They took us to the police station. When we got to the police station, they were using abusive words. I realized, hey, we're in danger here. I had a Weston Master III light meter. I took it out of my pocket. As this guy was talking, I opened the back. You know, when you open the back, it goes, "Wiing!"

So I open the back. It goes, "Wiing!"

The guy says, "What are you doing?"

I say I'm communicating with my office. I'm telling them that you are using abusive words and you are threatening us with beatings. So you can carry on now. If you want to beat us, you can carry on. And the guy called his superior. His superior came, and I did the same thing. When he started talking, I opened the back. So the needle's moving back and forth, and they think I'm talking to someone.

So, I said to him, "Well, if you want to beat us up you can." Then, I held the light meter, and I said, "Well, is this my editor there? We are still having a problem, which we are now discussing with these officers here. It looks like they're going to let us go. Okay, bye." And I closed the meter.

These guys did believe. They said, "Take your fucking car out of here and move," and we really got into our car and we drove off! And I said, well, you know, it worked. (Laughs) They were not that sophisticated because, those days, they used to take them raw, from the farms. They didn't understand what was going on. One had to use one's brain to play with the system, to beat the system.

One time this policeman came and asked for my pass. I gave it to him. It was not signed. By rule the pass has to be signed every month by your employer. And he said, "Well, it was not signed. I'm arresting you."

I said, "No, bring it here, bring it here." He gave it back to me. I said, "Could I have your pen?" I signed it, and I gave it to him.

He said, "Well, this is fine. Now you can go." (Laughs)

There are projects that I'm working on now. People need to know how we lived in the country for all these years to deal with things like the vanishing tribes. That is important to document, not leave it to Europeans to come down to South Africa and photograph this and have books made like they have done with other parts in Africa. It is im-

portant that one deals with these subjects, especially the street children and the children working, so that the government can do something about the plight of these children.

I introduce myself to these children, tell them what I'm doing. I become their friend and stick around without taking pictures. After a week, when they trust me and I trust them, I begin to work, and they don't see me as a stranger. It's only if someone else comes whilst I'm working, and if that person tries to photograph, then they go to this person. They say, "Uh uh, we don't want you to take our pictures."

The same applies to the children working. If there are any objections from whoever is the supervisor, I go to him, I tell him what I'm doing. And if he doesn't approve of what I'm doing, I carry on. If he wants to pick a fight, I say, "Well, if you want to pick a fight, I will fight as well." But first, my approach is very humble. I make them understand that I'm here to work, but if someone wants to pick a fight, I put my cameras down. I say, "Don't interfere with my work. Don't come between me and my camera."

Even though I suffered pain, that loss of images, today I still don't have any hatred whatsoever. I know that it will not help me. In fact, it will destroy me. I am not going to be thinking about what happened yesterday. I have to think about today and tomorrow. Revenge does not pay. Even though seven years of my photographic career was taken away by the South African police and the government, I will be able to make amends. Who am I to refuse to accept people of all colors and embrace them so that we can live peacefully in our country?

Matt Herron

The Civil Rights Movement and the
Southern Documentary Project

In 1962 Matt Herron, his wife, Jeannine, and their children moved to Jackson, Mississippi, and began the Southern Documentary Project, which he hoped would document the Civil Rights movement in the same spirit that the Farm Security Administration had covered the Depression. His project's eight photographers traveled through Mississippi, Alabama, and Georgia to document rural and small-town life in the summer of 1964.

More than thirty years later Herron's project has become one of the more important bodies of visual documentary on the Civil Rights movement. Photographs from the project have contributed to exhibits, documentaries, and books, among them *Eyes on the Prize* (1987), *The Movement* (1964), *Appeal to This Age: Photography of the Civil Rights Movement* (1994), and the *Civil Rights Movement: A Photographic History, 1954–1968* (1996). Herron continues to collect and archive photographs of the movement and has helped to establish an online database, at www.TakeStock.org, that displays digitized photographs, captions, biographies, and interviews with photographers.

Herron worked with Greenpeace to report on whaling voyages and the seal hunt protest at the mouth of the St. Lawrence in 1979. He is also a past president and a national board member of the American Society of Media Photographers. His photographs are in the Smithsonian Institution exhibit, "We Shall Overcome: Photographs from the American Civil Rights Era," which is traveling throughout the United States and abroad.

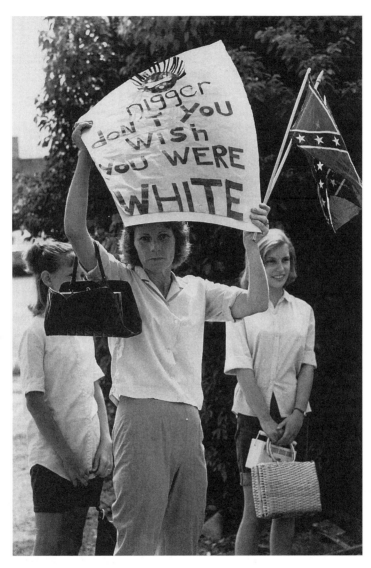

"Nigger don't you wish"
(© 1976 Matt Herron/Take Stock)

In 1962 and 1963 I was photographing in three different capacities. First, I was a photojournalist on assignment in the South. My hope was that by being in the South I could send better story suggestions to editors I worked with in New York. With a closer connection to what was happening, I hoped my suggestions would allow the magazines to do better journalism. What I learned was that basically the editors didn't care. They were interested in having somebody on the spot when the riots broke out. I got a lot of that type of assignment, and I have to admit that some of it was pretty interesting and led me into situations I might not have had access to otherwise.

Second, I went South to work with the Civil Rights movement, and in Mississippi that meant SNCC [The Student Nonviolent Coordinating Committee]. Although I was never a formal member of SNCC, I did some movement photography—demonstrations, jailings, marches, coverage of SNCC workers and activities.

Third, I tried to work as a social documentarian. I had met Dorothea Lange a couple of times in the fifties and sixties and had shown her work. Although [photographer] Minor White was my teacher, Dorothea was in many ways my mentor. She represented the direction I wanted to go. So, in Mississippi I was trying to document a manner of life; I was interested in Southern culture, black and white, and Southern institutions. Often, I would use assignments as a vehicle and a cover to do documentary photography. As social activist I was probably looking at what was going on in the country in a slightly different way. I had discovered a strong affinity for history courses at Princeton, and now I had a conviction that what I was witnessing was history, that things which people saw as everyday events were in fact special and unique.

For example, in 1963 *Time* assigned me to cover the inauguration of Mississippi governor Paul Johnson. It was a one-day shoot, but I felt like I was walking on another planet. The dress, the mannerisms, the folkways of southern politicians, including George Wallace and Ross Barnett, were extremely normal to them, but to me they looked like a scene straight from Mars, and that's the way I photographed it. There were newspaper and wire service guys and other photojournalists present who probably did not see it the same way I did. *Time* ran an extremely ordinary head shot of Johnson, but I came away with some real treasures.

These were the three modes of photography that I juggled, and in

this I was probably unique among civil rights photographers. People tended to be movement photographers like Danny Lyon, or photojournalists like Charles Moore and Flip Schulke. The juggling wasn't always easy. Sometimes movement people didn't trust my press connections—it was the mark of an outsider. And journalists would sometimes imply that I was not "objective" enough, meaning that I had ties to the movement. But it all worked for me.

Danny Lyon was actually finishing up in the South when I came to Mississippi. He had been photographing in 1961, 1962, into 1963 and was thought of as *the* SNCC photographer. Danny distrusted journalistic media and didn't want to have much to do with it. I don't know how he felt about me doing assignments, but we were friends and got along.

I believe SNCC was the first social activist group that understood the press could be an instrument they could use to promote social change. The press wouldn't necessarily be on their side, but they could be used to get the story out. This was essentially the vision of James Forman, the chairman of SNCC, who had been a schoolteacher in Chicago and had a more sophisticated understanding of media than more young activists. Forman invested scarce funds to set up a communications office in Atlanta, employ photographers, and create a darkroom. Julian Bond was his first director of communications. Although I was working independently, I cooperated with them. I trained some of the SNCC photographers, and there were times when Forman would call me, and I'd go shoot something.

In 1963 I photographed the riots in Birmingham [Alabama] following the Klan church bombing that killed three little girls and various news assignments into 1964. But it became clear in early '64 that the summer would produce a major confrontation between SNCC and the forces of segregation in Mississippi, as SNCC leaders prepared to recruit one thousand students from mostly white, Ivy League colleges to move into the state to teach and do voter registration. All of us were thinking how to prepare for it, and I could see that by then SNCC would have a team of photographers that could probably handle the movement's stuff pretty well.

I decided that what I wanted to do was set up a team of documentary photographers who could photograph white and black Southern society in transition. I put together a position paper and talked to people about it, and I suggested to SNCC that we work in cooperation.

I got in touch once again with Dorothea Lange. She was interested in my plan but felt that I was too politically motivated to generate true, objective documentary photography. Dorothea was always very concerned that a documentary photographer should have no political bias whatsoever. I'm not sure she herself always practiced this, but that's the way she preached.

I asked her to become our official adviser. She thought about it quite a while and finally decided she could not lend her name to the project, because she perceived my heat and felt I could not be objective enough for her. But she agreed to be an informal adviser.

Then I went North to raise money, and I failed utterly. I called Eastman Kodak and suggested they might want to donate film. Instead, I got a lecture from this Kodak vice president: Why didn't I stay North and mind my own business?

I was then in my early thirties and older than most people I was working with. I had a formal relationship with the Black Star Photo Agency, but for some reason I never thought to tell Black Star about the project.

One day, I was in the office of Howard Chapnick, the president of Black Star, and I told him about the plan, and he loved it. He asked how much money I needed. I said well, about $10,000. He got on the phone and in about fifteen minutes raised the money. He worked out a guarantee from *Life,* where *Life* would have access to us if they needed a photographer on site, in return for which they would give us a retainer. A union and Black Star also put up some money.

I turned to recruiting photographers. I wanted to get the best talent I could. Danny Lyon had left the South by now, but I made a trip to New York to enlist him. We had lunch together, and I twisted his arm and more or less dragged him back South. He said he would not have returned except for this project.

Eventually I had eight photographers, mostly unknown. George Ballis came from California where he had been covering the migrant farm worker movement and did marvelous work for us. George and I were the only ones who were married with kids. Norris McNamara was a SNCC photographer who gravitated to our group. There was also a black photographer named Fred Devan and a student who came down from Antioch College, Dave Prince. Dave is now a video filmmaker working in Africa.

Halfway through the summer I recruited another photographer, Nick Lawrence, who was touring the South with his wife. Nick worked about a month photographing white planter culture in Ruleville, Mississippi. All together the project ran about two months. It was a very chaotic time. Mostly we were on the road, living out of the trunks of our cars, operating on about $30 a week. I was shooting and running the project, calling clients, assigning photographers, negotiating with *Life,* and trying to keep in touch with my family. We shared some facilities and funds with SNCC.

By summer Jeannine and I had blown our cover in Jackson, Mississippi, where we lived incognito in a white neighborhood, and had been forced to leave our house. Jeannine moved to Atlanta with the kids and worked with Julian Bond in SNCC communication, running the darkroom. The darkroom processed film for both the Southern Documentary photographers and the SNCC photographers—ten or twelve all together.

I had phone conversations everyday or so with my photographers. George was particularly good. He would call and say, "I'm finished here; what do you want me to do next?" And he'd go off on some other mission. He went to Atlantic City to cover the Democratic Convention and came back with a wonderful collection of images. George and I probably produced the most consistent work.

Danny was pretty independent. He roved around, and he didn't shoot a lot, but what he did was lovely. He did some beautiful stuff at the Nashoba County Fair. Danny had begun as a movement partisan but was now burning out on civil rights and was beginning to be more concerned about following his own personal directions.

Dave Prince was just beginning his career and was still quite green. He got beat up in Selma, a very scary place, and ended up in the hospital. I followed him in the next day and found myself that evening photographing a meeting at the same church where sheriff's deputies had worked Prince over, but I managed to get out intact.

Later in the summer Prince photographed the funeral of James Chaney, one of the three civil rights' workers murdered in Nashoba County, and he spent a week with the Chaney family. He followed James's younger brother, Ben, in a moving series of photographs as he tried to cope with his brother's death. It could have been published as a very good magazine essay, but nobody would buy it. I spent a lot of

time in the Mississippi Delta in one particular community of independent black farmers. Norris and Fred had a dispute with me and left the project early.

The whole thing happened so fast. It really required three months of preparation: interviews with photographers, looking at portfolios, and so on. Instead we did it in weeks. The model was clear, but the project suffered from its hasty inception. Insofar as I understood how the FSA [Farm Security Administration] worked, I tried to work that same way. I made suggestions to photographers, I gave assignments, and I gave people lots of freedom and latitude. And they had film and cars and a little bit of expense money.

It was really a little experiment that should have grown and developed for another two years. We might have produced a real body of work had we done that. I always regretted that I was not able to raise more money and continue it, and I used to reproach myself with that, but in fact I didn't have the organizational skills at that time to pull it off.

Most of the film went to Black Star, which held the collection in New York and published a good deal of it. I had assumed we would have a show and book that would allow the project to go on from there. I showed the work to John Szarkowski at the Museum of Modern Art [MOMA]. John was intrigued with the project, and he began to talk about doing a show. He asked me to put something together, so I went out to Ohio, and Dave Prince and I put a set of work prints up in a gallery and pushed them around until they began to make sense. But that was as far as it went. John became less responsive, and finally I couldn't get him to return calls.

Later I learned that Danny Lyon had been to MOMA to see John, and, when John asked him what he thought of the project, Danny said the pictures were all terrible. And that was the end of it.

I think that to a certain extent Dorothea was right. It was extremely difficult in that pressure cooker to work in an objective fashion as a social documentarian. One could not travel the highways in Mississippi with cameras without being stopped and questioned. The pressures were intense. We were chased, and we had frequent dealings with police.

In the fall of 1964 there was a general ebbing of energy in the movement and a critical change of direction. The big push had been to send an alternative black delegation to the Democratic Convention in At-

lantic City under the auspices of the Mississippi Freedom Democratic Party. That effort ultimately failed. Lyndon Johnson, aided by some prominent party liberals, put great pressure on the Democrats not to seat the black Mississippi delegates, and there was great anger and disillusionment among movement people following that.

SNCC's strategy had been to shame the liberal establishment into forcing social change by confronting it with the disparity between liberal aspirations and actual practice. With the failure in Atlantic City, people began to lose faith in that strategy and to consider more radical measures.

Blacks were beginning to realize they were losing control of their movement. More and more SNCC offices were being run by white kids with typing and filing skills, and there was a growing sense that it was time for whites to get out of the way and let black people run their own affairs. We parted with hugs and tears. The only truly integrated, beloved community I had ever known was breaking up. Money also began to dry up as SNCC grew more militant. By the winter of 1964 people were living in freedom houses in the Delta on bread and peanut butter—that was all they had.

That winter I went to Mexico with a huge suitcase filled with Southern Documentary prints, intending to organize a show and a book. One night in Mexico City my van was broken into and everything was pulled out and taken away, including that suitcase. I don't know how many prints were lost—essentially the core of the show.

In the fall of 1964 we moved to New Orleans. We needed to put our kids in school and wanted something better than a Mississippi education. I established a darkroom with the idea that I would carry on the Southern Documentary Project from New Orleans. The Free Southern Theater also moved to New Orleans along with some movement writers and poets. Our intention was to start an arts movement based on our civil rights experience. But, in fact, everybody was very volatile, pretty shell-shocked from the fear and tension of working in Mississippi. Some people simply burned out, turned to religious orders or drink and drugs.

In a year our movement had boiled down to the Free Southern Theater and myself. But, during the next two years, movement people, especially photographers, cycled through our New Orleans apartment in

a steady stream. They would sleep on our floors and use the darkroom. Danny was among them. Those who were learning photography would show me work, and I would say, "I think you should do this" or "Why don't you go out and shoot that?" And they would shoot, come back, develop, print, and show me more work. Without planning to, I had established a kind of a center.

When the Smithsonian [Institution] came to do their first civil rights show about fifteen years back, and they interviewed me, they said, "Let's talk about your role as a teacher. Every movement photographer we've talked to speaks of you as their teacher." This was a huge surprise to me. I began to think back on those times and realized I probably had been teaching, but it was all so informal I never thought of it as such.

Sometime in the mid-sixties the Southern Documentary Project images disappeared for twenty-five years. Black Star told me that everything in their files had been returned and was probably lost in the mail. But when Black Star moved their offices about ten years ago, I discovered a huge carton left on my front porch by UPS. In it somebody had dumped hundreds of negative sleeves, contact sheets, and prints: the majority of my civil rights files and a good deal of Southern Documentary work as well. Apparently it had been sitting in a file drawer that nobody opened for twenty-five years—unused, unsold, and unutilized. There were five or six thousand negatives, mostly my own work but also images belonging to other photographers. Both outraged by the neglect and thrilled to get my work back, I sorted out Danny's stuff and mailed it to him.

As I began going through the files, I discovered work and visual threads I had long forgotten. It's hard to describe the experience—it was like getting a piece of my life back. I began to realize that the important pictures had never been printed. With the work already in my files I now possessed a coherent body of work, and that's when I decided to start my own stock agency.

That's the story of the Southern Documentary Project. Looking back, I think I share the feelings of most people in the Civil Rights movement: those were the most significant years of my life.

There is a coda to this. Among the Southern Documentary pictures I put together in the sixties was a set of slides of the best work. At one

point, probably a year or more after the project folded, I was in California and I phoned Dorothea Lange. I said I would like to show her the work, and she said she would like to see it. I did not know that Dorothea was dying of cancer. I went to Berkeley, and I projected the images on her bedroom wall. She was, I'd say, within a week or ten days of the end. She looked like a skeleton. I was probably there an hour, an hour and a half, throwing these pictures on her wall. Her husband and collaborator, Paul Taylor, was there as well.

Dorothea and I talked about the work, and, when I was ready to leave, she turned to Paul and said, "Now would you get the medication, Paul," and I realized that she had forgone morphine in order to be clearheaded for the showing. Then she said, "I want to give you a book." She sent Paul off to get their last copy of *An American Exodus,* the first book they did together on migrants in the Central Valley of California, and she signed it. It's probably my most precious possession. That was the last time the Southern Documentary Project was ever shown as a body of work.

Jill Freedman

Resurrection City

J̲ill Freedman, born in 1939, worked as a cabaret dancer and as an advertising copywriter before becoming a photographer. Upset by the 1968 assassination of Martin Luther King Jr., Freedman went to Washington, D.C., to photograph Resurrection City, the conclusion of King's Poor People's March. Thousands traveled from all over the United States to camp on the Washington Mall in flimsy plywood shacks and protest the squalid conditions of the poor.

Freedman then spent two years traveling with the Beaty-Cole Circus, paying tribute to a "dying way of life." In the preface of her critically acclaimed book, *Circus Days* (1975), Freedman wrote, "I was the kind of kid that always wanted to be carried off by the gypsies."

Freedman, who has freelanced for *Time, Life*, German *Geo*, and the *New York Times Magazine*, is known for her sharp sense of humor, which she displayed in books like *Street Cops* (1982), *Firehouse* (1977), and *A Time that Was: Irish Moments* (1987). She now lives in Miami Beach, Florida, with the subjects of her last book, *Jill's Dogs*.

T̲he Holocaust had affected me deeply. I was born during the war, and when I was seven I found old *Life* magazines in the attic. I saw the pictures—a burnt head under the door, the beautiful face on the skeleton on the pile of bodies.

I was a normal kid, a tomboy. I used to come home, go up to the attic, look at the pictures, cry for an hour, then go out and play soft-

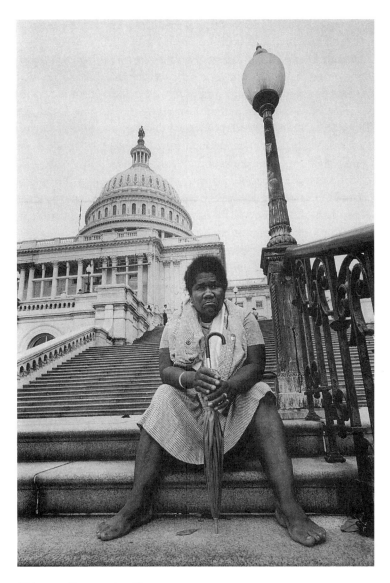

Old news; Resurrection City
(© Jill Freedman, Grossman Publishers,
1970, cover)

ball. After a year my parents discovered that. Burned the magazines. I'm sure that's why I was a photojournalist.

I lived in Europe after college a few years, and when I came back I didn't know what I was going to do, and one day I woke up, wanted a camera, borrowed a friend's, ran out into the street, shot two rolls. I didn't even know what a contact sheet was. I looked at it, I said "That's it, I'm a photographer." Pretty funny. I decided just to teach myself.

I got a job as a copywriter at an ad agency. Every paycheck, I bought my equipment, built my darkroom. I learned to print by reading books and watching a few people print. I went and looked at Gene Smith's prints at the library. I found a book of [Robert] Doisneau, with the cover ripped off, for $2.50. I'd never heard of him. Right away it was documentary photojournalism for me.

There were a couple pictures that really hit me. One that was a very small book that *Life* put out of memorable pictures of the war with that picture of Smith's where soldiers found the baby on that island. This friend said, "Oh, you could blow that up." I had that on my wall. I mean, talk about masochism. I lived with that.

When they killed Martin Luther King, I was so enraged. I just quit and joined the Poor People's campaign. We went through a different town each day and then slept in people's homes and churches. Wilmington, Philadelphia, Paterson, Newark. Chemical toilets, no chemicals. Bologna sandwiches on white bread every day. We marched through different cities and towns for a week and then lived in the mud next to the Reflecting Pool between Abraham Lincoln and the Washington Monument, which we called the Klansman because at night there was the pointed head and the red eyes.

I felt it was going to be the last big, nonviolent demonstration, and I wanted to be there. By then I believed in nonviolence; I saw it worked. In my heart I'm a killer—there are people I could absolutely kill with joy, and I'm sure not feel a thing about it—but I know that nonviolence is the only way to go.

My tent was right next to the Georgia Sea Island Singers. It was fabulous. The first night my boots and sleeping bag were stolen. It was freezing. It rained every day. Every day. So we sang—I played a really good kazoo and spoons—and we demonstrated every day.

That was six weeks, demonstrating every day, and I was loading my

film into cassettes from 100-foot rolls of Tri-X. I always thought that the day I could buy it ready-rolled I'd know I had arrived. I still feel that way.

I had my two little Nikons; I was working blind. One day a *Life* reporter was down there, and I got to talking with him in the food tent. He looked at them and he said, "Why don't you give me your film? Even if *Life* doesn't use it, at least they'll develop and contact it for you." My first published pictures were six in *Life* magazine for which I got $600.

I shot everything going on around me; it was like another American city. We had the first Black Panthers come from Oakland. I've always wanted to go to Marks, Mississippi, because I'll never forget those old ladies, when they came up with the mule train. I met some of the greatest people I ever met in my life.

After it was all done I looked at the stuff, I said, "This is a book." A couple years later I took them to Grossman, who published them. It was a great experience. It was the first story that I'd photographed and written. It set my way of working.

I try not to preconceive anything. Before I went to do *Circus Days,* [Federico] Fellini's clowns film was out. I adored Fellini, but I purposely didn't see it until afterward. I just go, and I immerse. I'm just like an antenna, an instrument. I like to feel it, absorb it into the skin. When I taught myself photography, I was very strict about composing in the viewfinder. I could only afford one lens, so I moved up for telephoto, moved back for wide. That freed me to just think of the pictures without much conscious thought. I work by feeling. I'd been a musician, and I think of photos like music. When I put together a book, I think in terms of a symphony—the rhythm, the beginning. Above all, I try never to preconceive until I'm faced with actually laying out and writing the book.

It's a very great honor and a privilege to be able to enter people's lives. It's very humbling. The most important thing which sets photography I like against most of which I hate is respect. You don't get anything decent unless you have the respect. When you're sincere, then people will work with you. If you put in enough time, you can be invisible. It used to amaze me what people would do in front of me, and what people would say—to the point where sometimes I would say,

"Remember, I'm a reporter; do you want to say that?" Documentary is a pure form. Certainly the photography turned me on, those moments, catching the moments, but unless it has the heart, to me it's nothing.

In 1971, after my first book, *Old News,* came out, I sent it to my heroes, people in the antiwar movement. I sent one to Walter Cronkite, and I got a note—"would I like to come see him"—and I did. I told him how I always wanted to do photography for TV, for news: stills, which you could animate, like that great Civil War series by Ken Burns. Uncle Walter said, "The time is right now, they're gonna have to let a woman into the union, and you could be the first woman."

I've gone over this at three in the morning with myself for years since. He had his hand on the phone. Without even thinking I said, "No, I want to be a photographer." I put myself down for years, saying well, I could have done that, earned a great living, met people, maybe even my true love, have people to work with so you're not out there alone in those hotels. Then I realized, well if I had, I wouldn't have done these projects.

The point is just to stay alive. I really didn't have much money, but I sold a couple of portfolios to magazines. A friend gave me his Volkswagen bus, and I got some film from one of the magazines. That's how I did *Circus Days,* on a shoestring, of course. I met the lead clown, and I was under his wings. It was seven weeks of one-night stands—two shows a day, one on Sunday, tent up every morning, down at night, drive to the next town.

I shot one roll of color. It took me months to talk my favorite clown into lying on the fur rug in the middle of this field next to a burnt-out house—the naked, round, pink clown, like a baby picture, a clown baby picture. That was the whole color roll.

I didn't have the money to develop as I went along, and I'm thinking, what an idiot, I mean if one of those cameras had been broken. But thank god. They say He watches over drunks and idiots. The cameras worked, and when I came back I had all the film. Arthur Rothstein was at *Look,* and he was wonderful. He had them developed and contacted. It was like a birthday present, like Hanukkah morning, you wake up and there are these presents, glistening contact sheets. I shot everything. It was only afterward that I saw I was only interested in the backstage life, the life of the circus.

We're storytellers, really. I consider myself a documentarian, in the sense that I try to show—of course from my point of view always. Otherwise, what am I, a machine? I try to show what's going on. I try to, as much as possible, keep myself out of the focus. I hate photographers who act like big stars. Somebody did a thing that's famous on Harlem, and he talked about the hardship. Well he had a bodyguard with him. He set up every picture.

I like to work to try to tell the story of the lives that I'm trying to show, from their point of view. Like *Street Cops*. When I was doing *Firemen,* someone asked, "Well, are you going to do cops next?" I said, "Get outa here; I hate cops." Because of Vietnam. And then I thought, what do you mean you hate cops? You don't even know one. I'd only seen books about bad cops. What I wanted to do was to show the job, and show a good cop, my definition. Compassion, humor, street smart, tough.

I get to identify deeply with the subjects. I've always felt like an actress. You live your role; you immerse yourself in your role, and that's what I do with the photography. I absorb it; I just become part of it. I'm not thinking of anything else. I have one rule: I never sleep with people I'm working with.

Sometimes I feel I don't have a real life at all. You always assume you'll have kids, but I think I really didn't want to, because I knew I just wanted to be free. I wanted to just go and take pictures.

I love my work. I love my books. It's important to love your work. But have the decency not to inflict it. There are far too many images, which has cheapened the sublimity of great photography. If you're gonna do it, have the respect to learn the craft, the decency not to bore or show mediocre stuff, and go and follow your bliss. For me it was a passion from the minute I picked the camera up. A lot of people, all they're interested in is exhibiting, being stars, and going to all those stupid openings. There may be technical competence and all kinds of machines, but without that heart, so what? There's all this cold, heartless stuff and without the craft. I don't care about snapshots of junkies. I like cocks, but I don't need to see a big old hard-on beautifully printed.

We still have the idea that we're gonna help somehow. I'm gonna have a big show in the Miami public library in January. I took them the book, and I said, "You should do this for Black History Week," and

they agreed. A few people on the committee were worried. They said, "I don't know; she's white." But I said, "Hey, I was there." So that's gonna happen, and I said to the director, "Look, get some of those people who were involved. Get them to sing those songs. Get these older people to talk about the experience so these kids know where they're coming from. Let them see the greatness of these people."

Even my last book, *Jill's Dogs,* is about love. I truly feel that even if you don't love dogs or animals, there will be some people who will see the book and maybe they will be nicer to animals. Maybe it will make them treat everything nicer. There's not enough love, you know?

Mary Ellen Mark

Streetwise Photographer

The curator at the George Eastman House in Rochester, New York, Marianne Fulton, describes Mary Ellen Mark as a "woman possessed—possessed of great talent, conviction, strength, and continuity. A person obsessed with photography, it is the center of her life, of who she is."

Mark studied art history and painting as an undergraduate at the University of Pennsylvania. Her "obsession" began in 1962 during her graduate studies at the university's Annenberg School for Communication when, on a whim, she took a course in photography.

In 1965, with a Fulbright scholarship, she began a two-year project in Turkey, which was later published by Ralph Gibson as her first book, *Passport*. As a freelancer, she photographed for several national and international magazines. An assignment from *Look* in 1970 on heroin addicts in England helped cement her reputation as a social documentarian.

While working as a still photographer on the set of *One Flew over the Cuckoo's Nest*, Mark became interested in the mentally ill. In 1979 she spent thirty-six days photographing women in a maximum security mental hospital and produced the book *Ward 81* (1979). Other major books include *Mother Teresa's Missions of Charity in Calcutta* (1985); *Falkand Road* (1982), on prostitution in Bombay; and *Streetwise*, documenting homeless teenagers in Seattle. Mark and her husband, Martin Bell, later developed it into the film *Streetwise*, which was nominated for an Academy Award.

More recently, she has pursued a long-term project on Indian circuses. She has also worked as a portrait photographer for *Rolling Stone, People, The*

Lauri in the Ward 81 tub,
Oregon State Hospital,
Salem, Oregon, 1976
(© Mary Ellen Mark)

New Yorker, and numerous other publications. Retrospectives of her work include "Mary Ellen Mark: 25 Years," organized by the International Museum of Photography at George Eastman House, and "Mary Ellen Mark: American Odyssey."

When I started to take pictures in the early sixties, I chose the path of magazine photography. At that time it was exactly the right choice for me, because magazines loved and supported documentary photography. Unfortunately, today most magazines are no longer interested in documentary photography.

This shift has occurred because now advertising has much more control of magazine content. There are still a lot of editors that would really love to have great documentary pictures in their magazines. But the advertising and business side is very powerful, and they want photographs that are more commercial and will sell the magazine.

Great documentary photographs are powerful and memorable. The fact that they no longer fit the economic needs of magazines is a tragedy. Because of this, the public is missing the experience of seeing many great images. It's especially a loss to young photography students who miss the opportunity of being inspired by the work of excellent documentary photographers. It is also very difficult for the seasoned documentary photographers who are at their prime and ready to do their greatest work, because they have a very hard time financing and publishing their work.

Still photographs do something very different than television. Still pictures exist forever. If they are really exceptional they can become icons. We see powerful video footage on CNN, but we see it only once. Great photographs become locked in our minds. For example, Larry Burrows's Vietnam photographs are stamped in our memories. Don McCullin's pictures in the seventies of the war in Bangladesh are also unforgettable, and the perfect decisive moments of Henri Cartier-Bresson are part of our lives.

All photographers have certain images that they are more known for. It is mysterious what makes a photograph an icon. Sometimes I think these icons are the photographs that are most easily understood by all people and all cultures. They are graphic, emotional, they cross cultural boundaries and touch us, and we remember them. When I see a great frame on a contact sheet I am not always sure; I say to myself, "Well,

maybe that could be a really fine picture," but I don't always know. I have to live with the picture for awhile to see if it survives time.

I have completed a book called *Mary Ellen Mark: American Odyssey* published in fall 1999 by Aperture. The book consists of my American pictures dating back to the early sixties, when I first started to photograph and ending in May 1999. During the last three years, I edited hundreds of pictures from my thirty-five years of work. I would select images, scan them, and then leave them in a folder. I would look at the pictures several months later and ask myself, "Are they really good?" The pictures I selected for my book were the ones that were still strong after looking at them again and again.

In order to survive as a magazine photographer, I've had to learn how to do magazine portraiture. I had to learn to do lighting and to work under time restraints. This has been both challenging and interesting. But, every once in a while I still do get a chance to do real documentary work for magazines, and I am always thinking of the different ways that I can finance my own work. Because without personal projects, what's the point? The self-assigned subject is your heart and soul.

With both magazine assignments and personal work I am really putting myself on the line. In magazine assignments I work hard to figure out how to achieve a great image with the added difficulties of limited time and limited access. The ideal situation is when a magazine assignment overlaps with your own body of personal work.

I have several subjects that I have slowly been photographing over the years. One subject is the circus. I'm obsessed with circuses. I made a book on the Indian circus. Two years ago, I went to Mexico to photograph circuses. I would love to photograph circuses all over the world, but it's really financially difficult to put that kind of project together. I financed the trip to Mexico with the help of *Texas Monthly* and some European magazines. I called and faxed magazines all over the world and got a little bit of money here and there. I made no money on the project but for me this was absolutely fine, because it gave me the opportunity to continue my circus work.

One of Mark's early stories was of heroin addicts.

It's horrible to be an addict—a terrible life. I photographed that story to show just how tragic the lives of the young people were. I wanted

the people who saw the pictures to enter that world and to better understand the plight of those kids. I hate fashion pictures that glamorize drug addiction to sell clothes. It's very tasteless and empty to commercialize social situations that are very serious and very unfortunate.

Years ago I got a call from a big Hollywood producer. He wanted me to do the title stills for the film *Mr. Goodbar*. He told me that he wanted me to take pictures in bars that were honest, tough, real. I went out every night from 11 P.M. until 6 A.M. for six weeks and photographed. I met all different sorts of people that were a part of the late-night bar culture. I worked intensely and made some good pictures. They were also very real and very strong pictures. I was so excited. I edited my contact sheets, made work prints, and sent them to the producer.

A few days later he called and said, "These are the most depressing pictures I've ever seen. We're not going to use them." He even went so far as to say that I would never work in Hollywood again. My pictures were too tough for him to understand. I guess he just wanted something much more commercial. The nightlife in bars is often strange and desperate. Anyhow, that was how I saw it. That was my reality. Even though those pictures were not used in the film, I still had the opportunity to make them. That was by far the most important thing for me. Some of those pictures are in *American Odyssey*.

Documentary photography is about reality, both in it's authentic sense and it's surreal sense. For me, nothing is more imaginative, or fascinating, than reality. Great pictures are the images that transcend time and content. That's what all of us strive for.

The best documentary images, like all great photographs, have always had a place in the world of fine art. This is very important, especially now when we no longer have the opportunity to see these pictures in magazines. Exhibitions and books are the primary way to be aware of documentary work. When I began to take pictures, my inspirations were the many memorable documentary essays I saw in magazines. Now we all must work more independently to produce books and exhibitions. We must never give up.

Earl Dotter

The United Mine Workers

E arl Dotter follows in the tradition of Lewis Hine, who documented the dangerous working conditions of the coal-breaker boys in the early twentieth century. Hine's photographs helped spark legislation against industrial child labor. In the 1960s, when Dotter began his work, another series of egregious events were under way in America's coal mines. Black lung, a disease caused by work in the coal mines, was widespread, and there were a series of disastrous mine accidents, such as those in Buffalo Creek and Farmington, West Virginia.

Dotter joined Volunteers in Service to America (VISTA) in 1969 and went to the Cumberland Plateau region of Tennessee during a volatile period. Jock Yablonski, the leader of a democracy movement within the United Mine Workers of America, had been brutally murdered by union thugs. The union president, Tony Boyle, was found guilty of the crime and was eventually ousted.

Dotter joined the democracy movement, and, when their slate was elected, he joined the new staff of the *United Mine Workers Journal*. His powerful photos, published in *Life* and other magazines, brought public attention to the mine workers' concerns, especially issues of safety. Dotter's work was later honored with a National Magazine Award.

Dotter remained dedicated to exposing occupational health hazards in several industries. In 1998 he assembled a collection of twenty-five years of work in *The Quiet Sickness: A Photographic Chronicle of Hazardous Work in America.*

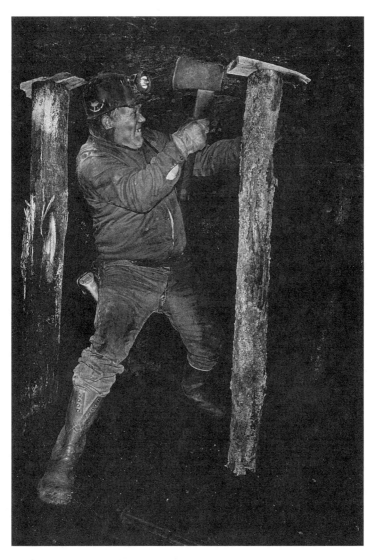

Coal miner setting temporary supports,
Clearfield County, Pennsylvania, 1976
(Earl Dotter/UMWA Journal)

I was a photographer fresh out of the School of Visual Arts [New York City]. My background was in advertising design, and I had one course in photography. This was 1968. Martin Luther King Jr. had been assassinated while I was still in school and Bobby Kennedy soon after. The cities were up in flames. An advertising career didn't seem appropriate at that time. The minute I picked up the camera, there was an opportunity for me, a rather shy individual, to reach out into the community where I lived in the Lower East Side. It gave me the greatest excuse to poke into other people's business and really helped me overcome a great personal timidity in relating to people.

I was 1-A and readily draftable in 1969, so I chose to join VISTA as an alternative and ended up in the Cumberland Plateau region of Tennessee.

I had become acquainted with a lot of disabled and elderly coal miners who were quite upset with their union, the United Mine Workers of America [UMWA], because of its position on the question of mine health and safety and the Farmington mine explosion. Seventy-eight miners had been entombed in a mine that had exploded, and the mine had to be sealed with the miners inside.

Jock Yablonski, a reform candidate for UMWA presidency, and his wife and daughter had been murdered for opposing Tony Boyle, who was the union president. There were other factors too. The union was not aggressively pursuing black-lung claims. Despite all these problems, the Mine Workers was an institution as close to miners as God is to religious folk.

Initially, my pictures were war-on-poverty oriented, but I became acquainted with the dissidents in the coalfield who were attempting to organize a mass movement to democratize and reform the UMWA. There was a publication called the *Miner's Voice*, that Don Stillman out of Charleston, West Virginia, was publishing. I was invited to join the UMWA reform campaign because I had multiple skills. I would take the photographs for the literature in the campaign and then design it. This enabled me to become a full-time staffer on the six-month campaign at $50 a week.

I managed to photograph in the coalfields, which was a bit dangerous, given the history of violence within the union. It was a remarkable experience. I began to get my first access to coal mines, and coal miners, and, in particular, miners who had accidents, who had become disabled, who had contracted black lung, but nonetheless were very active in the effort to repair their union. During the course of the campaign, I took one hundred rolls of film.

Once the reform candidate, Arnold Miller, was successfully elected and Don Stillman had become the editor of the *United Mine Workers Journal,* I was invited to do the first redesign of the *Journal,* as well as become its photographer—an opportunity I jumped at. After a period of time I passed the design work on to someone else and worked exclusively as a photographer for the *Journal* from 1973–77. It enabled me to develop or prepare a body of work that, as far as my own twenty-five-year history of photography, is still hard to beat.

As a representative of the *Journal* I was made welcome into the homes of mining families. I've learned that before I ever bring my camera out of the bag, the first thing I try to do is to let folks know who I am, why I want to take their picture. Then, if they are satisfied with what I'm up to, they are better able to respond and live out their life in front of the camera rather than act it out.

You are essentially a stranger. If you can connect on an emotional level, you really will get back so much more. I'm reminded of Robert Capa's saying "If your pictures aren't good enough, you're not close enough." I don't think he was talking about physical distance as much as emotional distance. Often, I would have dinner with the miner and his family the night before. Perhaps some other miners in the same section would join us, and we'd talk about how I would take the pictures, and the kinds of things they thought were important to record.

A picture-taking and editorial strategy was developed fairly early on by the four-person staff of the *Journal* to highlight individuals and community people who were doing exemplary work within their union and their communities on a wide range of issues. It became fairly easy to figure out what kinds of subjects were worthy of treatment.

Miners love to hear about some of the good things that their union was accomplishing after a period of so much violence and corruption. The doors just opened to us. The company wasn't so hot on us coming to a mine, but, because the union was together, and the local union was behind it, they were hard put to resist our access.

After our new editorial philosophy had been put together and a few issues of the *Journal* had shown evidence of this new philosophy, we began to hear from miners themselves about somebody doing something that was extra special, like developing a community garden for everybody prior to a strike so they'd have food. The administration was filled with people who had just arrived after the struggle to reform the

union and folks in the safety division of the union. We were really interested in hitting very hard on key issues where past activity within the union had allowed problems to get to such a difficult level that coal mining had become the most dangerous occupation in the country.

The *Journal* had been reestablished under the Miners for Democracy administration with independence. The *Journal* wasn't reviewed in the process of editorial decisions; occasionally there were some modifications, but generally it was not interfered with.

I do recall the controversy when women entered the mines. I had taken a photo of three women who had just emerged from the mine, and it has since become one of my most popular photos. I had taken it with the idea of it being on the cover of the *Miners Journal.*

Well, male coal miners had resisted the arrival of women in the pits with a great deal of fear, harassment, entrenched superstitions—they said it was bad luck. I was disappointed when the decision was made not to use this photo on the cover. It was used inside, and an illustration of Mother Jones [Mary Harris Jones], the organizer, was used in its place on the cover.

When Dotter was photographing in the mid-seventies, fast-speed films, such as T-max 3200, had not been invented.

I approached everything with pretty much a blunt-force technique. Rather than trying to do sophisticated lighting underground, I used direct strobe, and I was disturbed with the shadow direct strobe created and developed the technique of getting a very small Vivitar strobe that I could hold right against the lens barrel. So if there was a shadow it was just a pencil-thin line of shadow. It was just a blunt-force light, and the blacks and the highlights would kind of fight each other to some extent and create a very graphic rendition. The starkness of the subject really lent itself to this kind of treatment.

I've always developed and printed my own black and white negatives, and the darkroom side informs your shooting. You learn to not shoot things that are unphotographable. You learn to burn and dodge—with direct strobe you have things that are washed out in the foreground and need to be adjusted.

The most difficult obstacle with underground photography was the dust and the frame. My mine light would poke a doughnut hole–size shape of light into the dim, and you would see the character by moving your head in such a way that you could see the shape and where his body

began and ended. Well, when you began to frame a picture—and this is a subject that's moving—it became very hard to crop the pictures in a way that you didn't end up amputating some essential element of the subject.

The other thing was that in a dusty atmosphere, if you are using a strobe that automatically shuts down after the proper exposure has been achieved, all this ambient dust will tend to shut your strobe down prematurely. So, in real dusty situations I learned to just shoot on manual, and this was tough because you had a subject that was coming at you and moving away from you. Zone focusing became the rule for me, judging the distance and adjusting the lens barrel appropriately.

The consequence of all these difficulties was a lower success rate, but if your access was good, you were compensated by the fact that you had more time to spend and that you had a subject who wanted you to succeed. That was critical.

Photographing underground is sort of analogous to taking pictures from the moon. It's a subject we don't regularly see. Very few of us have been in a coal mine. It's a subject of great fascination because you don't get to see it everyday.

There was a lot of interest in this material. I never became a full-time employee of the *Journal* so that I would own my own negatives. This benefited the union, because outside publications would come to me directly for photographs, and I owned the rights to republish the work. *Time* magazine came to me for pictures that related to a strike that occurred in the mid-seventies.

After I left the UMWA in 1977, I started becoming interested in the problems of textile workers and brown-lung disease. That was concurrent with the effort to organize the J. P. Stevens textile mills. After that experience I really started to look at occupational health and safety in general and went into auto plants, and chemical plants, and all different kinds of occupations.

It became very apparent to me that in photographs of someone who has been victimized, about the only element the viewer of this kind of photograph can relate to is in an individual's desire for self-respect and dignity. So, when I photograph I'm always looking for the common ground between my subject and the viewer of my photographs. If you can attract their interest initially by your artistry and lead them into confronting the issues your subject matter raises, then you've gone a long way toward at least presenting material that they can think about.

Eugene Richards

Americans We

Eugene Richards has repeatedly returned to themes of tragedy and renewal in difficult or extreme circumstances. He has extensively documented American poverty in books such as *Below the Line* and *Few Comforts or Surprises: The Arkansas Delta* and an urban emergency room in *The Knife and Gun Club*. His book *Cocaine True, Cocaine Blue* created controversy for its unflinching depiction of inner-city neighborhoods destroyed by drugs.

Richards began his career as a Volunteers in Service to America (VISTA) worker in eastern Arkansas in 1968. After several dangerous run-ins with the Ku Klux Klan and local police, he says he was forced to "sort of limp home."

In 1978 he founded Many Voices Press, which published his books *Dorchester Days* and *50 Hours*. In the acclaimed book, *Exploding into Life*, Richards and his first wife, the writer Dorothea Lynch, chronicled her experience with breast cancer until her death from the disease.

A former member of the Magnum photo agency, Richards has won numerous photojournalism awards and prizes for work that has appeared in *Life*, the *New York Times Magazine*, and other publications. *Americans We*, a recent book, revealed Richards's continued interest in telling poignant stories about Americans. Richards lives in Brooklyn, New York, with his wife, Janine, and son.

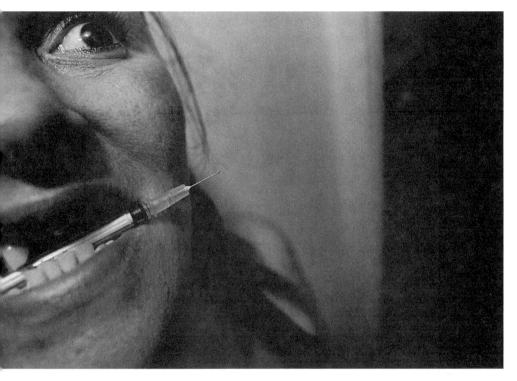

Maniella, East New York, 1992
(© Eugene Richards)

I was influenced growing up working class, with a mother who once worked as a domestic and a father who perhaps never got over the years his family had to struggle during the Depression. I was also profoundly influenced by the Vietnam War. I protested, draft resisted, finally didn't go, and always felt very fortunate, but very conflicted by my decision. I might have gone to prison, but other young men went to war.

When I was young, I never thought about being an artist. I had my viewpoints—I was writing poetry, I was doing things confusedly—and then I met a teacher at Northeastern University named Robert Wells, who got massively excited about painting and sculpture, its history and its influence on world events. He'd inform his students about the life of the painter, where he or she came from, and the great pains that come from doing something personally and socially creative. Most people don't care about the painter's processes, but they're important. Art is a crucible, the means to express what we're feeling, what we care about, providing we care about anything.

The photographer who caused me to recognize how wonderfully photography could define an era was Robert Frank. I looked at books of America that were being done then. Most were flag-waving books. Then I saw *The Americans*. Frank looked at this country in the fifties and saw a malaise underneath all the patriotism. I felt, after seeing this work, a pat on the back from someone I never knew. I felt freer to express my own feelings about this country.

My father and I have had a series of running arguments about politics my whole life. My father, who never went to high school, said the single thing he was proudest of himself was that he worked hard enough to support his family. Now the thing I'm proudest of is the ability to support my family with my work, that now I'm a working man.

My job is to get my worldview out there, to get what I see published. I'm a photojournalist as opposed to what some might call an art photographer, because I like to tell stories. Probably in the next life I'd be a writer. But I was driven by early events in my life to be a photographer, so I try to tell stories mainly through pictures.

If there's any philosophy that I have that I could put into words—and it's not particularly new or deep—it's that when you say you're a photojournalist, you attempt to tell the truth. After you become aware

of a person's life or a human situation, you try to find the tools, the metaphors, the shapes, the shadows to translate the event or personality as truthfully as possible.

Most documentary work is concerned with what's past—trying to preserve something, trying to record for posterity. That's why I call myself a photojournalist. It's about now. You have to go out and capture the spirit of the events or the environment today. Our society is changing and becoming more insular in terms of what we're willing to see beyond our own lives. Such insularity comes with being more successful, making more money. And we don't want to rock the boat.

Problems, of course, do exist. The labor camps are still here, the coke ghettoes are still here, the isolated people living along the delta regions of the South are still here. The people that I met up in the mountains of Tennessee are possibly in worse shape than before because the mines are closed.

So it's left to TV and the magazines to inform us. And we don't do our job. We ought to look at stories more deeply. Our work has to be closer to psychological dramas than literal dramas. We have to go inside the house instead of standing outside, because little is showing on the streets the way it used to.

I always felt I was part of a way of life, lived by a number of artists who came together in the age of the Vietnam War. A lot of people came out of the sixties and seventies with a lot of questions, not only about the war, but about class and where we personally fit into our society, about our lack of social balance, our nation's economic situation, what was causing the dire poverty and racism that was racking the country at that time. And many times, more often than not, we were full of anger. We were pissed-off photographers, and sometimes we pissed off the general population.

We pushed ourselves out there—sometimes in arrogant ways—into societies we weren't initially comfortable in. We weren't born into them. Some people went in to cover the war. Some people went to the South. I was a white guy going south, documenting the lives of sharecroppers, the Klan, the last of the Civil Rights movement. Other photojournalists covered the [Black] Panthers, joined motorcycle gangs. Everybody was pushing outside of themselves. Anger was probably the one thing I shared with other photographers of my generation. And now for many that's gone, displaced by other drives and concerns.

It's hard to sustain the vigor of youth. There are certain art forms of expression that improve with age. Very often musicians don't mature until late in life. Same with writers. Dance we know is a killer; you have it when you're young, then it's pretty much over. So it varies. Photography is tough. With photojournalism, your ass has to be on the street. And as you get older, there's no doubt about it, a certain physical energy fades, and it becomes tougher physically to do the job. Financial concerns also multiply; photo markets are declining. So the result is that not many social photographers after the age of fifty are still social photographers. At some point, some need the money, so they become advertising photographers, need steady work, so they become teachers. You get really weary of being pushed away, and weary of not making a living, and weary of not getting published. So it's a rare person that, for lots of reasons, can keep it up.

Also if you throw out something that is socially critical—especially about issues of race and class—no one is going to pat you on the head. Ultimately, few people, those with money, are going to buy your photographs. No one is going to give you exhibitions, except many, many years later, when you are old as hell.

In 1978 Richards's first wife, Dorothea Lynch, was diagnosed with breast cancer. Lynch wrote about her experience, while Richards photographed it. Their book, *Exploding into Life*, was published in 1986, after Lynch's death.

The photographers who worked in Central America in the 1980s got pushed around because they were reporting on wars that our government claimed we were not supporting. But who would have thought that a book on breast cancer would upset so many people? Perhaps it was the medical establishment that didn't care for any criticism of its methods. Perhaps it was the American obsession with the breast. Perhaps it was a fear of our bodies aging.

The truth is, after Dorothea kept a diary of her cancer experience, after I took the pictures, it required a personal subsidy before the book was published. Now this was after doctors had forced Dorothea to leave the hospital, where she was reporting on the lives of cancer patients. When the book was finally published after Dorothea's death, it was criticized at a meeting of the American Cancer Society and, if you can believe this, ostracized in effect by the Boston Women's Health Collective for having a male coauthor. This group, publisher of *Our Bod-*

ies, Ourselves, said they wouldn't sell *Exploding into Life* in their bookstore.

If you comment on women's lives, you're asked why you, a male, dare do that. Now, if you do a book on poverty, people ask, "Are you poor yourself? I see that you live in a nice house." No kidding. People have come to my house, and it bothers them that I don't live in a sty.

My book, *Cocaine True, Cocaine Blue,* showed people shooting drugs and dying of gunshots, overdoses, and AIDS. There were young girls prostituting themselves. And what was the primary criticism of my four years of work? If you cut through all the bullshit, critics were saying that I was racist, a white guy who had the audacity to look at the lives of poor black and Hispanic addicts. I was also accused of giving clean needles to addicts, which I did, of setting up pictures and paying addicts to model, which I didn't. But it was the racism charge that hurt, mainly because only a very few photographers came to my defense. Not surprisingly, most of those who did were black photographers. Almost all the others, who knew me, knew my past work, knew something about the nature of addiction, said nothing. This included major magazine photo editors, my own agency's director, and a renowned museum curator, who wished to maintain their privileged status among the politically correct.

The drug project that ultimately became a book began in Detroit. I went out with narcotics cops in Detroit and saw a pantheon of dying. There were kids in the morgue who were being killed by dealers after selling drugs for them. There were drive-by shootings; drug gangs were shooting up funerals. And all I could get was the cop work and some pictures of people tearfully holding their children's pictures.

I wanted to go out and do more, but no magazine would permit me to do more, and without an assignment I couldn't pay my bills. Then I talked to a reporter at *Life* named Ed Barnes, a really fine reporter, and he wanted to do the same thing. We honestly didn't know if we could. There were things done in the past by great photographers. Bill Eppridge did a piece on a couple in Needle Park, but it was somewhat acceptable, because it was a couple of young, attractive people who did the suffering. Could we do anything like that in the more complex, violent, interracial Brooklyn neighborhood close to where we live?

So Ed and I went down to Red Hook housing project—it was Ed's idea and it was the right idea. He found, after some research, a flag pole

around which people sold and bought drugs. We had an assignment from *Life*. We went down there for three weeks and initially got nowhere. We were a nuisance to the dealers.

Among other things, they thought we were police officers. That waiting period was nothing more than an exaggeration of what we all go through as journalists. You just grit your teeth and bitch and moan and call home all the time and complain and try to keep away from the alcohol and don't get too depressed and go back the next day.

The insecurity, the rage; you lie to your editor about how long the story will take, you beg not to have the plug pulled. And then about the fourth week we had a breakthrough moment. We witnessed a violent chase and residents of the project recognized we were journalists instead of cops. The doors opened. What happened is the classic thing where people start bringing you their stories. Even the drug dealer on the street who says I can't talk to you tells us who can. It starts to break open. Suddenly we were in the middle of things. The neighborhood drug bosses were watching us all the time.

The people I found most willing to reveal themselves, most tragic, were the young women prostituting themselves to get money for drugs. It was very complicated working with them. These girls, some as young as twelve, would sell themselves for two bucks. It was devastating to myself and to Ed Barnes to witness this.

Don McCullin talks about a starving kid—in Biafra I think—who wouldn't let him alone. Don took his picture, gave him food, and yet he couldn't do anything more for him. The child followed him. The girls were the same way. They'd offer us sex all the time, simply because we'd spoken kindly to them. We'd go there and tell them we wanted to do a story, and sex was the only way they could show affection. And this made our jobs and our lives more complicated, because you just can't get involved with your subjects, and not being able to help them got to be emotionally difficult. We stayed as long as we could, and then the story closed.

People say why does a story close? Most stories close because they're just too fucking draining after a while. You just wake up in the morning and you say, I don't want to go back to that nursing home. I don't want to go back and see that person. Or I can't go back to the crack houses in Red Hook, and that was it.

Richards also covered the drug scene in North Philadelphia.

That one started very differently, because the person we used as a guide in North Philadelphia was a drug addict named Sarah, who at first had tried to rob us. By the time she tried to rob us, we were so tired and getting nowhere that we didn't care. I wouldn't exaggerate and say we didn't care if she shot us, but we were so tired. We just laughed at her. If someone came up with an Uzi, we would have laughed at them too.

Anyway, it was a phony pistol, but we didn't know it right then. She ran away and we ran after her. Then finally she talked to us, the first person who really reacted to us, and we offered her a job as a kind of researcher. Later we were highly criticized by a Philadelphia newspaper because we paid her fifteen bucks a day to go up to doors of crack houses, gun dealers. Critics said we were encouraging this woman's addiction by paying her this money. Truth is, that newspaper was upset because we told this terrible story before they did, published before they did.

Paradoxically, when we got most known on the street, it became more dangerous for us. We were set up for a robbery. It was a matter of time before some kid would have hurt us, I think, simply because it would be an interesting thing to do. Our work was pretty much completed anyway. The article ran.

My time with Ed ended there. He went back to *Life* and subsequently to *Time* magazine and international assignments, while I wanted to do a book. After failing to get Ed involved in the idea of a book, I went off on my own for a number of months in east New York, another drug-troubled neighborhood—this one in Brooklyn.

Richards has produced nine books. Two were self-published.

You're working for magazines, usually not the writer. Although you respect the writer you work with, it's not your voice. Still I find myself responsible for the article, warts and all. If one of my books really sucks, it's because I did a bad job. If the book upsets people, it's because I intended it to. I'm responsible, not somebody else.

Photographic books reveal you. If you're a wonderful photographer but an egotistical asshole, it'll show in the book and it'll show in the design of the book. If you're confused—and a lot of us are a lot of the time—that'll show in the book. It's a good self-study. When it's all done, you know who you are.

The book with Dorothea—somehow the fact that we got her words down in a book—was the beginning for me of a healing process. Same with the drug book. I know it sounds so naive, but I do feel like each of us has a social obligation, and books are like paying off a social obligation.

Now that I have a child, I do stories on issues that might affect him. Like the majority of parents, I don't want my child going to war, still he should know of world history, of the issues involved in modern wars, in order to make choices. I don't want him using drugs, but I can't, any more than any parent, stop him from using drugs. All I can do is tell him about what is out there. My family is probably the major impetus for my continuing to work. That and the fact that after all these years of being a photojournalist, I'm not sure what else I could do.

When I was talking to photographer Jeff Jacobson recently, he reminded me of something the now-deceased photographer, Ethan Hoffman, had said to him. "Jeff, don't worry. If you do a really bad job, you won't be hired again. But if you do a really good job, they won't hire you again, either." I've struggled to do good editorial work, but lately the assignments are fewer and fewer.

People have been asking forever about the death of photojournalism. I say it's not going to die, but it's definitely a different time. Rather than head out to report on and show a situation, photographers are being asked more and more to illustrate editors' ideas, writers' ideas, even advertisers' ideas of what the world's about.

I have a wonderful wife, Janine, who really doesn't cut me much slack. I mean, she's not the person who's gonna listen to my emoting a lot of the time. She's the person who I call late at night and say, "This story sucks. I hate the business." I vent and then get back to work. Janine hates the business and the egos in photography probably more than I do. She's a very tough person in that respect, but she always encourages me and holds us together.

As for tomorrow, I'm looking at going back to Auburn, a tiny town in Nebraska, and doing not photography, but a film about the old farmers living there. But who's going to want a twenty-, thirty-minute film on old people? I'm doing it because I've got to keep what I love alive.

Susan Meiselas

Central America and Human Rights

Susan Meiselas studied anthropology at Sarah Lawrence College and graduated in 1970. She took her first photography class at Harvard, where she completed a master's degree in visual education and worked as an assistant editor for documentary filmmaker Frederick Wiseman on his 1971 film, *Basic Training*.

She began a documentary project, *Carnival Strippers*, her first summer with a camera. During the year, she taught children to read and write using photography in an experimental program for public schools. *Carnival Strippers* would become a book, a show, and her entree to the Magnum photo agency in 1976.

The following year she traveled to Nicaragua to photograph the civil war between General Anastasio Somoza García's dictatorship and the Sandinista opposition. Her book, *Nicaragua*, resulted from two years there. Meiselas was also in El Salvador during the country's civil war of the 1980s. She photographed the uncovered graves of four murdered American nuns, which helped prompt U.S. congressional investigations into El Salvador's right-wing death squads and the American role in the war. Together with journalists Ray Bonner and Alma Guermoprieta, Meiselas documented the massacre of civilians by the Savadoran army in the village of El Mazote. For her work in Central America, she was awarded the Robert Capa Gold Medal and the Leica Medal for Excellence among others.

Meiselas also helped coordinate the exhibition and publication of *El Salvador: The Work of Thirty Photographers*, a role she reprised with Chilean

Lena outside the girl show,
Essex Junction, Vermont, 1973
(© Susan Meiselas/Magnum)

photographers who witnessed the human rights abuses of the Augusto Pinochet regime in *Chile from Within.* She has also codirected two films, *Living at Risk* and *Pictures from a Revolution,* with Richard P. Rogers and Alfred Guzzetti.

In 1992 Meiselas joined other journalists and activists at Kurdish refugee camps on the border of Iran. Intrigued and appalled by what she witnessed, she launched *Kurdistan: In the Shadow of History* with the aid of a MacArthur Foundation fellowship. A major portion of the project was devoted to collecting and rephotographing pictures from anthropologists, missionaries, photojournalists, and the Kurdish people to help create and archive a visual history of the Kurdistan. The project gave Meiselas the opportunity to explore "the role that Western image-makers have played in shaping the West's and the Kurds' own picture of that history." Her innovative web site, www.akaKurdistan.com, was developed from this material.

For my first project, *Carnival Strippers,* I spent three summers traveling with women who were doing striptease in state and local country fairs. I developed relationships with women who were often transient. Sometimes they would start working on one weekend and end the next because their boyfriends would pull them off the show. My relationships with the managers as well as a few of the girls extended over more than one summer. I wanted to assimilate into their working environment and portray what was happening. It was as important to me to capture their ideas about what they were doing as it was to photograph them in the process of their working lives.

I showed my work in small galleries right from the beginning, putting photographs and text on the walls. The most successful installation included sound. Everyone was represented—the various managers, the clients, the women, their boyfriends—by mixtures of voices that you could hear floating in the background as you were looking at the photographs. The sound wasn't precisely linked, neither were the texts placed alongside the photographs of specific people. I wanted to recreate the feeling of that environment. In the case of the book, which I produced later, I built a parallel narrative so that those voices, when read, would bring you into the process of experiencing that world in a different way than the photographs alone could.

During the five years I was working with carnival strippers, I taught in the public schools as an artist-in-residence. I trained teachers to work

with kids using photography, and I worked in the classroom myself to develop a curriculum using photography to teach reading and writing. In 1975–1976, while I was beginning to edit *Carnival Strippers,* I chose not to continue as a public school teacher and tried to figure out how I was going to make a living as a photographer.

It was with two pieces of work, both with a documentary approach, that I went to Magnum. I showed them the *Carnival Strippers* portfolio and another essay on the basic training of women in the army, from one of the few jobs that I had managed to get—the *Daily News,* of all places. I became a Magnum "nominee" and started to work in the world of photojournalism, but I've always kept my documentary approach.

Magnum is about family in a strange way. There's something about being inside a collective of artists who continue to create and invent ways of surviving—sometimes sharing out of self-interest and sometimes not. Echoing exactly the human experience. This could happen within or outside of Magnum. For me, it just happens to be a little harbor. It's kind of a place where I go out from, out into the seas with all the torrential rains and currents and unpredictability that are out there at sea. This is a place that I come back to, one that's always there for me. There may not be a friendship with each member, but many have shaped my thinking.

My life changed radically when, two years later, I headed off to Nicaragua. By chance, my arrival coincided with a crisis inside the country, I decided to stay, not to hit and run. I wanted to go beyond the news event and document what I saw as history. I was fascinated and felt that I had to explore everywhere. It was knowing back roads. It was knowing neighborhoods. It was knowing people in places, so I could get a sense from them as to what was going on. Those relationships are not sources exactly, as writers always have to have, but they help shape your perception of what's important.

You don't always know where you're going or what something is going to lead to. It's discovered, not planned for. I never went to Central America looking for a guerrilla or an army officer or a this and a that to juxtapose. Very often newspaper photographers are forced to work in much tighter time frames and have to illustrate certain kinds

of stories. I was capturing the world I was seeing, completely follow-ing my own sense of what was important.

Assignments were very erratic. I was living cheaply, for five dollars a night throughout most of the period, until the war got intense, and it was really unsafe to live alone in a small place. It was rare that people would hire me to do a specific thing during the time I covered the war in Nicaragua in 1978 and 1979. Later, in the early eighties, I would be assigned to work with a particular writer to do a certain story else-where in Latin America.

The difference between my work in Central America and the earlier documentary work was that I could be on the road with the carnival strippers, come home, process the film, bring it back, show them the contact sheets, and then bring them prints of the images they wanted to give their fathers or their husbands or their lovers. There was a much closer, more intimate relationship with the carnival strippers.

I came up against different sets of problems in Nicaragua, partly be-cause it was a war. I couldn't always get back to the subject. I couldn't find them again. Very often I didn't see the photographs, because I had to send the film out of the country to have it processed. Magnum was distributing to several international publications, and they were edit-ing work that I hadn't always seen before shipping the film. I shot black and white as a sketchbook, to keep a record when the boxes of color slides were dispersed.

It was powerful to suddenly discover an image that I had made on the cover of the *New York Times Magazine,* reporting the insurrection in Nicaragua, before the war actually began. I was excited about that, but I started to feel some caution about what was implied by that power—the responsibility that comes with that power—to get it right. There is an illusion of control that we all have. For me, getting the names, the places, and the details of what is in fact going on is so im-portant. But beyond my own books, the images are out of my control.

Magnum participates as an intermediary in shaping what magazines are given to work with and in helping make sure they get the details right. But once the material goes to the magazines, difficulties can de-velop. There were definitely examples of images used to accompany text that misrepresented the feeling I had at the time I photographed. Some were just mistakes and some were intentional. Part of the struggle

of being a photojournalist is dealing with a medium that moves very fast: then we shipped film out by plane, while now everyone is digital.

When I finally put together the book, *Nicaragua*, it was very hard for me to see what pictures I had in relation to what I had missed. The enormity of the experience was so much greater than whatever I could render in seventy-two images. That is always the biggest challenge in making a book. That process is completely different than shooting stories or watching how what you shoot gets edited into illustrated magazine stories.

Though we might have more control through bookmaking, the distribution of photography books is still pathetic. There are many reasons for small audiences. In some cases it's the tendency to believe that the photograph carries all the meaning and therefore there's no other kind of text that might be helpful to a reader. Sometimes it's because the publishers themselves are isolated and not connected to enough sectors that might value the work. It's still a very primitive business. Sometimes I've felt like, "Why don't I just put the books in the trunk of my car and go door to door selling them?" I remember when we did take a lot of the El Salvador books to a major demonstration in Washington, D.C. We were selling the books to people who already knew about the issues—an obvious audience. But making books should be about creating a new audience.

I don't know if Amazon.com or web sites will help generate another kind of global community that we could never reach before. Is independent-authored production going to be supported or smothered out? Can small archives with limited resources compete against the capital that creates bigger conglomerates and then pressures to further control serial rights? These are critical questions for our survival in the future.

We need to continue to push traditional boundaries. As a documentarian, I have also been concerned about the aesthetics of an image. But if a photograph is in a gallery and it's sold to hang on a wall, does that make it fine art? Or, is it fine art because we're no longer interested in its caption and/or the context from which it came? I believe that the important question is how to seize opportunities to expose our work to a broader audience. If there's a gallery that's interested in the work, can you render the complexity of what you know through the installation? There are moments where the formal is of less concern to me

than the narrative function of a photograph, but I'm always looking for that thin line that I'm walking between form and content.

I shot *Carnival Strippers* in color and in black and white until I decided which I preferred. At that time, I was shooting recording film and experiencing many problems with exposure. There was no color negative with high speed at that time, so I worked in black and white. I liked the grainy feel of the pushed film.

In Nicaragua I again shot color and black and white, using two cameras, but I progressively felt that the work should be in color. It was expressive of the way people dressed and painted their houses. It caught the spirit of optimism about what was happening. This was quite different from El Salvador. In El Salvador I shot with two cameras, because at that time magazines expected color, but I really saw the brutality there in black and white.

There were criticisms when the Nicaraguan photographs first appeared. There were people that felt that I was aesthetisizing violence in Central America. There were people who just thought color was inappropriate. But it was not the first time people had used color. In Vietnam there was fabulous color by Larry Burrows. I saw that, but I don't think I was thinking about it in the abstract. I was looking at the world I was in and trying to figure out the appropriate translation to capture what I felt about that place at that moment.

There is an ongoing challenge for us, as documentarians, to continue to be committed and engaged, while at the same time innovative. I fear we have deadened out. You see this in exhibitions, which are often handled in precisely the same manner, or with similar variations. The same is true in magazines. There is a huge amount that still can be done in print, despite the efforts made by Alex Harris and Bob Coles with *DoubleTake,* or Colin Jacobson's *Reportage,* or, going back a few years, Peter Howe's *Outtakes* [a project of trying to print work that was shot, but never published]. Only one of them has survived. Why?

A lot of people buy cameras and film, and a lot of people buy photo books of a certain kind. The obvious example is the "Day in the Life of" series. Now, what's the problem? Why aren't people interested in what we documentarians are passionate about? Why are we in such a small ghetto?

Doing documentary work is not just building the relationships and shooting. It's also finding the spaces, be they magazine pages, books, or exhibition spaces, to transform and present the world we see differently. To get work into a public space is not easy. But we have to figure out how to do that effectively, not to mention the biggest problem, which is finding the sponsorship and the support.

We cannot always assume people are going to be interested in what we are involved in. We have to find ways of taking people someplace they don't expect to go. There was a time when we could surprise people. They would go to an exhibition in a museum and discover that it was so-called "photojournalism." That period was quite exciting. We were creating another environment, transforming the walls into a different experience for people who were going to museums in the traditional way.

When working with the material from El Salvador, I wanted to get the photographs into any kind of environment I could, from public libraries to storefronts, to the Museum of Photographic Arts in San Diego or the International Center for Photography in New York. The greatest success was in a public library in Rochester, New York. In order to go anywhere in the library you had to pass by a photographic display about El Salvador, at a time when U.S. military aid was intensely supporting that war.

I was trying to figure out what happens when this work is on different kinds of walls. What dialogue can it open up? Those are the kinds of explorations that we need to continue to do, and this involves partnerships. It's not just the photographer's problem. We've got to find partners willing to experiment with ways of getting people involved with "other" people and distant places.

The book that I've just done on Kurdistan is about encounter—the encounter of a variety of westerners, be they missionaries or anthropologists or photojournalists—looking at how they saw the Kurds and how they shaped the way the Kurds were seen. I see myself in that tradition of encounter and witness—a "witness" who sees the photograph as evidence. A lot of my work has been based on a concern about human rights violations. That's where that word is the most appropriate. But the other side of "witness" is that we do intervene, and we intervene by the fact of our presence in a particular place. We change how people see themselves sometimes and how others may come to see

them. I'm also concerned about how we see ourselves in the process of our role as witnesses.

When some of us began working in the early seventies, already the magazines of the sixties weren't hiring people to do what we dreamed we were going to do. We read the stories about Margaret Bourke-White or Robert Capa going off on long assignments and being guaranteed fifteen-page spreads, no matter what the subject. For my generation, those expectations weren't met. It is still tough for many of us with a lot of experience to get work today. Our production can no longer be sustained by editorial work alone. Does that mean that we give workshops and inspire people to do what we do, creating a geometric relationship of greater difficulty for all?

I don't see a major revival of documentary, although the current generation of students is again interested, after going through a decade where there was a tremendous assault against or controversy about documentary and the validity of documentary. I think there were issues that came out of that period that put some things in question, which was very, very positive, although it paralyzed production for many people.

The interesting question is, will there be a further extension of the vocabulary and the language of documentary? Can we go further than we've gone? That's what I still find myself excited to think about.

Sebastião Salgado

Workers

Sebastião Salgado is an economist who decided that photographs could better express his concerns than his economic reports. He made this discovery after borrowing a camera from his wife, Lélía Warnick Salgado, on a business trip for the International Coffee Organization in 1971.

Salgado left his native Brazil because of the military dictatorship in 1968. Relocated in Paris, he worked as a freelance photographer for several years. He was on assignment for the *New York Times Magazine* covering Ronald Reagan when the assassination attempt on the president occurred and took photographs that were widely reproduced internationally.

In 1977 Salgado began work on a social documentary project on indigenous life in Latin America that culminated in the publication of *Other Americas* in 1986. He also covered the famine in the Sahel, in Africa, working with the medical relief group, Médecins sans Frontières. A collection of these two bodies of work culminated in major exhibitions and a book, *Uncertain Grace*, in 1990.

Salgado has said that, "You photograph with all your ideology," and he is an activist as well as a photographer. On his family's farm in Brazil, for instance, he has established a forest restoration project that models a different type of economic development in the area.

In 1982 Salgado was honored with the W. Eugene Smith Memorial Fund award for humanistic photography for his work in Latin America. For several years, he has pursued boldly conceived multiyear projects concentrated in the Southern Hemisphere. *Workers*, which pays homage to manual labor-

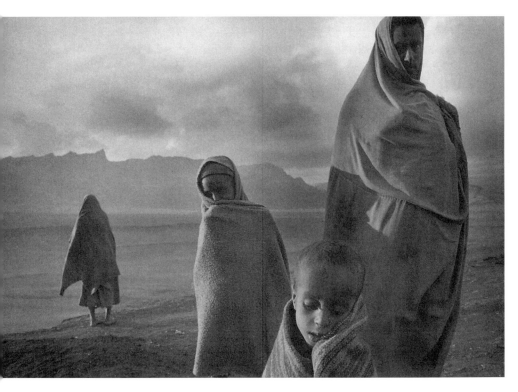

Ethiopia, 1984
(© Sebastião Salgado/Amazonas/Contact)

ers in many parts of the world, was published in 1993. More recently, he photographed agrarian uprisings in Brazil and completed work on a massive project on international refugees and immigrants. To coordinate these projects, he and Lélía established Amazonas, an agency that she directs in Paris.

I don't know if my photography is a passion. Passion is something that you can have one day and then the next day it disappears, replaced by another passion, by another wish. It could be that it is a way of life. I came from a reality that I've lived with from the beginning—that was my country, that was my family, those were my friends, that was the school that I went to, those were the political movements I worked for—before I became a photographer. I continue to do exactly the same thing, but now I include photography. I believe that it's more than a passion. It's difficult for me to imagine being any other way.

I began like an amateur and remained an amateur for two or three years. I tried to understand what my wish was. I tried to do portraits, I tried to do sports, I tried to do many different things because I had a passion for photography, for the camera. In the end I discovered that the stories that gave me the most pleasure were the same stories I did before, not as a photographer, but as an economist, as a student.

I had found what was important in my life. I believe that ultimately what you do in life is the thing that you are most capable to do, the thing that you are most concerned with. I don't believe that you do many different things in life. You do the same thing in different versions, but it's always the same thing.

I discovered this for myself when I was photographing in the Sahel. It was practically the first story I did, photographing the problems of starvation in 1973. And soon I did a second story like this, and that's more or less my life until now.

I've seen many difficult things, many hard things. It is important to have the capacity to adapt and, at the moment that you are photographing, to put these things in the context of your experiences in the other parts of your life—like the side of life you live when you are in your home.

You see the whole thing. You see yourself acting, photographing to show something to the other side, to people who did not have the op-

portunity to be there. And you have the idea of the link between these things. In the end you see documentary photography more as a vector than anything else. And as a vector it links points of the various concepts of "normal" life. The human situations you see that are very difficult are part of life; the situations that are very easy are also part, and they must be shown. They must be linked.

I have never put myself in a situation where I have a moral question about whether or not to photograph, such as, "Do I have a right to photograph when the death is there in front of me, the suffering is there in front of me?" I never ask myself these questions, because I asked myself the more important questions before I arrived there. Do we have the right to the division of resources that we have in the world? Do I have the right to have the house that I have, to live where I live? Do I have the right to eat when others don't eat? These are the basic questions.

I believe that there is no person in the world that must be protected from pictures. Everything that happens in the world must be shown and people around the world must have an idea of what's happening to the other people around the world. I believe this is the function of the vector that the documentary photographer must have, to show one person's existence to another. Sometimes we meet people in mainly rich countries—sometimes in poor countries, too—that are so shocked to discover that some people have such a hard way of life. These people are very serious, very honest when they say they are shocked because they never really had the opportunity to see. And when you show them, when you discuss the situation with them, they become integrated with the problem, and the problem becomes part of their life.

The most interesting function of this kind of photography is exactly this: to show and to provoke debate and to see how we can go ahead with our lives. The photographer must participate in this debate. I don't believe you do this because you are good, or because you are bad, or because you have a mission. You don't do it because of any of these things. You do it because it's your way of life. And in doing this you are minding yourself, you are minding your children, you are minding your wife, you are minding the things that you love most in your life. How can the documentary photographer help to assure the survival of all these people and to assure the survival of the next generations? Documentary photographers have a slice of the responsibility—they must pro-

voke a discussion. You don't go to a place to create good images, to create beautiful things. That's not what it is about. You have your own way to show them, and the photographer must find his own way.

In my case I prefer to work on very long-term stories. For all the stories I do, I write an outline. I create a framework where I concentrate my energies and my ideas. Of course, in this framework there are plenty of doors and windows. I can come and go by any one. I can put things inside and take things out. Using this method, it is much easier for you to evolve and to work with people. How are you to prepare the reportage? How are you to raise the funds? What about the magazines that will use these pictures or the organization with which you will be working? Does an environment exist that will allow you to give to them and receive from them? I try to work in the most open way. For example, I never produce a picture to show the end of a story. All of my pictures, without exception, were made as the story unfolded.

When I went to begin to photograph the project in Mozambique, Rwanda was not really in a state of civil war. A month later the civil war in Rwanda began. It was impossible for me to anticipate this, so the framework changed. I had a general idea of what was happening there because I read a lot before I arrived, and I also consulted people. But the test of the information comes when you are in the country. Only then will you see how real the things presented are, how difficult or easy they are, how important they are to you, and what part of the story you must touch to make it real, because you have a country, a huge country, in front of you. You have a huge number of refugees preparing to come back in addition to the ones inside. I remember when I first came to Mozambique, I spent about thirty days there, but for at least ten days I was organizing my story. I was looking, going to places, getting different things, to see where the refugees were coming back.

I made my second trip to Mozambique because I thought a lot of different things would be happening, and it would be the right time to photograph. But, by the time I arrived, all things had changed. The programs had changed. Things had happened in surrounding countries. It was necessary to go back a third time, really, to close my story.

You don't go to do one picture. You go to build a story. In the end, I believe that documentary photographers are people that love to tell sto-

ries. These stories are made with a big sequence of pictures. When I worked in Zaire with the people who came from Rwanda, I gave about fifty-five pictures to the magazines. In the fifty-five pictures I have a sequence. I have the beginning of the story, I have the middle of the story, and I have the end of the story. I have the captions that can accompany these photos. If you read the captions, you read my story. If you read the pictures, you read the story. That's the point. Sometimes people say, "Oh, you go to make good pictures of poor people." The people don't understand peanuts when they say this, because I never go to do a picture. I never go to do a good picture. What is a good picture? No. I go to stay inside my story, to try to understand what's going on, to be close to the people I photograph, and to create a flow of information that we can use to communicate something.

When *Life* magazine or *Time* magazine or *Stern* magazine has an idea to build a story, to do a story, it's their idea. They create the story, and they ask a photographer to go and shoot it. Or a photographer has an idea for a story for *Life* magazine that would represent one event, that is, one story.

With documentary photography the difference is that the photographer must have a big concern. You must have a big ideological affinity with the subject you will be shooting, because if you don't, you cannot remain sincere and empathetic for long. You must strongly identify with the subject. Then when the photographer first actually encounters the subject all of his preconceptions change.

At this moment, the way you look at the people you come to photograph, the way you relate to the people you come to photograph, the way you relate to your story, and the way you relate to the organization you are linked with are forever changed. Now they are a part of you and a part of your work. The people that you are photographing are a part of the universe in which you are living in the deepest way.

You change the region, you change the language, you change the country, but the story continues to be the same. After six years of shooting, I finished a story about the working class. I worked in forty-two different places of work in many different sectors of the production process, like agriculture, light industry, heavy industry, and miners. Each year I spent at least eight months in the places of work, living with the people, some for months, some for weeks. I have a very good idea about what the world of production is today. I understand how mod-

ern the world is today, how the means of production are linked. In practice, you realize that some theories were correct and some were not. You begin to make corrections, and sometimes you go in a direction that is completely different from the one you had in the beginning. All of these discoveries along the way make this flow of information very, very interesting.

I've never made a picture meant to be shown exclusively in one magazine. I don't have a closed agreement with one magazine, and I don't have an agreement with one kind of medium. For example, if I have an agreement with one magazine in one country, I will have an agreement with another magazine in another country. That allows me to have a group of magazines, a group of different countries, a group of different art directors, a group of different editors of magazines with whom I can exchange ideas and publications where I can present the photographs.

In addition to magazines, I work with a group of nongovernmental organizations. Nongovernmental organizations for me are very, very important, because they are so dynamic and positive. That work is as important as the magazines. For example, Médecins sans Frontières saw my work and asked me if they could use my pictures. I accommodated them initially, because I already had the pictures. I never sell pictures to these organizations. I give them the pictures, because the magazines have already paid me. The organizations use them in their newspapers, their shows, their posters, their television campaigns, and that kind of thing.

I'm trying to work with the new electronic media. I'm trying to do a CD-ROM and to use pictures on television. I'm doing a lot of small shows. For example, I'm preparing a television show with one of the United Nations organizations about Mozambican refugees returning to their country, which will be shown in Mozambique, Tanzania, Malawi, Zimbabwe, and in South Africa. The documentary photographer today must adapt to and accommodate the new ways we can use pictures. There are more uses for photography and documentary photography than ever before. When you see, for example, the CD-ROM's capacity to use pictures, you discover that it is probably as important as a book. In fact, it's capable of showing much, much more than you see in a book, and it could make documentary photography

more accessible because it is more cheaply and quickly produced. You can change language; you can do different versions, different translations in many languages.

And this is the point: to see how we are capable of adapting ourselves to the technological evolution of the world and to take advantage of this change of tools. It will always be necessary to have a photographer there to get the image. It's only the field that's changing. We must accept that there are more photographers than ever before and that we must live more densely than we have lived until now.

Documentary photography has always been hard. We probably have more opportunity now than before, because, even though many of the big "picture" magazines have disappeared, so many others have appeared in their place. We have all these big newspapers in this country that have Sunday supplements, Sunday magazines. And many nongovernmental organizations publish their own magazines. How many possibilities are there to do CD-ROMs? How many possibilities are there to do films from still pictures—where you film the pictures and you tell the story? That means that possibilities to use photography are as great or greater than before in proportion to the number of photographers and the general population.

We cannot continue to tell the same stories *Life* magazine did in its heyday. We must learn about and integrate what happened in the thirties and the fifties and the way stories were told, but we must see what's happening with this story today. You must live intensely the story you intend to do. The opportunities are there.

There is much, much more to photograph now than you had before, because the population of the world has more than doubled in forty years, and communication is much better. There is another way to see—television. It pushes the stories more quickly than they were pushed before. Urbanization is more than before. The world's problems are probably bigger now than they were, so there are more stories happening now in proportion to what we had before.

Whether the image lives as an historical document is for history to determine. You cannot foretell history. It would be a bit pretentious to say that I'm a historian. I hope people look at my pictures because my pictures tell the story accurately. I try to link my pictures with an historical moment that we are living. I believe that these pictures will stay or they will disappear depending on whether or not they ultimately

are linked with the historical moment. It's not because they are good pictures or bad pictures.

People who want to do documentary photography are not artists in the sense that an artist's work can stay. It's not this. It must be your life one hundred percent. If you find you cannot do this, you must find where your passion really is. But if your passion is in photography, documentary photography, that must be your way of life.

Graciela Iturbide

The Indigenous of Mexico

Graciela Iturbide was born in Mexico City to an upper-middle-class family. After her six-year-old daughter, Claudia, tragically died, she gave up a conventional family life to study cinematography. As a student at the Centro Universitario de Estudios Cinematográficos, Iturbide met and became an assistant to Manuel Álvarez Bravo, Mexico's foremost photographer.

In 1979, at the invitation of the painter Francisco Toledo, Iturbide traveled to southern Mexico to study and photograph the Zapotec Indians in Juchitán. Her book, *Juchitán de las Mujeres*, emphasizes the traditions and customs that shape the values of their precolonial, predominantly matriarchal society. Juchitán is "a place the conquistadores never reached," she said. On the basis of this work, Iturbide received the prestigious W. Eugene Smith Memorial Fund award for humanistic photography in 1987.

Although most of Iturbide's work is about Mexico's indigenous peoples—throughout the course of her career she has documented the Mayo, Totonae, Tarasco, Kickapoo, Seri, and Nahua Indians—she has photographed the role Mexican traditions play in immigrant communities, particularly the "cholos" of East Los Angeles. More recently, she completed a short essay, *En el Nombre del Padre*, that discusses the tradition of the yearly goat sacrifice in the province of Oaxaca, Mexico.

The original interview with Graciela Iturbide was conducted in Spanish and translated by Almundena Ortiz.

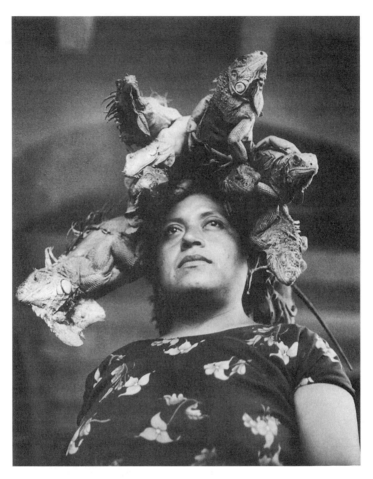

Nuestra Señora de las Iguanas,
Juchitán, Mexico, 1979
(© Graciela Iturbide)

When I met Manuel Álvarez Bravo, the world of photography came alive to me. I went with him into the field. Bravo never really worked on a theme. He would just photograph what he found.

My education as a photographer was little by little, going to festivals, parties, finding the images. My first real photographic essay or photography with a theme was in the desert in Sonora [California] with the Seris Indians. I was interested in the culture of my own country, and I realized how important it was to work in a thematic way. I made a book of the Indians.

At the same time, Francisco Toledo, the painter, invited me to go to Juchitán and asked me if I wanted to make a book. I would donate the exhibition to the House of Culture in Oaxaca—that was the objective of my introduction to Juchitán. So Juchitán was my first developed theme for photography. I had some freedom when I was doing this project; it wasn't like a job. Juchitán was totally my own creation.

My own country fascinates me, even though I work a lot outside of Mexico, including in Europe and Madagascar. But I feel more of a passion for Mexico, and I feel safer working here. I've also been working with Mexicans in the United States, in East Los Angeles, in the San Joaquin valley. It's part of my country's situation.

I go to the community first, always with my camera so they know I'm a photographer. I speak to the people and normally I stay and live with them. I try to involve myself in the legends, because they're related to the festivities I'm photographing. I also read materials that are related to the topic, for example, in the case of Juchitán I read [Miguel] Covarrubias.

It's little by little I speak to the people. I read a lot about the place itself, I speak to the fieldworkers. We sort of work together, and after a while the fieldworkers and the people in the community invite me to the festivities. They tell me about when a fiesta's going to happen. So we work together, it's not an aggressive confrontation.

For the Seris project I stayed for a month. That's the time that I had to develop the work. But in the case of Juchitán it was around fifteen days at a time, and then I would go back to Mexico City, because it was very intense. There were a lot of festivities, you had to go to the dances and actually dance so it's very intense. They drink a lot, and I also had to drink.

It is one of my principles that whenever I work with a community, I always bring prints back. It's different if I go and photograph festivi-

ties somewhere. But if I work with a community, that's always something I do. It's different when it's only a one-day festivity because you really can't go back and give prints to everybody.

The Seris had only been photographed by Americans and with Polaroid color film. So, when I did my project, I went back and did a show for them to see in one of the little houses there. They would say, "No, we don't like it," because it was black and white. But later, each one grabbed their photograph and took it home.

After I did the book on Juchitán, "The Woman of the Iguanas" became a celebrity. She has had about forty different journalists go and photograph her and talk to her. The journalists don't really understand what she's about. They come and ask her, "Why are you a feminist?" and really in the Zapotec culture we call it the matriarch culture, but it's their own culture. We cannot translate our Western ideology to them. So, they don't understand.

It's been easier for me being a woman and working in the field. I go and I stay with the women, and I have never had any problems. It's interesting because if I had been a commercial photographer and I had been working in publicity, it would have been different. There's a lot of competition, and being a woman would be a problem. But in the field people take care of you.

I've been more and more interested in different cultures in my country. For example, the Seris women have no relation to the women in Juchitán as a community itself. The fact that I'm a woman and working in the field has facilitated things for me, because I live with the women, I go with the women to the market, so it's very nonobtrusive. Of course, I focus a lot on the women, because I'm living with them and it's easier, but I also photograph men. And my approach, it's a woman's approach because I am a woman.

The men in the field do take care of you. For example, in the Seris case, initially I was there with an anthropologist, and the Seris were not very happy about my being there. But later they warmed up to me and even came and gave me a little heart that they had knit for me. They don't even speak a lot, but they would hang around and they were comfortable.

In Mexico indigenous cultures are very marginalized. The rest of Mexico doesn't really pay attention. They don't even acknowledge their

existence. Except this is changing, for example, the Zapatistas movement. I am interested in Mexico as it is—or as it was—and I'm also interested in the changes now. Many of those communities were abandoned. They had no roads, no anything.

The Seris case is very interesting. The community was a rich community by indigenous standards. They were given permission to fish in the Sea of Cortez, and the Americans would buy a lot of crafts from them, so they had money. I have this photograph of a Seris woman coming down a hill, and she's carrying a big tape deck. That to me is fantastic. Or, sometimes the Indians would dress in a tux and would go to the desert, and that's a part of them. I just stand there and observe, and it fascinates me.

My pictures upset some of the bourgeois, the upper class, the mainstream in Mexico. At least they know there is another part of Mexico that they have not acknowledged. But the people that see my photographs in a show in Mexico, it's not like they're going to have a social conscience after that. They just see it differently. Mexico's very difficult in that sense.

I don't pretend that my photography's going to actually change the world or make it a better place or anything like that. I photograph this way because I want to. The camera is like a pretext to put me in a situation, to go to a community so I get to learn about them and I get to learn about my country.

My photographs deal with the dignified aspect of humanity, even if I'm photographing the worst of situations. And there is a very deep complicity or dialogue between the person who is being photographed and myself. Of course, one of us is holding the camera. But if that dialogue does not exist, it just doesn't work. For example, in the case of Juchitán, there's a photograph I have depicting "El Rapto," a custom in which a virgin bride is deflowered by her husband-to-be before the wedding. If she is not a virgin, the wedding ceremony doesn't take place. This is the first time that this has been photographed. But they were the ones that asked me to come help photograph, because they know the way I photograph.

Mexico has always had a tradition of social documentary photography. We really don't know what term to give it in Mexico, but it's always been there. For example, Tina Modotti, [Edward] Weston, [Henri]

Cartier-Bresson, [Paul] Strand. There are young photographers work-
ing in the social documentary tradition because of this legacy. There are
no magazines where you can work or make things for publication, but
young people are still continuing to work in photography. Mexicans
don't have as many places to publish as Americans or Europeans. Eu-
ropeans and Americans have traveled to Mexico and India the most
to photograph. These countries have been a mecca for those photog-
raphers.

Manuel Álvarez Bravo is a special case. He's a very intelligent, cul-
tured man, but he also had a very close friendship with the muralists
when he started. And because of the muralists in Mexico, he met Andre
Breton and of course his work was published and known in Europe.
Initially when Breton came to Mexico, Manuel Álvarez Bravo was
asked to make a photo for the cover of an exhibition catalog, for which
he presented "La Buena Fama Durmiendo, 1939" ["Good Reputation
Sleeping"], but in the end it was censored. He was fortunate enough to
know these people and be well-known. Then again, later on, a lot of
the time nobody bought any of his work.

He had the same problems that other people faced, that his work was
known in Europe, but he was not recognized in Mexico. He had to do
little odd photography jobs, illustrating books and so on, to make a liv-
ing. He is a personality well-known in Mexico, he has a good reputa-
tion, but it's not like he is glamorized like a painter or anything like that.

Now that there are some international awards, more Mexican pho-
tographers have been exposed, and their work has been published
more. For example, I'm working with Maya Goded, the woman who
won the International Fund for Documentary Photography award.
She's going to present a book that I'm helping her to edit.

Of course, in Mexico we don't even have schools of photography.
We learn in life. You go, you do a little job here, and maybe you pub-
lish and someone sees it and calls you, but it's just little by little, there's
not really a structure. There used to be a school called the Mexican
Council of Photography. There's a place Centro de la Imagen where
photographers are able to show their work, and there is a space for lec-
tures from both Mexican and international photographers.

On the other hand, we are a small community of photographers
where we feel there's a responsibility to help younger photographers,
help them out, talk to them and that sort of thing, so there is a niche,

a tight community of photographers. There's a lot of enthusiasm and a lot of photographers showing their work to each other and pushing each other.

Also, because of the nature of my work, I get to travel, I get to do symposiums or show work. So I do travel, especially in Latin America. I've been to Cuba quite a few times, to Spain where I gave a symposium. When you are there you are a part of that community of photographers, you keep track of each other. So in that respect, I feel a part of the community.

Antonin Kratochvil

The Fall of the Iron Curtain

Born in Czechoslovakia (now the Czech Republic), Antonin Kratochvil was a child when Soviet communists seized power after World War II. His family was sent to a relocation camp for five years and lived in sub-human conditions. He fled to Austria in 1967 but was forced into a refugee camp before escaping to France, where he was drafted into the Foreign Legion and sent to North Africa. After an injury, he again escaped, this time to Holland, where he was able to take a course in photography that changed his life.

The influence of his refugee experience is felt vividly in his numerous photo-essays, such as those on street kids in Guatemala and Mongolia, Tibetan refugees, and war-torn Afghanistan. He spent twenty years, before and after the liberation of Eastern Europe, documenting the problems of refugees, economic dislocation, political chaos, and pollution in the former communist nations. This work was collected in his book, *Broken Dream*, published in 1997.

Kratochvil, who now lives in New York, is a member of the Saba Photo Agency and works for numerous magazines including *Natural History, Rolling Stone, Men's Journal, Time*, and *Newsweek*.

His many awards include the Leica Medal of Excellence, the Ernst Haas Award, the International Center of Photography's 1991 Infinity Award for Journalist of the Year, and the Alfred Eisenstadt Eye Witness Award for Photo Essays. He is currently working on a second book of photographs "about misery, about poverty and prisons and other horrors I've witnessed."

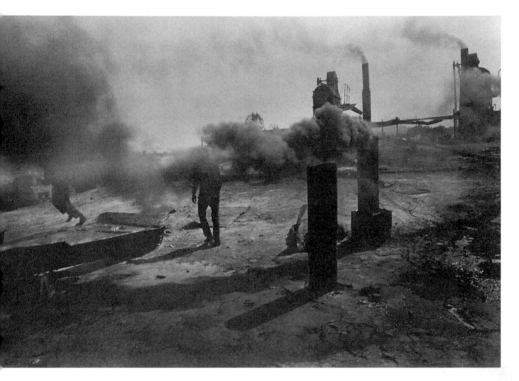

Tar Factory, Romania, 1978
(© Antonin Kratochvil)

I was born in 1947, after the war, a little brief moment of freedom before the communist coup. My parents were singled out as class enemies, and we were all sent to concentration camps for reeducation. I got my "education" there. We lived in a pig stall. That was my introduction to justice.

Before the "Czech Spring" of 1968, I was active with a student underground group, passing out leaflets. The secret police started to arrest a lot of us—there was a fink in the group—and many ended up in jail and many left the country illegally. We didn't know then that there would be an amnesty later. One friend worked for the train company and would smuggle people out in the train's water compartment. I walked and crawled under the barbed wire to Austria. It was dangerous; many people who tried to cross were shot without warning.

I left Czechoslovakia believing that people would be willing to help you because you'd suffered so much. Nobody gave a fuck. They put me in Traiskirthen, the infamous refugee camp, where I lived for a year and a half. It was a horrible place, with lots of killings and rapes. My cousin was killed there, thrown out of a window by some people who didn't like him.

Traiskirthen was a meat market. The Americans and Canadians would come through with their quotas and take only doctors, engineers, educated people—those good for the economy. Young guys without an education, like me, and old people were left to rot there. They're not going to put you through school; that would cost them money. It was before the great sympathy about the Russian occupation of Czechoslovakia, and nobody was giving anything.

Finally, Sweden took me, out of humanitarian consideration. I was designated like a guest worker and got a seasonal job working in a hotel. After the season was over, I was on the street. They just said, "This is it, goodbye." I had to go back to Traiskirthen. After about six months, I snuck out.

I was nineteen or twenty, on the street, homeless, with no money. I started stealing food, got busted, sent to prison, and deported. I wound up in France, where I was arrested for being in the country illegally. They gave me a choice, join the Foreign Legion or stay here and rot. I was sent to the desert in Chad [Africa], where I learned to dig a hole in the sand and lay there while tanks rolled over me. I would have to attach bombs to the tanks as they rolled over.

I was injured and sent to Marseilles, where I escaped over the wall of the fort. By chance I got to Holland, which changed my life. By that time the mood was more sympathetic toward the Czech refugees. With the occupation of Czechoslovakia by the Russian forces, the world took notice, and said, "Hey, you know, let's help these people." The media created the sympathy. I was on my way to being a bona fide loser. Sometimes you get a break.

I enrolled in art school and got a scholarship. I studied two and a half years and I graduated—the biggest achievement of my life. (Laughs) Actually, it was a breeze for me; I discovered I was a photographer. When I was going to school, I never really photographed what the other kids did. They were preparing themselves for careers in commercial photography. I was on the street. My first essay, which I did at school, was an essay on a decrepit old folks' home. I was so poor that I only shot one roll of film. Every frame had to count. Every paper had to count.

One of my teachers saw it and loved it. He got it published in some sort of leftist newspaper, and it created an uproar. The government actually closed the home down and improved the lives of those old people. I said, "Shit man, you can actually do this with your photography?" It's tremendous. I thought, "I want to stick to it." I'm going to go out there and do this because I really have this keen sense of justice in my brain, however twisted it is. That's what I set out to do, and I'm doing it still today. There were little corners I had to turn, but basically I'm drawn to this, because I feel I owe it to these people since I rose above it. I never really analyzed it, like psychotherapy, but that's probably it.

I just follow my gut. Sometimes I run into things, like the Mongolian street kids. I was out on assignment, photographing some idiotic story for *Details* in China. I go to this train station, and I see these homeless kids—but they're not doing drugs. I've shot homeless kids before, in Guatemala, places like that, but these kids were working for their money, making an effort. They were trying to maintain some kind of order, some kind of discipline, to try to sell Coca-Cola, go get the luggage for money. They didn't steal. So I tried to get some money to go back. I approached the *New York Times*, they said, "We did street kids in Afghanistan." Then I found this guy, Bruce Stutz, who was the edi-

tor at *Natural History,* and he sent me back. I went to Moscow, so I was near Mongolia, so I spent three weeks there.

I try to stay as long as I can. But I train myself, because I am a magazine photographer and I have been most of my career. I know the limits. Most of these things, if you get two weeks, it's fantastic. So, I work all day long, and I work in black and white so I don't need to wait for sunset. Sometimes I feel I have to go back. With my Eastern European project, *Broken Dream,* it was twenty years of going back.

The important thing is the prep work before. You should read about it, get all the information about it, as much as you can. You have to line up a fixer—somebody in the country who speaks the lingo and can fix things if there is a problem.

For instance, in Afghanistan, a group of mujahadeens climbed up on the truck where I was sleeping and decided to kill me. It was right before the Russian invasion, and they thought I was a Russian adviser. I knew I was in trouble when they tried to read my passport upside down. It was an American passport, but it had my place of birth as Czechoslovakia. They all knew about the 9mm guns manufactured by the Czechs. They held loaded guns to my head for two hours—it seemed like an eternity—while the fixer talked to them, told them I was on their side, whatever he could think of. Of course, I couldn't understand any of it, because I didn't know the language. I was very calm; I just thought, well, I'm going to die. The fixer saved my life.

Another fixer, in Rwanda, drove me into a minefield. He didn't know jack, so I was telling him, "Don't make a u-ey, just back out." Rwanda and Zaire in 1994 was the worst situation I've ever photographed. There were so many people dying; it was like the camps after World War II. There were piles of bodies and bulldozers making mass graves. A lot of people covered the war, but nobody was prepared for such mayhem. You see dead bodies in conflicts, but nothing like that, and it was hard.

Sometimes you photograph something you don't even know is going to be that difficult. Recently, I worked for the Rockefeller Foundation on a report about poor families around the world. I went to photograph a family in the state of Bihar, in India, and discovered that the family was living in bondage to a landlord. They were slaves. They had owed the landlord money for generations, and the debt would be passed down to the sons.

I had brought some money to pay the father of the family for the story, but the landlord told me that he would take the money and apply it to their debt. Instead, I invited the man to the landlord's house and gave the man his money. He just touched it and passed it to the landlord. I didn't know what to do. Later, I gave him more money in private. The Brahman class was basically in a conspiracy to keep those families in debt. The teachers were also Brahmans and would sign papers saying the poor children had attended school, when they were actually forced to work in the fields. Even though it was formally illegal, they protected the caste system, their way of life.

Another difficult story was in 1997, when I did an assignment for *New York* magazine on a missing child. I worked with the parents, who were still looking for him. They thought that if the story came out, maybe someone would see him or he would come back. The kid was about seventeen and had been seen last in a bar on the Upper East Side. There was still hope, but so much anxiety, waiting by the phone. They speculated about everything. Since I'm a father myself, it was a heartbreaking story for me. Eventually, the boy was found floating in the East River, but they still don't know what happened to him.

Oftentimes, when a magazine gives you an assignment and you bring the goods in, they expect something else. They just want to go with what is a popular trend, or they don't want to be too controversial about it. In this way, they suck the real juice out of the story, because the strongest images might be a little bit out there, and they want to tone it down. They have the right to say that. They have their own reasons. They have their own jobs on the line. That's all part of it.

Like this prison story at *New York Times Magazine*. The picture editor wanted to do it really badly. She kept it for three months. She hit them every meeting with it. They said no. They stonewalled her. But sometimes even the chief doesn't have the power—it's the money guys, the advertisers. A lot of photographers bitch and moan, but I feel sympathetic for the picture editors.

All kinds of noise gets in between you and the public, so then you get more perversion, like the sound bite. In a very twisted way, I feel fortunate I could actually be in places like Rwanda—that I don't get it secondhand from the TV screen. It really effects you, the smell of it. You get this antiseptic version of it on the TV screen, but if you're there,

you're enriched in life. And you're not really afraid, because you know it's part of life.

Many press photographers never look back. That is not what I do, I turn back and I look behind. That's my role. They go for the shot, because they have to get the shot. I'm freer. When the CNN dish leaves, then it's my time. You can relax and get down and do it right.

I was lucky to do the *Broken Dream* book. In the beginning people here didn't really care about Eastern Europe. Then the Soviet Union disintegrated and people took notice. I was able to come close to the psyche of those people, because I understood it. Often the press reports are bad, because they go for the blood, not the psychology of the place. I know that terror is in the eyes.

I saw it in Peshawar, Pakistan, over a three or four year period when it was the staging ground for the Afghan war. All the journalists covering the war had to hook up with mujahadeen there to get inside Afghanistan. I'll never forget the terror of the refugees living in the camps on the northwest frontier, near Peshawar. The place was filled with agents, like the crew-cut American I met who told me he was selling irrigation equipment. That was the standard line for the CIA men and mercenaries who were running guns through there for the mujahadeen. There was also KGB and KHAD, the Pakistan security service. There were regular car bombings.

In the months I lived there, I made a home away from home on the third floor of the Hotel Green. I even had a bird in a cage. Late one night a car bomber blew up the lobby, killing the receptionist and a guard. I thought that whole place was coming down. I said to myself that at least I wouldn't have to pay the hotel bill. No such luck.

I want to go to places that people don't give a damn about. Once I was in Mexico, on vacation with my family, and I read a little report in the international edition of the *Miami Herald* about the Cueta prison in Caracas, Venzuela, which they called the worst in South America. According to Amnesty International, prisoners are routinely tortured and killed there. With the help of my agency, we got permission from the minister of justice to photograph in the prisons. There's always someone in these governments who tries to make a difference. The ministry wanted to draw European attention to the prisons in order to force the military and police to reform them.

When I went in, they showed me the best parts of the prison. I had to bribe the guards to get into the other parts. Even then, the guards were too afraid to go in with me. Gangs with guns ran those areas. There were bullet marks everywhere, as well as cholera and sodomy. They don't feed the prisoners. When I said I wanted to photograph a lunch line, they told me, "Well, we're not ready yet." I waited for three hours while they worked to scrounge up something to feed them, and of course it was for my benefit. If you want to eat, you have to buy the food.

One of the dungeons hadn't been opened for months. The door was so rusted that the prisoners had to push it from the inside to get it open. Coming in from the light, I couldn't even see the prisoners, and it was dangerous so I had to work fast. I just put up my camera; I was shooting blind. I developed the pictures back in New York and luckily they showed the situation—the knives, the guns, the drugs.

I want to bring the light to these places. I was in prison myself. Sometimes I'm anxious before I go, but once I'm on the ground, I make a decision to be there and I'm not afraid. I'm much more scared of horror movies. I had to cover my eyes during *The Shining*.

You have to be aware of yourself, of course. Prisoners and soldiers are attuned to fear; I believe they can smell it on you. It changes the situation completely by making them suspicious. They suspect you are doing something wrong because you're not sure of yourself. You have to know why you're there.

There are a lot of press guys that are desensitized, but I don't feel like that. I'm not putting myself above the people I photograph. To those critics who have qualms about photographing difficult situations, I say: "People ought to know. I'm just the messenger."

Donna Ferrato

Living with the Enemy: Domestic Violence

Donna Ferrato attended Garland College in Boston and began work-
ing as a freelance photographer in 1976. A former member of the
Black Star photo agency, Ferrato has published work in *Life, Stern, People,*
the *New York Times,* and other magazines.

After witnessing a man beat his wife while on a magazine assignment in
1985, Ferrato launched a project on domestic abuse for which she won a
W. Eugene Smith Memorial Fund award in humanistic photography. Ferrato
traveled throughout the country to hospital emergency rooms, shelters, bat-
tered women's therapy groups, and self-defense classes to photograph the
effects, and often acts, of domestic abuse. The story first appeared in the
Philadelphia Inquirer in 1987 and became a book, *Living with the Enemy,*
published in 1991. That same year Ferrato founded the Domestic Abuse
Awareness Project, a nonprofit organization that utilizes installations of
Ferrato's photographs to raise money to combat domestic abuse.

Ferrato has been honored with many awards, including the Robert F.
Kennedy award for humanistic photography and the Kodak Crystal Eagle
Award.

I was on assignment to document love, not to photograph domestic
violence. Accidentally, I discovered a woman could get beaten in her
home by the man that she loves. I never considered that.

This was back in the early eighties. I was more naive then, always
looking for love. So, there I was, photographing this couple who

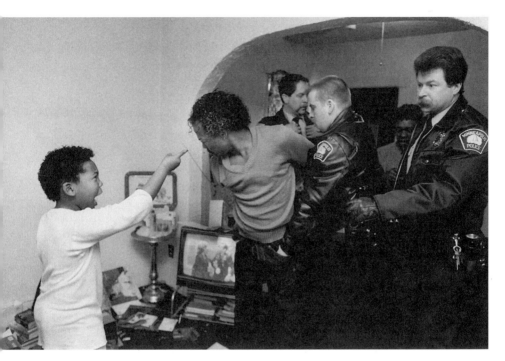

"I hate you for hitting my mother.
Don't you ever come back to this house," 1991
(© Donna Ferrato)

seemed to have a great love. One night this man attacked his wife. He didn't care that I was there. I photographed it because I was shocked to the soles of my feet to see a woman being beaten.

Who could she call? I saw her calling the police. Then he grabbed the phone and said, "She's beating me." He had me confused, and it took a long time to figure out what was really happening.

I remember calling a photographer from these people's house, wailing, "This great love story I've been working on, it's not. What am I going to do?"

My friend said, "Just stick it out, keep looking."

I went into denial. I never even developed the roll of film. I wasn't looking for a Pulitzer or to get it published. After I got a picture of a man beating his wife, I threw that disgusting roll of film into a drawer.

When I told my editors at Japanese *Playboy* what I photographed, they said, "You're fired."

It's been a long process for me. I get sad when photographers—experienced or amateurs—come to me and say, "How can I get my name out there? How can I get people to respect me? How can I get the assignments?"

They ask, "What am I going to get?"

My feeling is it's not what you're going to get. More like what are you going to give? What are you going to learn? There's so much to learn out there with a camera. It gives us power for educating ourselves and for educating others. We have to be patient, try to learn as much as we can until there comes a point where we have something to share with other people. And that doesn't come for a long time.

I rode over six thousand hours with cops around the country to get the pictures. You have to be there.

When I took the picture of the little boy shouting at his father, I'd been riding with the cops in Minneapolis for a month, usually on the four-to-two shifts. Nothing was going on. A lot of the things I had already seen. There were times when I asked, "Can I take a picture?" and people said no. So I watched. I respect people's rights to say no. It's not insulting. I just say, "Hey, I understand. It's up to you."

By watching I'm learning, but I needed to get *the* picture eventually.

I was riding days as well as nights. We were on our first call to go to this house where the boy had called the cops. It was early morning; I didn't have a flash on the camera.

We got inside, the shades were drawn, and it was dark, very dark in the house. The woman at the door was screaming, "My husband's in the back room."

Police rushed ahead. I asked the woman, "Ma'am, I'm from *Life* magazine. Do I have your permission to take pictures of whatever happens from this point on? I don't know what's going to happen here, but I promise you I will not publish anything unless you sign a release."

I said this fast. She said, "Yeah, I don't care." So I followed the cops and started taking pictures. The little boy was crying. "His knife is under the bed mattress." They flipped it. I'm trying to get my flash out because it's dark, and I needed to bounce light off the ceiling.

I was fumbling, feeling like Columbo. The police were handcuffing the guy, and every time he budged, they beat him. The wife was crying, trying to stop the police.

They take him out into the living room, finally. I am in front of them, camera and flash ready. Suddenly the little boy opened his mouth, pointed his finger, and accused his father in a way that I had never seen anyone do. We were stunned at the depth of the angry feelings from the mouth of a child.

They took the father to the cop car. I rode down to the station, because I wanted to hear his side.

As we were leaving, I said, "Ma'am, about that release. . . ."

She said, "What magazine did you say you were from?"

"*Life.*"

She said, "I thought you were from *Ebony*. No way."

I said okay. I'm used to it. So, in the police car the father told me how he hadn't been violent with his wife for ten years. He's been in a program. Used to be a drinker. Wasn't a drinker anymore, but his wife was using drugs and had blown the family savings. He snapped. These complex shades of gray, most of the time, are never seen because there's no follow-up.

Back in New York, I developed that roll and knew that the boy shouting was *the* picture. When Peter Howe at *Life* saw it, he wanted it. But I didn't have the release.

A month later, I went back to Minneapolis to their home in the middle of a Saturday. The husband answered the door. I explained why I was there, and he said, "Come back and meet with my wife. She and I are back together."

I couldn't show them the picture; that's magazine policy. But I described the photo. "This is the toughest picture that anybody will ever see about what a child really feels. People must understand what children go through when fathers beat their mothers."

They signed the release.

My releases are ironclad. They're lengthy. Photographers who work in foreign countries don't have to get releases. In this country you have to get releases, and not just so you don't get sued, but also because it's the responsible thing to do. They better know that these pictures are going to come out in a magazine. When the parents saw the picture, they hated it. But it was too late. They signed the release.

Also, I try to make sure nobody puts false stories with my photographs.

An artist who was in a group show at the Whitney Museum [of American Art, New York] took that boy's picture and used it repeatedly in her collage about sexual abuse, insinuating the wrong things. I went after her and the Whitney Museum. The Whitney lost, but this artist won't give me any guarantee that she will never show the artwork again. It jeopardizes the integrity of the people in the pictures, everything.

I wanted [*Living with the Enemy*] to be a mainstream book that would get to the people who needed it. Every mainstream publisher turned me down, year after year after year.

A woman named Melissa Harris worked at Aperture. We met, and she said, "Please, Donna, bring your work in to show Michael Hoffman [executive director of Aperture]." I'd already had an encouraging letter from Aperture a couple of years before, but I didn't take them seriously. Melissa set the meeting up. Michael was interested. I was slow to respond.

I ignored him and kept trying to find bigger publishers. Meanwhile, he was sending me letters saying all the right things. Finally, one morning I woke up and said, "What a dummy I am! Here I have someone who really wants to do it. Why don't I give them a chance?"

When the book was published, I thought that would be the end of it. Then a shelter in New York City approached me with the idea of having a fund-raiser, exhibiting fifty photographs, inviting their wealthiest donors to come, charging them a lot of money to look at these pictures, giving autographed copies of *Living with the Enemy*.

They raised $300,000 in one night. I started thinking, "Ha! These pictures have a power to do good."

When *Life* magazine published information about the show on the editor's page, I got calls from shelters everywhere. That's why we established the Domestic Abuse Awareness Project [DAAP] as a nonprofit. The idea was to send the exhibition around the country to teach groups how to raise money and educate people at the same time. Usually, battered women's groups plan fund-raisers at the ballet, something cultural. Rarely do they have a chance to show their rich patrons the force of domestic violence. One men's group in Washington State raised $86,000 in a week with my photographs.

For the last four years, I've been learning how to use these pictures in campaigns, public service announcements—way beyond the magazines stacked in the newsstands. We work with the criminal justice system, with the sheriff's department, with the prisons and hospitals.

Magazines have to pay standard usage rates. The money supports DAAP, to pay for an executive director, and to pay for the office expenses. I don't take a salary or percentage. We have two shows that travel. This month it starts off in Milan, hosted by Italian feminists. Then it goes to Holland. The Men Against Violence to Women are bringing it to Israel. Another show is traveling to Tennessee to seven different hospital sites, raising money for battered women's shelters.

These photographs are the backbone of many domestic violence campaigns. Michigan's Health Department has a series of PSAs [public service announcements] on TV, pamphlets that educate people across Michigan. There's the Matilda Cuomo campaign, in English and Spanish, on TV and Stacy Kabat's Academy Award–winning film, *Defending Our Lives,* which was about women in prison.

I go out and try to raise money for DAAP. I also have an agent who books speaking engagements for me at universities across the country. I've appeared at forty different colleges over the last two years. I get through to kids, show them my pictures, tell them stories, and learn about what young kids are facing in their own relationships.

We are learning together that there are some really crazy, violent men out there and few who are willing to confront them. We put all the responsibility on women and children to protect themselves. We've been doing a really lousy job protecting women and children.

I want to make the subject of violence against women and children

something natural to talk about, to get the facts out, and to make it fun to learn about. I'm not against men. My biggest influences have been from good men in my life, starting with my dad.

[Photographer] Philip Jones-Griffith, was also a good influence. When I got discouraged that nobody wanted to give me assignments, thinking maybe I should sell the old pictures of domestic violence because I needed to get it out there, he'd say, "No, Donna, have faith in yourself. They don't want to give you assignments, because they're stupid. You just keep working, keep quiet, keep your costs of living low, don't let anybody control you." Philip always told me the work was good, and he'd never seen anything like it.

Philip believed in me. The fact that he was president of Magnum and saw everything being done gave me the confidence. Philip's book [*Vietnam, Inc.,* (1972)] was the most incredibly strong, honest, and compassionate book about war I'd ever seen. I respected him. His book showed the truth about war, no bullshit or glorification of death and suffering. He showed what soldiers do. His pictures showed the inhumanity of men to other men, to women and children, to the earth.

The photographer I admire is Robert Frank. I studied the retrospective of his life's work, and I saw his heart, his suffering, his joys, and his pain. His photos are very moving.

I always wonder: "How does a person inspire a movement? To make changes?" If I don't like something, I don't complain about it. I figure out how to change it. That's what I try to do with a camera.

Things are working out without a plan. I keep following my heart—things just come together. Photography is in my blood—I love to photograph the daily life, the people I love. Especially my daughter. She's the pride and joy of my life. Everything I do, I do for Fanny to help her understand what it means to be female, how she must stand up for her rights.

I love darkroom work. I haven't been with an agency since I left Black Star three years ago. I am a lone wolf and do okay representing myself, except I miss Howard Chapnick [the late president of Black Star photo agency]. I am pretty stubborn. I'll turn down an assignment because it's not right for me.

Photographers need to think about how they can make contributions to put their ideas across clearly so they can show there's a reason for

their work. Photographers must do their own proposals, research, and budgets, meet with the editors, represent themselves, figure out ways to make their work a vital tool needed by the community, by the society.

We have to face it—the magazines are not there for us, they haven't been for a while. American magazines fund fewer and fewer social documentary projects.

A lot of the photographers are disgruntled, but many are used to having things fall into their laps. It's going to be a particularly difficult struggle for the single-minded photographer who wants to see things change, to make a difference.

I always tell young photographers, "Discover the world. Take pictures. Live cheaply."

Someday, I want to write a book on love and living from the heart. To show things from my early years as a secretary and then as a wanderer. I did everything I could just to be able to take pictures. I worked on a farm; I traveled like a gypsy. I learned so much and had so much fun. Nobody owned me. I didn't have a credit card. I lived off the kindness of strangers generous to me who gave me food to eat and a darkroom to print in.

All these years, and I still don't have my own darkroom. But, it sure is sweet getting older. Those ten years, when I was working on my book, I was very low-key about it. I just had a lot to learn. I still do. Boy, do I ever.

Since the interview was conducted, Ferrato reports that she has gotten her own darkroom. Her book about love is nearly done. Best of all, she said, she is in love.

Joseph Rodriguez

In the Barrio

Joseph Rodriguez's early life in Brooklyn was troubled by drugs and petty crime. After a short term in prison, Rodriguez attended the School of Visual Arts in New York and dabbled in photography for several years. Then Rodriguez met photographer Larry Clark while helping to hang the exhibition "Tulsa," Clark's work about drug addiction. Rodriguez told Clark that the work moved him, and Clark replied, "Listen . . . just go out and take pictures."

Rodriguez took Clark's advice, and he also enrolled in the International Center for Photography (ICP) to study photojournalism. Fred Ritchin, a teacher at ICP, organized a project with nine students on East Harlem that was to revisit the area Bruce Davidson documented in the late 1960s in his acclaimed work *East 100th Street*. Documenting East Harlem turned into a four-year project for Rodriguez. The photographs appeared in *National Geographic* and became his first book, *Spanish Harlem*, in 1995.

With grants from Pacific News Service, the Alicia Patterson Foundation, the International Fund for Documentary Photography, and the National Endowment for the Arts, Rodriguez moved to the West Coast to photograph gang life in Los Angeles in 1995. Three years later his book, *East Side Stories: Gang Life in East LA*, met with critical success. With a fellowship in 1998 from the Center on Crime, Communities, and Culture of the Open Society Institute, Rodriguez began working on a project about young people struggling to succeed after prison.

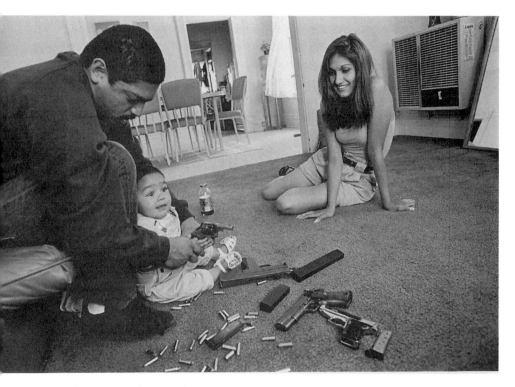

The morning after a rival gang tried
to kill Chivo for the fourth time,
he teaches his daughter how to hold
a pistol, East Los Angeles, California
(© Joseph Rodriquez, from *East Side Stories,*
PowerHouse Books)

Social documentary for me is very personal. And even though I would like very much to change things, over the years I've been a little disillusioned to see that sometimes it doesn't really turn out the way I'd like it to.

My photography is about where I came from and the struggles of my own life. I have a different agenda in that way. It's not a news agenda.

It's also about humanity, but not in the old cliché *Family of Man* way. Now is a very important time for us to see humanity. I wish editors would get that idea in their heads. I think we could probably bridge some gaps, like racism, if we could actually start learning about cultures in a much more human way, as opposed to these flashy, sexy, violent images that come out of Hollywood.

It's funny. You see people, just ordinary people on the street and see how they're dressed—some with tattoos, some with hot, sexy fashion. This is the image of today, the whole "notice me" thing. "Notice me."

I think it's important to have passion—I really do—in your own work. It keeps you going. At the very beginning, I did anything I had to do. I only allotted myself two or three rolls a week. I drove a cab on the weekends and assisted a wedding-studio photographer in Manhattan. Whenever I could get up to Spanish Harlem, I'd go up there. Passion is about being in the spirit of things. I think lots of work is intellectualized too much in this country.

As a kid I was always told to shut up, you know, be quiet and speak when spoken to. I could never get my voice out. Photography is my voice.

One of the difficult issues for photographers is dealing with rejection. I went to the *New York Times Magazine,* and they said, "Well we're not doing stories about poverty." I went to German *Geo.* I went to *Stern.* That is probably the most difficult thing to deal with—besides the times you think your work is not ready.

We live in an era when everything has to be done quickly. Whether it's magazine editors or television producers, they all want results quickly. I think one of the most urgent issues to address is how much time it takes to tell a good story. For myself, I just want to be able to get enough money so I can have the time it takes to do my work in a responsible manner and get it out.

In my twenties I kept thinking about the three D's: desire, discipline, and determination. Those are the qualities that actually changed my way of thinking and my way of being. The desire to be a photographer was always there. I was determined. It was the discipline part that was kind of tough. I was disillusioned, and I was depressed, and I had my lows and my highs.

I'm not strong all the time. I go through periods where I have to pick myself back up, and I have to go out there and come back and go out and come back. People look at me and say, "Wow, you know it's very romantic what you do." Yes, there is a part of it that is romantic, you know, but it's also hard. It's lonely. It's people telling you most of the time they are not interested in your work.

I've been behind bars. I know what drugs are about. I've had these struggles within my own family. We've been poor, so don't come and ask me, "What right do you have to do that?" I've been there. These experiences helped me get close to the gang kids I photographed, because I gained their respect. But there are various ways to work. People don't have to go through these experiences to be good photographers. People think you have to be struggling or starving to be able to document people's lives.

For me it's important to be able to show a little bit of the positive side of life and to try to give that balance, to give respect to people. There's a lot of heavy-handed photography today. In America social documentary has always been like, "Where's the problem? Let's try to document it so we can correct it." But after looking at other influences of documentary photography in Latin American, Africa, Scandinavia, and Russia, I feel it's a little more than that. It's also about people's lives and showing something positive.

I always wanted to photograph gangs. The reason why I wanted to do this was simply because I was paying attention to rap music and what these kids were talking about. I wasn't going to get my research from newspapers, because they already have an agenda that's obvious in their writing.

I guess I had this romantic view of doing a gang essay because of a photographer named Bruce Davidson who I've always admired. I remembered his Brooklyn gang essay that he did for *Esquire* with Nor-

man Mailer. He was documenting this gang in the neighborhood where I grew up, and I knew some of his subjects. Before leaving for Los Angeles I was naive. The nineties were totally different.

I heard about the Community Youth Gang Services in Los Angeles. I walked in there the first day and sat down, and nobody talked to me for about four days because they thought I was just another media person. Finally I got to talk to one guy, and after two weeks I met more people, and then I met a family.

I got close to this family, and through them I began to meet these gang members. This was in Watts. Things were quiet at that point. It was after the riots of 1992, and the Bloods and Crips, the two biggest black gangs in Los Angeles, were having a truce. But in East Los Angeles things were really going crazy. So at that point, I began looking at the newspapers; I watched the news to see where the action was. There was a drive-by, and a two-year-old was killed, and there was going to be a funeral. So I went to the family's house cold. I didn't know them. I knocked on the door, expressed who I was and what I was doing, and they let me in and told me the funeral was going to be the next day. I covered the funeral at the church and the media was there. The television people were in the back. I walked up to the front of the coffin.

You know, there's always this uncomfortable feeling of having the camera and people staring at you. You have to swallow that to make pictures. I guess it's like acting. You have to change yourself and really get into it. So photographing the gangs was very difficult. Then I went to Stockholm, where I was living at the time, to process my film.

I felt this project should be black and white. Black Star made a small foreign story for syndication. It made a little bit of money. One editor said to me, "Well, you know we need a little bit more action. We need some guns. We need some more blood." I went home very despondent.

Later, with the assistance of Sandy Close of Pacific News Service, I edited some prints for grant submissions. I applied to the Alicia Patterson [Foundation] fellowship and later for the International Fund for Documentary Photography fellowship. I received both grants and decided to move to Los Angeles a year later.

To be there every day was the only way to do it. I went back and started all over again. I started going back to this one gang, and I couldn't get in. Then I went to a school where I connected with one

gang. I was photographing them until the police arrested some of them and found some of the photos I made of them. The police gang unit confiscated the photos, and this whole problem began. The police told the gang members that I was working with them. The gang thought that I set them up, and because of this my life was in danger. I had to flee that neighborhood and find a new gang to start over with.

Talk about being depressed. You couldn't get any lower than that. I had to start completely over. It took a really long time to get in with another gang before they would even begin to trust me. It took another month and a half before they could even start to trust me. Every day of the year and a half that I worked, I was questioned whether or not I was a cop. Even after I witnessed a drive-by shooting, even after hanging out with their moms and taking their girlfriends to the doctors, they were still paranoid about me. The danger, too, got me down from time to time.

The kids kept asking me, "What are you doing here?" And I said, "I'd like to make a book about you guys." And they said, "Why would anybody be interested in us?"

In the gang work and the East Harlem project, I told people it was going to be a book. It's always difficult five, six, seven years down the road when your work finally comes out. So I try to be as straight up with them as possible about what's going to happen. I tell them it could be a magazine story. With the gang work, I wouldn't go back to them with some of the magazine stories, because I didn't think they were done in good faith. And it would only make the gangs look bad and feel bad, so I'd rather wait until there's a book, something a little more substantial and a little more honest.

I spent a good year and a half photographing them, and it's very important to note that out of the whole project there are less than three hundred rolls of film. There was a lot of driving mothers to court and back, taking them food shopping, picking up kids from school, helping this person, helping that person, trying to talk about jobs, you know, this whole thing. You get involved. You become like a taxi driver. You become like this den mother. They were trying to come up with a name for me. They were calling me "Kodak." They were calling me "Fuji." There was all this crazy stuff. Finally, they just called me "the photographer." That was my name.

You know from your gut when you're onto something. My heart-

felt vision of photography is to look at Latinos here in the United States. And I kind of knew what these kids were about. I liked their music, I hung out, we drank beer, we went to fiestas. It wasn't like, let's document these guys with the guns and all that stuff.

There was one situation when they said, "Come on. We're going to go on a drive-by." And I was like, wait a minute here. Will I be implicated in a possible murder? I don't think that's gonna work too well.

I think there are a lot of photographers out there that get kind of stuck. They do commercialized editorial work and they seem to be pretty good at it, but they seem to be very depressed. They don't have anything personal going on with their own work. They don't seem to be making books or putting their work into exhibitions. For me, I think that these are important goals for us photographers. I try to tell them, "Get yourself a small project going on the side so you can be happy with your own work, so you can be happy with yourself and you're just not getting caught up for the money of it." I guess I'm not in it for the money, so I don't know any other way to say it.

In photo agencies the time factor becomes a big problem. It gets to a stage where you have these editors sitting there, and they're typing up the captions. And sometimes, it's like, oops, they made a mistake. Or, I didn't get to check it in time, but darn it, it's out there already.

One time a magazine was going to use the picture with the baby and the guns from the gang series, and the caption information was misleading and unclear, and if I hadn't caught it, oh my God, it would have been a disaster. Their caption was something like, "He did this carjacking and that's the reason for the guns," and that wasn't the truth. The correct caption of the picture is, "Last night they tried to shoot my father." That's the reason why all those guns were there. Mistakes happen. They miss one, and it goes out, and it's just gone. You lose control.

You have to digest your own work. Because once it goes out into the world, there are always going to be people that complain or criticize what you've done or what you haven't done. I went through a lot of guilt with the gang project, documenting things that were very violent. And even though this is their life and they know I'm there, it comes up, "Why are you doing this?"

There's a part of me that lets the editors get something from me if they want. If they want me to photograph it, okay, I'm going to try to

do it, simply because we have to make a living. So there's this sense of giving in.

If I can make pictures on a particular assignment for myself, then I'll try to use those pictures somewhere else. So I think it's very important to put a perspective on the work. For instance, when I go out to do a corporate assignment, I just try to close it off and do that corporate assignment and say, "Okay, for a week I'm going to do this." Then I just try to do my personal work later.

Photography has been a beautiful thing for me. I don't mind saying I had a drug problem and photography saved my life. That magical thing. It's being in the darkroom and really having that connection and watching the image come up and saying, "Wow, this is mine. It may not be the greatest thing in the world but it's mine." And it's the richest thing. I'm not monetarily rich, but I feel very rich in another way.

After a couple years in the business, you start to put things in perspective. You learn a little bit. You know the agencies are going to eat you up. When I talk about photography it's a very passionate and a very holy experience. It's hard to deal with editors. They don't understand what it means, that it's part of our life. This is not a job. Seven days a week, 365 days a year, I'm working and thinking about photography. It drives our families crazy.

Dayanita Singh

A Truer India

Born in 1961, in New Delhi, Dayanita Singh was the oldest of four sisters. Her father gave up a corporate job to turn their saline land into a successful wheat farm and her mother painted and photographed in her spare time. "Although not religious," her parents consider themselves Sikhs. Her father died when she was eighteen.

Singh studied at the National Institute of Design in Ahmedabad, where she created a book on the tabla player Zakir Hussain, who also became a mentor. The book was published in 1986. The following year she moved to New York, where she studied with photographer Mary Ellen Mark and attended classes at the International Center for Photography.

After returning to India, Singh worked as a photojournalist for *Time*, *Newsweek*, the *New York Times*, and other international publications on stories ranging from AIDS in Bombay to behind the scenes at the Ms. India beauty pageant. More recently, Singh shifted her focus away from the poor of India to create *Family Photos*, a series of "academically composed" portraits of upper middle class Indians. Her current project is entitled *The Women of Calcutta*.

Singh credits photography for her ability to stay single and travel widely in India's class-conscious society. "I cannot think of any other profession that would allow me such diverse experiences," she said.

What drew me to photography were my childhood memories. They come from the photographs my mother took of us as chil-

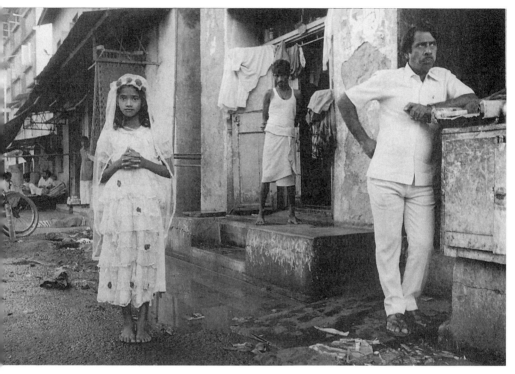

Marie, daughter of a sex worker,
days before she too is put on the job,
Kamathipura, Bombay
(© Dayanita Singh)

dren. As the first born I was the most photographed, often to validate an important moment. Once I was placed on a chaise lounge in the Oberoi Hotel in Kashmir, so my mother could show her family that she had lived in a five-star hotel.

While at design school, we had an assignment to photograph the moods of a person. I went off to photograph the tabla player Zakir Hussain. It was then that I realized what an amazing tool a camera is. Suddenly the world was mine. I could enter any situation as a photographer.

Through Zakir I entered the world of the classical musician and bunked classes every winter to travel with him and photograph. My final project in design school became a book on Zakir. He became a "guru" not just in photography but in a life philosophy.

Since the beginning of my photography I could not separate my life from my photography. This continues to create problems in work, but I will not have it any other way. If I got a strong photograph but nothing happened, then it was a waste for me. But if I had some great interaction with you and the film went bad, that's ok, it's just my connecting point.

One of my early assignments was from the *Philadelphia Inquirer* to do an AIDS story in Bombay. I went to do the story and was horrified by what I saw and heard. I couldn't convince anyone in India to let me work further on it. That's when I contacted Jocelyn Benzakin at JB Pictures and said, "Either they are crazy or I am crazy." She was fantastic. She supported all my expenses for about two years.

My work was not published in India, which still makes me angry. This was 1988 and 1989, and they said this is a Western phenomenon that you brought back with you from America. They didn't want to look at my pictures. It's still like that. India is still waiting for its Rock Hudson before actively doing something about the problem.

I was so naive with my AIDS work and so idealistic. The photo of Marie about to be made a sex worker created a lot of sympathy for her in America. People across the world wanted to adopt her. But no one wanted to help the thousands of other such girls in Bombay.

The AIDS work was a five-day assignment that stretched into two years. Then it was too many assignments in the same vein. I was working for an American audience. I was constantly catering to the "exotic disaster" in India, because those were the stories that people wanted.

One day I said enough. I just want to explore my own world. And

everybody said to me, "You're crazy, you'll just ruin what you've built up in all these years." And I said no, I don't really understand what it is to be a prostitute, but I do understand what it is to be born in this transitional period in India, to be part of this upper middle class where you are neither middle class nor upper class. You are trying to be both.

I started photographing Indian families in this situation and showed it to a couple of photo editors in America. One editor in particular said, "This is not India. This is Indians in London or Indians in New York."

I said, "You are accusing me of being dishonest. You have such a huge magazine, it's worldwide, you should know better. How do you think I bathe?" She told me it would never get printed. I realized that in my small way I was presenting an India that didn't go down very well. I decided to make it a personal project.

The biggest influence in Indian photography—ninety percent of Indian photography—is very bad copies of [Henri] Cartier-Bresson. He is the absolute God of photojournalism and documentary photography here.

We don't have this concept of independent photography in India. There are no funds or grants for photography. Ninety-nine percent of the photographers work for magazines or newspapers where the work doesn't belong to them. It's just a job. The only people who can afford to work independently are the ones who are working for the international market, maybe eight to ten photographers working at the most. Then there is this problem that you cater to what the editor in New York says they want to see from India.

I find it harsher in the American media than in the European media. The British are going to have a different view of India, of course. They always want the colonial touch, they always want the Raja stories or the last tea planter in Darjeeling and stories like that.

The Americans like either the exotic or the disaster. But I think it's because we have been catering to that and presenting that again and again. Already there's a small shift from when I met the photo editors at the beginning of my project to now. People are able to look at my work and say, "Great, we must put out this different aspect of India."

I get furious when foreign photographers reduce India to blobs of color and exotica. But photographers who work longer and are more specific in what they are seeking have amazing bodies of work. I admire them for being able to enter this alien culture, which often baffles

me as well, not knowing the language or the nuances and coming away with such in-depth work. It's the fly-by-night photographers who succumb to that superficial vision of India all in color and chaos. I do not mean this for foreign photographers alone; we in India do this ourselves.

If I keep doing street children in India, then of course documentary photography is dead. If I kept doing stories on child laborers or a story on child sacrifice, which I saw in the *Sunday Times* magazine two or three days ago, then sure photojournalism would be the pits. How much of dowry debts can you see, photographed in the same style?

With the families project, I have given myself another lease on my photography. I want to work with the teenagers because they're changing overnight, with MTV and the current economic liberalization in India. It's going to lead to other things. I am going to feel like I wish that there were five or ten of me.

With the changing nature of publishing it would seem documentary is dying. But the more I work, the more possibilities I find to sustain that work. It's such a great time in India. Even if for the next two years or five years the market is bad, it will work out.

I used to think, Oh my god if I was a photographer during independence, what a time, from British colonization to independence, but it's like that now. It's even a stronger time to be a photographer.

Fazal Sheikh

Portrait of a Refugee

Fazal Sheikh, born in 1965 in New York City, has a Kenyan father and an American mother. He graduated from Princeton University, where he studied with photographer Emmet Gowin in visual arts, and has received several grants, including a National Endowment for the Arts fellowship, the Leica Medal of Excellence, and a Fulbright scholarship.

In 1992 Sheikh's concern over the refugee problem in Africa led him to the northwestern border of Kenya, where thousands of Sudanese refugees had gathered. Sheikh stayed for several weeks photographing the refugees, using a large-format camera, a tool most often associated with portraiture and landscape photography. His aim was to provide a more in-depth study of the camp refugees than ordinary photojournalism could afford. His photographs were collected and published in the book *A Sense of Common Ground* and exhibited in New York, Houston, Chicago, Rotterdam, and Geneva in 1996.

More recently, Sheikh has photographed Afghans in exile in Pakistan, including women abused and tortured by different rulers, elders, and warriors who brought their families across the border for safety. A book and exhibition of this work, *Fazal Sheikh: The Victor Weeps*, was completed in 1998.

In 1992 I was given a Fulbright fellowship to document the Swahili communities of the Kenyan coast. I traveled to Kenya and began preparations for the trip to the coast. However, in the year since my last visit, nearly five hundred thousand refugees from Sudan, Ethiopia, and

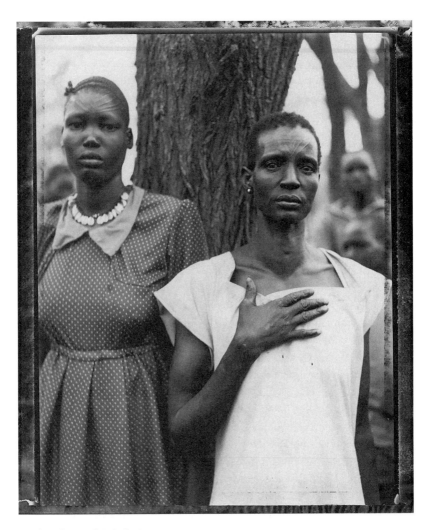

Ajoh Achot and Achol Manyen,
Sudanese refugee camp, Kakuma, Kenya, 1993
(© Fazal Sheikh)

Somalia had flooded into northern Kenya in search of a safe haven from the civil wars in their home countries.

Before heading to the coast I decided to make one trip to the refugee community on the border with Sudan. I was given permission by the United Nations High Commission for Refugees to visit the Sudanese refugee camp at Kakuma, a small village in the northern desert. This camp provided sanctuary to more than twenty-five thousand Sudanese refugees. Of that number, twelve thousand were "Unaccompanied Minors"—children between the ages of eight and eighteen who were either orphaned or separated from their parents in the flight from their homes.

On the appointed morning I arrived at the airport for a preflight briefing by the United Nations spokesman. In the course of his description of what we would encounter, he told us about the "Unaccompanied Minors" who had been abducted by the Sudanese People's Liberation Army, forcibly conscripted, and sent to military training in southern Ethiopia. Many had walked more than one thousand kilometers through the desert in search of sanctuary in Kenya.

Later, as the plane moved away from Nairobi over the desert, the words of the spokesman resounded in my ears. I remember feeling reticent about my place among the journalists. In an hour we were circling over the camp in our descent toward the border.

On landing the others with whom I traveled immediately began their work. They seemed to know exactly what they wanted. I experienced a kind of paralysis and had no idea how to begin working in the midst of such turmoil. The spokesman's description of how I should meet this place and the throng of people in the camp seemed to banish thought. Now, as I look back upon that time of unknowing, I see what a turning point it was for me.

I decided to stay on in the village, giving myself time to sift though the initial impressions. During the first few days, I wandered throughout the camp without photographing. Eventually, I approached Deng Dau, the elder of the community. He greeted me generously, and we sat together in his home. During the course of our conversation, I asked his permission to begin working in his village. He turned to me and said, "Why do you ask me? I am only a refugee."

The meaning of the words was clear—"If I am a refugee, you may do as you like, and it is not my place to give, or withhold, consent."

But the tone of his voice held another, latent meaning. Its tenor laid bare the irony of those words. It had been a trespass for people to storm through the camp without consulting those whom they were photographing. In the following moments, he agreed to the collaboration, and we began a work of documentation, which continued for two years.

With this approach, I discovered a way of working that I have retained on other projects. Now, I recognize the initial sense of unknowing when first visiting a community and embrace it as part of the process. I see it as a sign of receptivity to what the place and the people have to offer. I begin by asking the members of the community for their willingness to collaborate in the documentation. In my recent work among the Afghan villages of exile, the elder's agreement to work with me, to provide insight, as well as protection, has been crucial.

Many of the images that I make are formal portraits. I use a simple Polaroid camera that yields both a positive and a negative. The slow process dictates the pace of the work. The act of photographing becomes an event in the village. We construct the image together. Many of the people have never been photographed before, and the Polaroid provides a point of reference for the discussions that follow in which the residents of the community offer their opinions on how the documentation may unfold.

For so long I have thought about "African" and "refugee"—such loaded terms. The media seems preoccupied with encapsulating communities and paring them down to myopic tag lines. There is a horrifying element to the refugee stories from Somalia and Rwanda, but the lives of those people are more complex than the way that they have been represented. Being an African or a refugee is only one facet of who they are as human beings. I would like to balance out the equation, to broaden and challenge our preconceptions as structured by the media.

When I began working on the Somali border, I had a conversation one evening with a Kenyan doctor who was working in the camp's hospital. He told me about Somali parents smothering their malnourished children. These occurrences he described as evidence of the "essentially callous and aggressive nature of Somalis."

Later that night, as I lay alone in my tent thinking about the doctor's story, I decided to spend some time in one of the camp's feeding centers. I was interested in testing the doctor's explanation of the reasons

for such incidents. During the weeks spent in the feeding center, mothers or siblings brought the malnourished children—fifty in all—to the center twice daily to receive their treatment. They would sit for photographs, the gesture and gaze revealing the familial bond.

In my last days there a nurse told me of a mother and child who had recently arrived from the desert. The woman was registered in the camp and—as the child was severely malnourished—they were immediately brought to the feeding center.

When the woman saw how the treatment was reviving the children, she broke down. She related the story of how, during the flight through the desert from Somalia into Kenya, she had smothered the first of her two children. Now, in the feeding center she was forced to confront the possibility that what she had thought to be an act of sacrifice in sparing the infant's suffering, might, in some sense, have been a killing.

The body of images, names, and stories from that time, later exhibited in a large grid and a mainstay of *A Sense of Common Ground,* provide a visual response to the doctor's declaration. There is the question, in this case the doctor's assertion, and then there is the documentation that explores the issue. In this way the working process becomes fluid and revelatory.

As I worked in Africa and Afghanistan, I realized that many of the connections and decisions about where to work are based upon intuition. After working in the tribal area of northern Pakistan for several months, I realized that my time there was not only about documenting the situation of the Afghan refugees and the history of the war, but also searching for the legacy of my grandfather and his relationship to Islam. Although it is inevitable that the photographs are also a product of who I am, I hope that my perceptions defer to or mingle with those of the people that I photograph, allowing the personal chord to resonate with the documentary.

The people in the photographs often look directly into the camera and, by extension, to the viewer. There are no visual gymnastics, and the image is pared down to what I believe to be its essential nature. The sitters present themselves. My role is not to confer upon, but rather to encourage that which is already inherently part of the person to come forward. The strength of a sitter's gaze and an entire life lived in their bodies speaks for itself.

I am unable to predict what will be a strong photograph. The most compelling images have come from remaining receptive to what the place has to offer. A photograph with its roots in my imagination pales in comparison to that which is given in the moment of collaboration. In the time following my engagement with the people, the experience lingering in my mind overwhelms my perceptions of the photographs. It takes quite a while before I am able to recognize the strength of any given image. Time and distance provide a frame and a context.

I traveled with a Somali woman who was working for the United Nations High Commission for Refugees. She was recording the testimonials of women who had been assaulted and raped in the border region. The Kenyan government denied the allegations of such happenings for fear of a negative impact on tourism.

I have always been troubled by the notion that a person becomes the subject of a photograph simply because they have been raped. It is not the sum total of who they are. For their part, the women understood that the images and their stories would be shown in public, and they still insisted upon speaking out. However, I felt protective of the trust that they had placed in us, and I struggled with the responsibility of bringing those testimonials to light.

For nearly three years after photographing those women and recording their stories, I refrained from using them. When piecing together *A Sense of Common Ground,* the book from those years, I skirted the issue of their inclusion. I now realize that by omitting them I had perhaps failed in my charge. The women who we met had gone through such trauma that they ultimately wore it as a badge of honor, a declaration that they had persevered in a society that ostracizes and shuns the victims of sexual abuse. Now, when showing that body of work, I include the images and the testimonials in their own voices, unfiltered.

At a pivotal point in my development as a documentary photographer, I read *Let Us Now Praise Famous Men.* I found the marriage of text and image in which both ways of working, both mediums, retained their dignity. They function in separate realms, yet they inform one another. Neither element serves as illustration or embellishment.

In my recent work, that is what keeps me busy. In confronting the complexity of Afghan society, the people's relationship to Islam, and the depths of both hospitality and loss within that culture, I have be-

come aware of the need for text to elaborate upon the message of the photographs.

I hope that my work reaches toward a greater good. However, I am not willing to achieve that goal at the expense of the individual. I believe that it is the individual and his testimony that allows us to access broader themes—through the specific to gain entry to the universal. I want to be able to go to a community and ask that it teach me about its truth. I try to encourage the medium to pierce the alienation in a return to the basics of humanity.

Editors and Curators

Gifford Hampshire

The Environmental Protection Agency's Project DOCUMERICA

Gifford Hampshire received a Purple Heart for wounds sustained in aerial combat in the Pacific during World War II. He was educated at the University of Missouri and enrolled in their photojournalism program. Inspired by the Depression-era documentary project at the Farm Security Administration, Hampshire convinced the Environmental Protection Agency to organize a national documentary project on the environment in 1970 called Project DOCUMERICA, for which he received a Special Citation from the National Press Photographers Association. Retired now in Virginia, Hampshire said, "I am an eighth-generation American, and that is the greatest honor of all."

My father was a schoolteacher and an amateur photographer, and he set up a darkroom in the bathroom. As a boy, I used to go in there and watch him. He put that paper in the tray, and the next thing you knew, there was a picture.

The Depression was on. I was living right in the middle of the Dust Bowl out there in Kansas, and I was witnessing many of the things that the FSA [Farm Security Administration] photographers were photographing.

When I was drafted in 1943, I showed up in Leavenworth, Kansas, and they said, "What would you like to do?" I said, "What about photography?" I thought that maybe I could get into the Signal Corps.

Instead of the Signal Corps, they drafted me into the Army Air

Industrial pollution
(Marc St. Gil/Project
DOCUMERICA/EPA)

Corps, and I wound up as a radio operator and gunner on a B-24 crew. The only photography I did there was to try and get the Fairchild camera going on our bomber missions. My interest in photography lay dormant until I went to the University of Missouri School of Journalism after the war, and got involved in Cliff Edom's classes. They had just started a major in photojournalism at the University of Missouri, and I was one of the first products of that. I was interested in writing and reporting as well as photography, and I always thought about my work as a photojournalist—that was Cliff Edom's term.

Photojournalism, in my mind, was words and pictures. So much of what I'm going to talk about in documentary has to do with that concept. Photojournalism came out of the idea of documentary photography, because documentary photography has always been, in my opinion, an art—because it's the product of an individual's creative effort, rather than an institutional creative effort, rather than a team effort. That's the essence of documentary photography.

At the University of Missouri, Cliff Edom started the photo workshops in 1947; I assisted him. He brought out some of the FSA photographers like Esther Bubbley and Russell Lee. They were on the campus there for a day or so, and we met in the evenings and had bull sessions. I thought then, and ever since, that the FSA was a benchmark in photographic history.

Early on, I had realized that the subject matter of a documentary photographer has nothing to do with sensationalism, nothing to do with the unusual—it has everything to do with the very commonplace events of lives. All the good documentary work you can think of is perceptive photographs of people doing what they normally do.

When I graduated from university, I went to New York, and was practicing public relations work with the Fairchild Corporation. They had a change of management, and *National Geographic* was looking for picture editors. I came down to Washington and I went to work for *Geographic* in 1954.

Geographic was a very successful magazine then, and it is now. They had worked out a formula, and part of the formula was that they looked at noncontroversial subjects. The photographic clichés they were working with—people in red shirts and red dresses in the foreground and all the rest of it—were all very artfully staged, and very

undocumentary. But they were open to change at that point, and that's one of the reasons they hired me.

They had a picture editor who was of the old school, Walter Edwards. When they brought in a bunch of pictures that were produced for a particular story, he would throw them on the light table and pick out the prettiest ones he could, without any regard for the story or the truth. If you look back on those old issues, you'll see that quite often the pictures have nothing to do with the story, and vice versa.

I tried to start thinking about the story, about the subject, and select pictures based upon their journalistic value as well as their artistic value—and therein lay the conflict. I and some of the other guys from Missouri, Bill Garrett and Tom Smith, who were there by that time started doing the layouts the way we thought they should be done—by the story.

In one of my first stories, Frank and Jean Shore, a husband and wife team, were in Morocco, and I was assigned to be their editor. I reviewed their pictures and sent them back comments—that was our routine— about what I thought they had and what they might photograph. I got a letter back from Frank Shore saying, "Who the hell is Giff Hampshire, and what does he think he's doing?"

I got straightened out right away. I wasn't supposed to think too much about the story. I shouldn't go to the library and study about Morocco, and I shouldn't read the papers about the problems they were having with the colonial revolution.

I had to back away. When the assignment was finished, we'd begin working on a selection and a layout. I would present that layout in a projection session with the editor, Melville Grosvenor. He would take a personal interest at that point and make changes and suggestions, and those would be done. It got to the point where I went into Melville's office one day with a layout, and he said, "Oh Giff, it's you." And I said, "It is I." Here we go. We knew that we were in for it. I would try to sell my layout and my story. I'd try to present it to him based upon what I thought was a well thought out and logical way, and often that didn't go over very well. He wanted more formula, the tried and true pretty pictures.

I got a reputation. Frank Shore was an assistant editor by that time. He called me in one day and said, "You've probably got a lifetime job here if you'll just shut up, and not think so much."

I'd been talking with Ruth Adams at the United States Information Agency [USIA], and she had started a new, slick magazine for the Arabic-speaking world called *Al Hayat*. She asked me if I'd be interested in joining her agency. It was a mistake, in retrospect.

When I was talking with her in 1959, I was just as naive as I could be about government and politics. All the people I talked to at USIA were Eisenhower appointees. When I went to work there, they were all Kennedy people. I had to do something else. At that point, I'd become a father of twins.

A year earlier, my attention had been caught by an event. The Food and Drug Administration [FDA] prohibited the sale of cranberries that year—a big event around Thanksgiving time—because they had been contaminated with an herbicide. This was the first time I could remember that the federal government had done anything as important as that to protect the food supply of America.

Since World War II, our nation had, all of a sudden, been caught up in things like pesticides and chemicals and plastics. It used to be wood and leather and water and earth, and now it's all plastics and chemicals. There's a lot of harm done there. I was looking for something to do with my life, and I thought, "Perhaps that's the place to try."

I went to the FDA and got a job working in the Public Information office. Over the next ten years there, I worked for four different commissioners. Then the Senate hearings for Bill Ruckelshaus' appointment as administrator of the EPA [Environmental Protection Agency] came along in 1970, and I went. Bill Ruckelshaus sounded like a guy who was really going to get something done.

I applied and was transferred to his staff in 1970. His immediate aides were a bunch of young, interesting, intelligent, go-get-em people from Indiana and elsewhere. We had these bull sessions, and I threw out the idea of a documentary project. It caught on immediately. They could see right off the bat the parallel between the FSA and the EPA.

I became deputy to the director of the office, responsible for day-to-day operations. Meanwhile we were gestating this idea about "DOCUMERICA." When it came time, I said to Bill Ruckelshaus, "There's only one way to do this. If you like the idea, and you think I'm capable of carrying it out, what needs to be done is say it's Giff Hampshire's thing, and I want him to have the support he needs." That's the reason it happened at all.

We even got presidential approval. I had everything going for me when we started, except I didn't have any help. It was just me and my secretary. I wrote the press release announcing Project DOCUMERICA.

I had it pretty well worked out in my head, and it didn't require much of a staff, because we were going to hire the photographers to do the work. All I needed was a setup to handle the film when it came in, and get it processed, and get it into a file.

I said, "There's gotta be a way to manage this file with the new technology." One of the first things I did was get a contract with a firm in Alexandria [Virginia]. I said, "I want to develop a file, where we can look at the pictures by asking for certain kinds of information. For example, every picture has to be identified in terms of its geographic location, date, and its photographer. In addition, we've got to have certain descriptors of the picture: water, vegetation, traffic, solid waste, etc." We actually created the first computerized photo file.

As each picture was selected for the file, one of the contractor's people would write the caption, basic information, and key in these descriptor words. We hooked this all up through the computer to microfiche.

We started the assignments in the spring of 1972, in the South. The idea was that each photographer would be given an assignment of a particular period of time. They were paid $150 a day, plus expenses. They were to be given, let's say, twenty days at that rate. I don't think there were many over thirty days. The idea was that the photographer was to select a subject relevant to EPA interests.

There were about 120 photographers. I gave each photographer an assignment number, and it was sequential. We started with 01 and finally got about 164 assignments. This was a kind of a project that somebody worked for twenty days or so, and then went back to activities that supported his or her living. *Life* magazine had folded, and *Look* had folded, and there were a lot of good photographers looking for work, which was fortuitous, in a way. Also, in a way, it was not, because some of these photographers thought that maybe this was a thing they could live off of. I discouraged them from thinking that.

The first meeting was held in Atlanta, and the photographers who were selected to participate were invited to come to that meeting, and they heard the people at the Atlanta office of the EPA talk about the air pollution problems, the water pollution problems, and so forth.

On the second day, at night, [former FSA phographer] Arthur Rothstein and I met with them individually. He was helping me select photographers. We'd invite them to come into my room, individually, and the basic question was, "Well, what did you hear that set you off, as a subject?"

Some of them would come up with stuff that was almost directly related to what they heard, and others came up with things that were tangential. Often air pollution and water pollution were not very interesting to the photographers, but the conditions under which people lived in those environments was of interest. It was of more interest to me, too. I said to them, "Look, I can only sell this program at EPA if it's based upon the EPA programs, but that doesn't mean that we're not connected to everything else."

During the FSA, Roy Stryker, head of the Historical Section, was more direct. He would say, "Let's do a story on cotton," and he'd call photographer Carl Mydans in and say, "What do you know about cotton?"

"Nothing. I know nothing."

"Well, before you leave, you must know a lot more about cotton." And Stryker would get specific about shooting scripts. We didn't get into that. My philosophy was we're dealing with intelligent people here, people who are concerned about things. They have the resources, the intellectual resources, to develop it. All I wanted to know was whether they were interested enough in a subject. If they were, I would make a few notes in a little black book that I kept, and that was it.

They were on their own at that point. We had a contract with Eastman Kodak, and they could go to the local Kodak outlet and, using their social security number, get all the film they needed. A lot of the photographers, I found out later on, felt they were too much on their own. They didn't have any feedback, they said. They didn't have any encouragement. They'd call me up on the phone and I'd talk to them, but I wasn't about to get into telling them how to do their assignment, what to shoot. As a consequence, we had a lot of stuff, all over the yard—some very good, some not so good.

I insisted that before the photographer was paid, he or she turn in the documentation—the caption information as well as the images. We would make a selection. We would send it back to the photographer and say, "Do you agree with this, as a selection to go into the file?" We

were pretty liberal about it. Whenever the photographer asked for something else to be included, we did.

What we selected for the file was the first and seconds, and the rest of it went back to the photographer. This was government property, but the photographer had full control over those rejects, so to speak.

I told the EPA people right off, this was not to be a propaganda effort. One of the problems they had in the FSA project was that Roy Stryker and others were really propagandizing the FSA programs. "The legitimacy of DOCUMERICA and the value of the images will be from our determination to be truthful, our effort to be objective as best we can," I said.

Today, if someone wants to understand the environment in the early 1970s, they can find the answer partially in that file—to the extent that we did our job properly. That makes it a baseline of what was happening in America environmentally when the agency started.

That's the value of documentary. It has no commercial value at the time, has no real journalistic value at the time, but if you could persevere in doing it, then one of these days, if it's preserved and kept in a public file in the public domain, then maybe it does. If it's in some photographer's file, tied up in his estate, it probably doesn't have any value.

The project started, as I said, in '72, and during '72 and '73 we did most of the photography. In 1974 there was an economic recession, and the EPA had to take its hit along with some other federal agencies. DOCUMERICA really had to take a hit. More important, Bill Ruckelshaus had been pulled out of the EPA to temporarily head the FBI as assistant attorney general, and the whole Watergate scandal happened. He was part of the October Massacre.

Gradually, the guys that resented my doing it in the first place came out of the woodwork, as it always happens in government, and they found their opportunities to snipe at me. One of them wound up being my boss. In the final analysis, he had the budget. So we had to cut out the computer program. I cut out various things, but one thing I didn't want to cut out was the photography. There are about another 6,000 images that were selected for the file but never got into the file, because I couldn't afford to have the microfiche made or the rest of it. They're sitting with the other 16,000 that are in the file.

Those are the edited images. Those are at the National Archives [and Records Administration] right now. While the Archives has digitalized

the images and they are available on the Internet, they have not made it easy. [Search for DOCUMERICA in the NAIL database at www.nara.gov.]

When I left the EPA in 1980, the project had pretty much stopped. As far as photographers were concerned, it ended in 1976. Up until the day I left, anyone who wanted an image could get it.

As soon as I was out the door, the National Archives people who had wanted to add DOCUMERICA to their still picture collection came to the EPA and asked for it, as the law entitled them to take any inactive government file. EPA agreed that it was not an active file, and it went to the Archives.

I am fairly well satisfied that the federal government, unless something changes drastically, will never be able to sponsor a documentary project again. The only reason it happened is because I basically wanted it to happen. I paid the price, physically and mentally, but it was worth it. It was a lot of fun at the time.

The greatest compliment I ever heard about a project I did was when I once took a publication that I put together to the government printing office and they screwed up the transparencies. They had taken them out of the slide covers and scratched them. So I had this big meeting with them, to tell them what the problem was. And this guy, sitting in this great big office, with paraphernalia around him, looks at these pictures and says, "Well, I could've taken these damn pictures."

And I said, "Thank you, sir. That's the best thing you could have told us because that means we have accomplished our objective." I remember he was looking at this picture of this kid fishing on a creek. Looked like a snapshot to him.

That's the subject matter of documentary photography, and those images have meaning only because of their relationship to the time, the place, and the circumstances at a later date.

I think that documentary happens because a photographer wants it to happen. A photographer decides something should be documented, and he or she puts in the intellectual, as well as artistic, effort. The payoff has to be in terms of that photographer's satisfaction with the work itself, because there's no economic reward, there's no fame and fortune in it.

Peter Howe

Life Magazine and *Outtakes*

Peter Howe worked as a photojournalist for fourteen years before be-coming a leading picture editor. Howe covered breaking news stories for the French press agency SIPA, wrote features and photography reviews for London publications, and created the book *Peter Howe's Picture Book of the Salvation Army* (1975).

He joined the *New York Times Magazine* in 1984 and *Life* in 1987 as di-rector of photography. Howe helped to revitalize *Life* by shifting its focus from celebrities and lifestyles to harder-edge journalism. He helped fund and publish works like Eugene Richards's *Cocaine True, Cocaine Blue*, which fo-cuses on the problems caused by drug addiction in the United States. During this period, *Life* was a finalist in the National Magazine Awards three times and received two first-place awards from the New York Newspaper Guild's Front Page Awards.

In 1992 he founded the magazine *Outtakes* for underpublished documen-tary work. During the same period, Howe was appointed the director of photography for *A Day in the Life*, one of the more successful photo-book series ever published. The National Press Photographers Association and the University of Missouri School of Journalism honored him for Best Magazine Picture Editing in 1993. *Outtakes* ended in 1995, and Howe has since become vice president for photography and creative services at Corbis, a large digi-tally based photo archive.

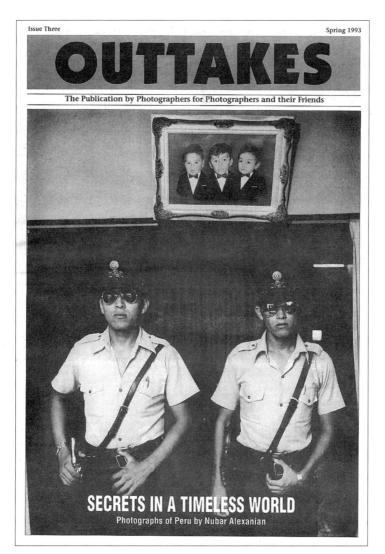

Issue Three

Spring 1993

OUTTAKES

The Publication by Photographers for Photographers and their Friends

SECRETS IN A TIMELESS WORLD
Photographs of Peru by Nubar Alexanian

Outtakes magazine, issue three,
spring 1993
(cover photo © Nubar Alexanian)

We have gone far away from using photography as journalism and much more toward using photography as illustration. Documentary photography is not being published as much as we think it should. This does not devalue documentary photography. It's still as valuable as it ever was for the right reasons. The right reasons probably don't earn a lot of money, but it doesn't make them the wrong reasons.

The job of the photojournalist is to witness those things that people don't want to think about. When they're doing their job right, they are taking photographs that people don't want to publish by their very nature.

When photography was invented, painting didn't die, but it changed its character and its social position. When television was invented, photography didn't die, but it changed its position and its character. I think that we're still struggling through and redefining the role of what this kind of photography is in the world. If our society ever rediscovers what really is important—socially, intellectually, emotionally—then they'll rediscover how important documentary photography is. One of the things we found with *Outtakes* is the extraordinary high quality of work that came over the transom almost every week. A lot of this work is from people I've never, ever heard of, and I have no idea who they are or how they make a living.

When you come down to it, the problem is that photography is no longer, and hasn't been for some time, a primary news source. The demand for photojournalism, strict documentary photography in the way that it had been used in *Life, Look,* all the British magazines, *Picture Post,* and other places like that, the commercial need for it has literally shriveled up.

We have to look at a new environment, an environment that is not magazine dependent, not even newspaper dependent. We have to look for other areas and other venues to be able to both fund and place photojournalism.

To me, "documentary photographer" and "photojournalist" are almost interchangeable words. I think a documentary photographer has to be a journalist, but a committed one. If you look at it in terms of text, you can get a reporter and you can get a writer. A reporter is someone who goes out and reports. A writer is somebody who gives his or her own personal style, his or her own personal viewpoint and

twist and spin to that story. A documentary photographer is a writer rather than a reporter. Great documentary photographers come to their craft with their own preconceptions, their own interests and ideas. They are not neutral observers.

I don't employ Gene Richards to give me photographs like Sebastião Salgado. I don't expect that Gilles Peress is going to give me Mary Ellen Mark. You employ each of those photographers for their vision. I'm not denigrating reporting—it is a complex and difficult skill—but the reality is that most of the time I'm not using photo reporters. And, to me, that is what a documentary photographer is.

A picture editor's only ever as good as the editor of the magazine allows that picture editor to be. You are not the ultimate voice in the magazine. One of the things that always amazed me, and particularly with *Life,* was that it was a picture magazine that was always edited by a text editor. A picture editor is often very low down on the food chain. If you look at the masthead of most magazines, you will see that.

When I was fired from *Life,* I felt I was a victim of some sort of corporate drive-by shooting. For picture editors there's no such thing as job security. You just have to do what you want to do as best as you can and try and push for it as best you can.

One of the things that I think distinguishes photo editors is their ability to articulate to text editors why a particular photograph or photographic project is important. It's a skill that all photo editors need and not a huge number of them have. You can't just say, "It's a really great picture." You've got to actually be able to give substantial editorial and journalistic reasons as to why that particular picture or that series of pictures is important for the magazine.

It's very hard to explain to an editor of a magazine that has to be commercially successful why it is we should depress the shit out of the readers. And, of course, we shouldn't. But this makes it hard to get the really tough stories in, particularly in this country. The perception is that the average American reader does not want to read about the more thorny, gritty side of life. And that is sort of the bread and butter of the documentary photographer.

For instance, there's the wonderful set of pictures that Lauren Greenfield did about growing up in Los Angeles on the other end of the social spectrum. It's mostly incredibly overindulged, overprivileged chil-

dren in Los Angeles and the values they're brought up with. It's just as serious as doing a hospice for AIDS patients but it's different—and an easier thing to get into a magazine.

I look at *Life* magazine nowadays and you hear people complaining, "They're doing cats and dogs on the cover" or "They're doing the parties of the year on the cover." That's no different than the way *Life* magazine always was. *Life* was the magazine that brought you such groundbreaking photojournalism as "How to Undress in Front of Your Husband," when it was at its most commercially successful and its most powerful. If you go back through all the covers of old *Life* magazines, you'll find eighty percent of them were film stars. You didn't have the country doctor [Eugene Smith's pioneering photo-essay] on the cover.

When [editor and publisher] Clay Felker was at *Life,* he said that the editor would put up the fifty-two covers at the end of the year in order of their sales. The top left-hand corner of the wall would be the highest selling cover. The top left-hand corner was always pretty girls, and the bottom right-hand corner was always sports personalities. He said that it never ever varied.

Publishing magazines is a commercial venture. The difference is that in the forties and fifties *Life* magazine was a primary source of visual news. That's absolutely changed, and the magazine has changed with it.

I am optimistic that despite everything that's against the documentary photographer, there's still an enormous amount of documentary photography being done of very high quality. People are getting it done by whatever means they can.

I don't know what the avenues are going to be. I am very excited about the possibilities of the Internet, but I am worried it may be another area where still documentary photography is left out. The appeal of using photography in an electronic environment now is that still photography takes a lot less memory than moving images, but that's just a technical problem. Once that's solved, you'll be seeing much more video than still photography on your computer screen.

I look at Kathy Ryan's career. I employed her as a deputy picture editor at the *New York Times Magazine.* When I left the magazine, they made her the picture editor, which was one of the smartest things that they ever did. But it has worried me that she's veering much more toward what seems to me to be art photography rather than what I, in

my stubborn old-fashioned way, consider to be documentary photography. Although she does use a lot of documentary photography, there's a high proportion of what appears to be conceptual photography. I would expect to see that on the walls of a gallery rather than in the pages of a magazine. I was wondering, whether, in fact, that she's right, that photography as it stands at the moment is becoming much more of an art form than an information medium.

There are times when I feel like the last of a generation, the last of a profession even. I often wonder if I was nineteen or twenty whether I would go into documentary photography. One of the things that I have learned in the time that I've been in this business is that if there is a secret to being involved in photojournalism, then the only secret is persistence. The people who survive and prosper are those people who persist.

I very strongly believe that what documentary photographers do, and what journalists in general do, is of almost unparalleled importance to human society. The act of witness is very important. Without journalism, there's no democracy. Without journalism, there's no freedom.

Colin Jacobson

Independent Magazine and *Reportage*

Colin Jacobson studied politics, philosophy, and economics and, in 1971, entered journalism as a picture editor, a position he has occupied for several British publications, including the *Observer* and the *Economist*.

In 1988 Jacobson joined the original staff of the London *Independent*, where he succeeded in publishing many photo stories. A story about land mines in Cambodia spanned ten uninterrupted pages and helped raise over £90,000 (about $89,280) in aid for mine victims. In the early nineties, when the *Independent* followed many other magazines in scaling down on photojournalism, Jacobson left to found *Reportage*. That quarterly photo-journal was grounded in the same spirit as Peter Howe's *Outtakes*, maintaining a simple format and giving photographers more control over visual presentation.

Jacobson left full-time journalism to teach in 1995. He writes articles on contemporary photojournalism and more recently has become interested in the effect of digital technology on photojournalism.

Certainly in Great Britain, and I suspect in other parts of the Western world, the whole thrust of magazine publishing is cerebral. The people who edit magazines, the people who are in the driving seat of publishing and journalism, are word oriented. There is little acceptance that there can be another way of understanding the world, which is more visual, more aesthetic.

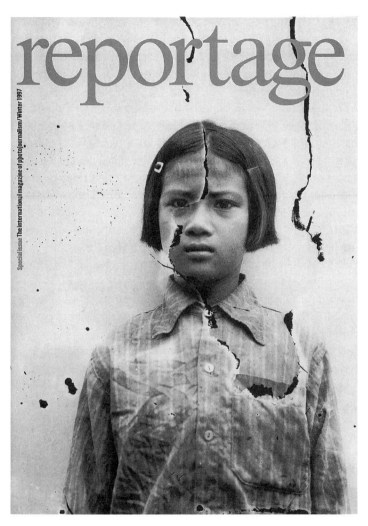

reportage

Special Issue The international magazine of photojournalism / Winter 1997

An anonymous young prisoner
photographed by the Khmer Rouge,
S-21 camp, Cambodia,
Reportage magazine, winter 1997

It's a very strange thing. With almost every magazine I've ever been on, when they get around to doing a readership survey they find that the thing that people most like and remember about the magazine is the images. But it never seems to make any difference to the way the magazine is put together.

With *Reportage,* I wanted to be in a position where I didn't have to justify the stories all the time. The basic, very simple philosophy of the magazine, which is behind all these discussions about "Photojournalism, is it dead or is it alive?" and "Why are magazines so bad?" came down to one thing in the end. Until you have magazines where the visual decision making is in the hands of people who have a visual orientation, they'll never get better.

A lot of the younger photojournalists in Europe are very intelligent, aware people. Certainly on the *Independent Magazine* some of the best stories we did—even stories which weren't particularly visual, which ended up as text stories with backup pictures—were ideas that came from photographers or picture editors. Photographers know what the stories are about and can push the frontiers of the story, more satisfactorily than the writer in many cases.

The *Independent Magazine* started from scratch in 1988, and I joined just before the launch. I was able to influence the way the magazine was going to look because, strangely enough, it was launched without any very clear idea of what it was going to be. The editor respected people who could fight their corner and justify what they were doing. I was able to use picture stories from the very beginning that I liked. If I said we should publish the story, generally speaking, at least in the first two or three years of the magazine's existence, the editor would accept it.

It was a slightly schizophrenic magazine in the way that the front and the back of the magazine were not very visual; they were quite text driven. But in the middle of the magazine, the heart of the magazine, there was always a picture story—usually eight pages, sometimes as many as ten pages of a self-contained picture essay. Advertising was placed in the front or the back of the magazine.

For two to three years we had that wonderful space for a wide-ranging photojournalism, without any sort of very specific agenda. The text was always limited and there to support the pictures. We took

trouble to find the right writer, or writers, who knew what they were talking about. That is rather unusual in contemporary magazines.

The two disciplines, words and pictures, need each other and should complement each other. I wish there were ways to break down those barriers. Photographers and picture editors have some responsibility for the situation, because they tend to be very overprotective or oversensitive and refuse to acknowledge that words or text can contribute to what they are doing. It should be absolutely clear to everybody that brilliant images are not enough. You need the text, you need great headlines, great captions, great introductions, good text to amplify and expand the sense of what the pictures are doing and give them context and meaning.

One of the great areas of conflict within the picture fraternity is between photographers and picture editors or art directors. There's this awful crisis when the harsh reality of editing for a magazine or newspaper comes into play. You can have twenty wonderful photographs from a story, but you only have room for eight or ten. Space in a magazine is like time in a film or video; both demand a heavy degree of editing. You get into an editorial way of thinking and working, which is to my mind vulturistic—you descend on a body of work. If it's a day's work or six month's work, you're still landing with your claws on these images. It's like losing blood for the photographer, and sometimes for the picture editor as well. But the truth is that editorially you have to do this. Magazines are not in the business of being repetitive or boring, or they shouldn't be. So then you have to pat the photographer on the back and say, "Never mind, old chap, there'll be an exhibition in the future where you can have all your pictures up."

The stories that I remember are strangely not about universal topics, not about the great sweeping aspects of life or society. I really like focused photojournalism, often about daily life and not about the huge, harrowing problems of the world.

Unfortunately, in many people's minds, photojournalism is seen to be about life on the edge of the precipice. So we get drowned in stories about war, homelessness, street kids, unemployment, AIDS, drugs—all of which are photogenic subjects. Of course, we can acknowledge their importance, journalistically and as human beings, but we don't have to keep on doing the same things all the time. I do think

that photojournalists are shooting themselves in the foot by constantly returning to these themes.

Photojournalism is being a journalist with a camera. Documentary is more culturally driven, designed for learning to understand one another, to document life at a particular time. It is not for the here and now but for posterity.

The whole Robert Capa era holds up because we as magazine people go back to it. We publish retrospectives on anniversaries and exhibitions. We are all aware that there is a great reservoir of amazing photography. People get forgotten and taken up again because of excellent work they have done in the past.

I'm not so sure about the future. I don't know whether work being done now will have the same resonance in twenty or thirty years time, because attitudes to photojournalism are changing so much within the digital revolution. Speed and simplicity of image delivery seems to preoccupy the press nowadays, and not much attention is paid to composition and story interpretation. I worry about the quality and range of photojournalism—tomorrow's history—now going into the archives.

Ann Wilkes Tucker

The Museum Context

Ann Wilkes Tucker is the Gus and Lyndall Wortham Curator of Photography at the Museum of Fine Arts, Houston. She decided to major in art history after seeing an inspirational exhibition of Vincent Van Gogh paintings during her freshman year at Randolph Macon Woman's College. She obtained a second undergraduate degree from Rochester Institute of Technology, where she studied as a photographer and, she said, "decided I wasn't one." When Nathan Lyons formed the Visual Studies Workshop in Rochester, Tucker joined him for her graduate training. "The idea was to take a broader look at pictures and communication," she said.

Her thesis on photographs of women was completed while she was an intern under John Szarkowski, the former director of photography at the Museum of Modern Art (MoMA) in New York. It was the height of feminism's "second wave." In 1971, working in her office at MoMA, she remembered women marching on Fifth Avenue, imploring others to join them and she did. Her thesis led to an exhibition from the MoMA collection, a special issue of *Camera*, and another project of photographs by women that was published as a book, *Woman's Eye*.

In the early seventies she taught and, for photography historian Beaumont Newhall, researched exhibitions of photography in New York between the closing of Alfred Stieglitz's famed 291 Gallery in 1917 and the opening of the MoMA in 1939. She became particularly interested in the Photo League and has continued to research and write about the League.

In 1976 Tucker was asked to join the staff at the Museum of Fine Arts,

Mastectomy (© Joan Myers)

Houston, which had just received a large grant to begin a photography col-
lection. She became the main force in shaping the museum's collection. She
has curated over twenty-four exhibitions, including retrospectives for Robert
Frank ("a very important influence on me"), Ray K. Metzker, George
Krause, Richard Misrach, and Brassaï. She has written and lectured exten-
sively on photography throughout the United States, Europe, Latin America,
and Asia. Currently, she is researching the career of photographer Louis
Faurer and preparing a history of Japanese photography from 1850 to the
present, which she described as "an extraordinary body of work that we just
don't know about."

We began the twentieth century by believing what we saw in a
photograph was true and ended the twentieth century by dis-
trusting every document.

There is an inherent problem in discussing the whole concept of the
document at the end of the twentieth century, when you can so seam-
lessly create in a computer any reality that you want, visual or other-
wise. In some ways it is liberating for photography because, as in a
written essay, our faith is based on the integrity of the maker. Photog-
raphers are liberated from trust being inherent in their medium. Our
acceptance or rejection of the information they present will have to do
with the reputation of the photographer, the declared intentions of the
maker, and what else we know about that subject. In some ways it's
probably the best thing that's happened in documentary, especially so-
cial documentary photography.

There is a friend of mine who, whenever I talk to him about docu-
mentary photography of any kind, tells me I am looking forward out
of a rearview mirror—that nothing new in terms of aesthetic form can
be added to the genre. This same person believes that a play with a
good plot and solid characters is no longer relevant.

A photographer who had done a really beautiful series on a particu-
lar family in North Carolina took his work up to a New York museum
and was told that his work was passé. This attitude adopts another par-
allel to writing, which is the hierarchy that fiction is more important
than nonfiction and essays are the bottom of the heap. It places too
much of the responsibility for whether or not something is art on its
formal properties. It emphasizes the hierarchy of form over subject that
was formed early in the twentieth century.

The prejudice against documentary work, especially work about controversial issues, also comes out of the practice in the museum world that one didn't buy an artist's work until that artist was dead. The National Gallery [of Art, Washington, D.C.] still has a rule that they can't show a living artist unless they own the work. In essence we apply the same standard to issues. We don't collect during the heat of the issue.

There's a wonderful quote by Therese Heyman, in one of her early Dorothea Lange catalogs of about ten years ago, in which she said that the photographs are art today because the issues that motivated Lange's photography are no longer within our power to correct. To respond to work coolly is supposed to be more scholarly than buying work at the moment of a crisis. For one thing, you don't alienate either side of your public by jumping into a controversial current issue.

As long as I see so much strong work being done in both documentary and social documentary, I find it a peculiar position to devalue, or worse, to ignore these genre. If you want to understand what were the current controversial issues of a particular decade, go back and look at the photography from that period. If we have no reflections on the heart of the social debate for any particular decade, I find that an arid interpretation of culture.

What museums collect can affect history. John Szarkowski once stated at a conference that he had played no role in the making of art, that he merely responded to what was out there. Well that's not quite true. When you're as articulate as John and you publish all these books, you are creating the veins of ideas and information about a specific group of people that are going to be mined by future historians and future artists.

What we collect can affect the pictures that are made. Future artists and historians will follow the shaft already created to mine a decade as opposed to digging a new one down through the mountain, if you will. They will more likely go to the most available sources and the monographs where the work has been gathered, rather than do the nitty-gritty digging out of information in magazine articles or track down the works of photographers that are not in repositories such as museums.

Once work has been done—for example, the civil rights work or even the Photo League work—the museum *should* become the repository for future generations. However, there are also practical realities that govern. For a museum to have collected the work of Photo League

photography after the blacklisting was inconceivable. It was inconceivable for the health of the institution. People can rally all they want about how that shouldn't and oughtn't to be, but that's just not the real world. Showing photography—showing any art—that might get your institution into the kind of trouble that the Corcoran [Gallery of Art, Washington, D.C.] and Cincinnati [Art Museum] got themselves into with [Robert] Mapplethorpe's images is not something that any museum professional should do lightly.

We were given a very large collection, a wonderful collection, an extraordinary collection of a thousand photographs a few years ago. There were pictures in it that I don't think I would ever have gotten the trustees to accept as gifts except as part of a collection. The collector had a category that he called "cock penis" with photographs by Peter Hujar and Robert Mapplethorpe and a couple of European photographers. It's an important series to have in a museum, but I could never have raised the money to buy it.

There are two pictures going in our collection that are about having mastectomies. Because a friend died of metastasized breast cancer, I will be the first to admit I am not in any way distanced and impartial from this subject. One is a picture Joan Myers made because a woman approached her. Before the woman had a mastectomy she couldn't find any pictures of other women who had it and this upset her. She wanted Joan to photograph her so that picture would be there for other women who had to make those decisions.

I was on a public panel, and I reported that I have to fund-raise for every picture I buy. I felt that I would never find a donor for Joan's picture as much as I would love to have it in the collection. A woman in the audience then bought the picture for the museum and donated it in memory of a friend of hers who had died of breast cancer. What I love about this picture being bought is the chain of people who shared a certain concern, a certain sensitivity to a phenomenon that has previously been silenced by shame.

Afterword

Witness in Our Time

KEN LIGHT

Social documentary photography offers the future a view of the past and a voice to the dispossessed. It bears witness in an age when publications turn toward entertainment and celebrity photography and when individual expression is often drowned out by huge media companies. It amazes me that an individual with a camera and a few rolls of film still has a powerful and enduring voice.

Many of us have a moment when we see a photograph that captures an age or an event and scrutinize it for clues about ourselves and our world. In the beginning I was attracted first as a viewer. My path toward documentary photography began as a slow curiosity. I was drawn to an image that is still vivid in my mind's eye; an image that was unlike anything I had ever seen.

I was distraught taking the bus home from seventh grade that November afternoon. It had been announced over the school loud speaker at my junior high school that President John F. Kennedy had been shot. I grew up under Eisenhower but have little childhood memory of him. JFK was something else. I remember the photographs of the young senator from Massachusetts. I collected campaign literature, and I remember, like a dream, a campaign motorcade one block from where I lived—the sirens, the black cars, the photographers with their cameras all clamoring for a picture as the candidate's car rolled by.

School was dismissed early that afternoon of November 22 so that we could go home to our families. The tragedy disoriented us all. Time

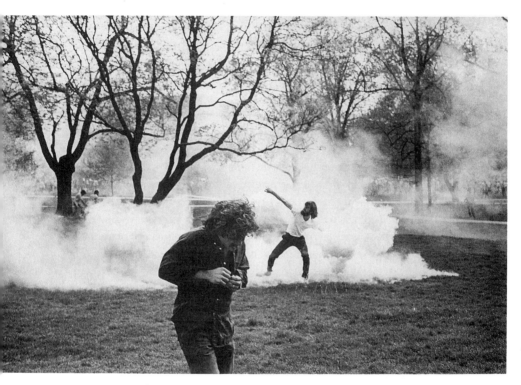

Throwing back tear gas,
Ohio State University, 1970
(© Ken Light)

stood still. Our lives had been filled with images and reaction to the cold war, like the Cuban missile crisis. Might the air-raid drills, where we would cover our heads and duck under our desks to survive the fire and atomic radiation, become a reality?

When I arrived home the black and white television was fixed on Walter Cronkite and frantic images of the Dallas hospital, reporters, and spectators in total chaos. Regular broadcasting all but ceased to exist for days.

Then it happened. They were moving Lee Harvey Oswald, the assassin, through the garage of the Dallas police headquarters and, out of nowhere, right in front of my eyes, bang, he was shot dead. Hysteria. For me and my generation it was the first time such a horrific act had been brought into our homes.

That next day the *New York Times* ran a photograph on the front page by *Dallas-Times Herald* photographer Bob Jackson. I still have that newspaper tucked away. It is yellowed, but it holds the memory of that November day when all America stopped. It has, as photography will do, historically crystallized the event. Weeks and even years later I would look at that photograph and relive the assassinations of JFK and Lee Harvey Oswald and ponder their meaning.

The sixties was a time of overwhelming political upheaval. The Cuban missile crisis, the Civil Rights movement, the assassinations of Malcolm X, Dr. Martin Luther King Jr., and Robert Kennedy, the riots in Watts, Detroit, and Newark, and the Vietnam War—all these events entered my life through photographs in the daily newspaper and *Life* and *Look* magazines.

I had a camera that my father, an amateur photographer, gave me, but I had no sense of what I could do with it other than photograph family, friends, and the occasional tree. Despite being drawn to the powerful images of my time, it never occurred to me that I could make them. In high school not much caught my interest. I worked in a darkroom with my best friend, Carl, but we had no formal training and little understanding of the technical side of photography. Once we developed film at 120 degrees and wondered why it was completely overexposed.

The Vietnam War was raging when I graduated from high school and I left for college in Ohio in 1969. The Oswald photograph was nothing compared to the photographs and TV broadcasts of the Vietnam

War. Every night I saw the war up close on television, and the next day I could look more deeply at the images in the morning newspaper—like Eddie Adams's photograph of a Vietcong terrorist being shot point-blank or Nick Ut's photo of a Vietnamese girl napalmed by friendly fire.

Opposed to the war, I threw myself into the fray like so many others of my generation. I helped organize the Vietnam Moratorium; we sent dozens of buses from my college to Washington, D.C., to protest the war. I brought my camera with me, more by accident than design. I made some images of a candlelight march in front of the White House and the thousands of students protesting.

Slowly, I began to understand how the camera could help tell the story of my world. I found excitement and a creative connection. But I started to notice there was a difference between what I was trying to do and what I was seeing in newspapers and magazines. The newspaper and magazine photographers I would meet at demonstrations were interested in making a quick photo. They felt no historical sense of witness. They were good at what they did, but most seemed uninvolved and disconnected from the people and the events unfolding in their viewfinders. Many of their editors saw us as dirty, unpatriotic hippies, and the stories and images that they published often echoed these sentiments.

In late April 1970 President Richard Nixon secretly invaded Cambodia. America's colleges exploded in massive demonstrations and riots. I learned that a major protest was being organized, and I traveled to Ohio State University in Columbus to photograph the students. Rioting broke out. National Guardsmen with fixed bayonets and lobbing tear gas made hundreds of arrests.

Armed with a single 35mm camera with a 50mm lens, a press pass pinned on my green army surplus fatigue jacket, a few rolls of Tri-X, and a gas mask, I began to photograph the melee: close-ups of students lobbing tear gas canisters back at the National Guard and police; Ohio highway patrol officers clubbing students; and troops with loaded and bayoneted rifles advancing toward the thousands rioting.

Late in the afternoon I focused my lens on a student pulled in two different directions by police officers. Suddenly I felt four hands on my shoulders. I quickly turned around to find two helmeted highway patrol officers, their eyes peering at me through the dense plastic of the gas masks jutting from under their helmets. I pointed to my press pass,

but one of the officers ripped it off my jacket, tore it up in little pieces, and threw it up in the air like party confetti. They handcuffed me, marched me to the paddy wagon, and sent me to jail with some three hundred others. I was charged with a felony—inciting to riot. My camera and exposed film were placed in a brown paper bag with my name on it. To this day, I marvel that my film was still there when I was released from jail that evening.

While these events were overshadowed by the killing of four students at Kent State University a week later, my photographs of the Ohio State riots appeared in the alternative press that was flourishing. Some of the photos were published on posters and in a few books. A photographer had been born.

Over the next year I discovered others who had witnessed their time—Robert Capa with his Spanish civil war reportage, Lewis Hine's pioneering study of child labor, and the Farm Security Administration images of America's Depression. I read how the publication of Jacob Riis photographs in the 1870s of the squalid Mulberry Bend Slum in *How the Other Half Lives* had led to massive urban renewal of the slum by Theodore Roosevelt, then the governor of New York.

I saw how long-term projects such as these could show a more in-depth presentation of issues. Ironically, many of the magazines that had a small commitment to the longer narrative essay began to falter in the seventies. *Look* and *Collier's* were already gone. *Life* magazine soon closed.

About this time Robert Capa's brother, Cornell, founded the Fund for Concerned Photography. He organized shows of social photography and published two volumes of *The Concerned Photographer* (Grossman Publishers, 1968) book series, which became my well-thumbed bible.

The introduction he wrote profoundly moved me.

> Today so many pictures are being taken that no one is really interested in what has gone on before. Man's witness of his own times dies with him. Added to that, the technological advances in camera design have made photography seem easy. It has become so popular—so used and abused—that because of its popularity, it is in danger of losing its own self-respect as well as the trust and confidence of viewers in its veracity and artistry. The role of the photographer is to witness and to be involved with his subject. There are many concerned photographers all over the world whose work will provide the visual history of our

century—the first century of which such a documentation will exist. The concerned photographer finds much in the present unacceptable that he tries to alter. Our goal is simply to let the world also know why it is unacceptable.

Cornell's manifesto and publication gave me direction and focus, showing me that it was possible to make important visual statements and survive as a photographer. I was elated when Cornell, in 1973, bought ten of my prints for ten dollars each for the Fund for Concerned Photography collection. I felt I had become part of a community.

Other photographers' work also came to my attention. Danny Lyon's projects, *The Movement* and *Conversation with the Dead,* breathed new life into documentary photography in the late sixties. Bruce Davidson's *East 100th Street* liberated photographers to create images far from the typical photojournalism of the day by using a large-format view camera and lighting. Larry Clark's *Tulsa* showed the photographer as biographer. W. Eugene Smith created *Minamata,* showing photographers that the lone voice of the photographer was still viable.

I realized that a handful of contemporary photographers had moved outside the generally proscribed role of photojournalism. Like earlier twentieth-century photographers, they were witnessing their time. Photographer Lewis Hine had said, "There were two things I wanted to do. I wanted to show the things that needed to be corrected. I wanted to show the things that had to be appreciated." Like Hine, this new generation of photographers was actively partisan in a time when editors and academia were telling us to separate our personal feelings from our images. Editors also began the slow move to limit photography to illustrating stories, a format that is prevalent today. Photographer Walker Evans once said, "We need more than illustrations in the morning paper of our period." How true this now seemed.

As the Vietnam War ended I turned to other subjects. I now look back at my naïveté in wonder. I had been filled with passion and rage of what I saw happening in my country in the sixties, but I had little understanding of how to support myself as a photographer or even to understand what a life in photography might mean. The movement photography that I had done the last many years now seemed so narrowly focused. I had believed that my voice was important and that photography might change the things I had seen, but now I was consumed by what I saw as a bigger picture for my photography—looking more

deeply at America with my camera and sustaining long-term projects.

I worked in a warehouse and did design and pasteup at night, so that my daylight hours would be available for photography. I took a few freelance assignments, but I wanted to remain independent without an editor or employer to dictate how I should tell my stories.

I photographed DeWitt Clinton High School in the South Bronx, where I learned to navigate the bureaucratic morass and to connect with my subjects. A year later I began to photograph industrial workers who were exposed to dangerous working conditions in decaying foundries and factories, which lasted six years and led to a staff position creating labor images, posters, slide shows, and a series of 16mm documentary films about occupational health at the University of California, Berkeley. I had my first exhibitions. I had begun to forge a life as a social documentary photographer.

However, when I tried to find a publisher for a book of my industrial workers photographs, one book editor told me, "Workers don't buy books."

In 1978 I started photographing migrant and child farm labor. A fellow photographer, Bill Owens, tried to discourage me, saying that Dorothea Lange had done this already and had done it well. Documentary photographers are often met by such comments, but I believe that each generation needs to reexamine important issues despite what has been done before. I was amazed to find that so little had changed since the days of Lange's work. This strengthened my conviction to see, reveal, and support those trying to make change. Organizations like the National Migrant Ministry and the United Farm Workers Union used my work to illustrate their cause. I was awarded two National Endowment for the Arts (NEA) grants and my first NEA photographer's fellowship to help complete the farm-worker photographs. They were published in two books, *With These Hands* and *In the Fields*.

In 1982 the farm-worker project led me to the U.S.-Mexican border, where I documented the thousands of "illegal aliens" crossing into the United States. Like solving a visual puzzle, I looked for pieces of this amazing journey that could be edited and sequenced in an in-depth presentation. I received a second NEA photographer's fellowship to photograph their conditions in rural Mexico. This body of work traced the journey from rural Mexico across the border to a new life in South-

ern California. It would be published by Aperture as *To the Promised Land.*

In 1989, after some friends commented about the deplorable conditions in Mississippi, I turned my camera to the Mississippi Delta. I had seen or read little about this part of the country and found the region to be so important to the fabric of contemporary American life, as well as a startling and amazing place. Over the next four years I photographed the effects of poverty and a century of neglect in the region. The end result was *Delta Time,* published by the Smithsonian Institution Press.

In 1994 I collaborated with writer Suzanne Donovan. She had orchestrated access for us to death row in Huntsville, Texas, where I spent a year photographing. It was a great challenge to show this world and remain connected to the world outside, where the men I had photographed committed unspeakable crimes. Many of the inmates I photographed (over thirty-five) have since been executed. This work was published in the book *Texas Death Row.* By that time I was a member of a photo agency, JB Pictures, and, with agency support, the work reached a global audience that I could have never imagined at the beginning of my career. My images were published in a six-page portfolio in *Newsweek* and in a similar manner in England, Germany, Korea, Japan, Switzerland, Italy, Spain, Venezuela, Finland, and other countries. As a result, I was invited to speak about my experience to many groups and organizations all over the world.

Three decades after my first published images, I am still photographing. I also teach and curate photography exhibitions. I have tried to get my work into as many venues as possible—in publications, slide shows, posters, exhibitions, magazines, books, and the World Wide Web at www.KenLight.com. But making photographs and trying to attain publication continues to be one of the most difficult challenges.

I think back to a comment that Jacob Riis made almost a century ago: "For more than a year I had knocked at the doors of various magazine editors with my pictures, proposing to tell them how the other half lived, but no one wanted to know." Photographers today continue to face the same problem; images now must fit onto a convenient news peg for editors to even be interested in them. It's not enough to have a good project or visual story, and museums continue

to largely steer away from contemporary photographs that have a human or social connection.

Many of the questions I reflected on in my early years continue to be asked and debated—they have been part of the fabric of documentary photography since its inception. One day, while looking at old issues of the Photo League's Depression-era newsletter *Photo Notes,* I noticed discussions on how work is created, how photographers create a photographic life, and how to continue to spread the idea of social photography. I recognized from this that each generation struggles with similar concerns, and that my generation should weigh in with their ideas and knowledge to create a record for the coming generation.

As the idea for *Witness in Our Time* began to form, I realized that my many years of photographing had given me an opportunity to look more closely at these same questions, ones my students had been also raising. A contemporary record of those issues would be a valuable resource to fuel the dialogue on the visual language of documentary photography. A book would give me the opportunity to talk with and question my peers. My interest in interviewing social photographers was as a kindred spirit and fellow photographer, not as an art historian or critic. Many of those interviewed were friends, and most knew my work; sometimes this made it easier and sometimes more difficult.

Two of the most difficult questions I faced was who to include in this book and how to explain the many who are missing. I interviewed many more than the twenty-two photographers, editors, and curators in this book. My goal was to interview those who had not only made humanist and socially engaged photos, but who had been socially active. I tried to avoid those who had simply been given interesting assignments related to social causes. I wanted those who had used their camera as a personal witness. Those included are but a small part of the documentary family. The choice was often predicated on accessibility to the photographers and my personal knowledge of their work. I wanted to include both the well-known and those less recognized.

Danny Lyon wrote me, "My mind is far away on other things—I just couldn't do it, sorry." Interviews with Gilles Peress and Cornell Capa, whose work with the Fund for Concerned Photography had inspired me, were not satisfying to either party. Arthur Leipzig and Roland Freeman proved difficult to pin down. Interviews with photographer Ben Fernandez, filmmaker-photographer Leo Seltzer, and photo-agency

founder's Jocelyne Benzakin of JB Pictures, Michael Kaufman with Impact Visuals, and David Fenton of the Vietnam War–era Liberation News Service were not able to be included. Sometimes I missed an opportunity. When Josef Koudelka came to my house, we talked for many hours, but a friend had warned that he would never let me tape a conversation, and unfortunately I listened to this advice. I accepted the same warning about Roy DeCarava.

Many photographers in the photo agency Magnum have worked deeply within the social documentary tradition, creating a special problem; so many have done work that I admire that this could have easily become a Magnum book. Michael Hoffman of Aperture spoke at length about the many risks of publishing important socially oriented books. Rather than include his words I chose to include Aperture's important books in the bibliography. I tried to choose photographers from a variety of countries and cultures, but travel costs and, in some cases, communication were prohibitively expensive and difficult. The majority of the image makers in this book are from the United States, where the tradition of social photography is strong.

One early morning recently, as I sat in a shabby little motel room in West Virginia waiting for a Klu Klux Klan rally to start, I realized that I was four hours away from where my photographic journey began. I thought back to those early moments with the camera and how far photography had come—for example, few cameras then had built-in light meters and electronic strobes were cumbersome and unsophisticated. Computers, e-mail, and the World Wide Web were not yet invented. Few photography galleries even existed, and the idea of buying original photographic prints was just on the horizon. It has been three decades since my first images, and my colleagues and I continue to struggle to photograph and get our work seen.

Over the years I have heard and read critics questioning the need for documentary work and the need to witness—"It's been done before" or "After all, doesn't TV do it better?" The need to reconstruct a more contemporary vision for photography seems utmost on their minds. But the humanist vision in photography has had a way of triumphing by offering meaning and a way for people to connect with their own experiences. As the photographers in this book show, the need to inquire, to express, and to witness one's world will always, even under the most dangerous and economically difficult times, endure.

Bibliography

Dotter, Earl. *In Our Blood: Four Coal Mining Families.* Washington, D.C.: Highlander Research and Education Center, 1979.

———. *The Quiet Sickness: A Photographic Chronicle of Hazardous Work in America.* Washington, D.C.: American Industrial Hygiene Association, 1998.

Ferrato, Donna. *Living with the Enemy.* New York: Aperture, 1991.

Freedman, Jill. *Circus Days.* New York: Harmony Books, 1975.

———. *Firehouse.* Garden City, N.Y.: Doubleday, 1977.

———. *Old News: Resurrection City.* New York: Grossman Publishers, 1970.

———. *Street Cops.* New York: Harper & Row, 1981.

Iturbide, Graciela. *Los que viven en la arena.* Mexico, D.F.: Institutio Nacional Indigenista: FONAPAS, 1981.

———. *En el nombre del padre.* Mexico, D.F.: Ediciones Toledo, 1993.

———. *Fiesta and Ritual: Graciela Intrubides Mexiko.* Bern: Benteli, 1994.

———. *Images of Spirit.* New York: Aperture, 1997.

———. *Juchitán de las mujeres.* Mexico, D.F.: Ediciones Toledo, 1989.

Kratochvil, Antonin. *Broken Dream.* New York: Monacelli Press, 1997.

Light, Ken. *In the Fields.* Oakland, Calif.: Harvest Press, 1982.

———. *Delta Time.* Washington, D.C.: Smithsonian Institute Press, 1994.

———. *Texas Death Row.* Jackson: University Press of Mississippi, 1997.

———. *To the Promised Land.* New York: Aperture, 1988.

———. *With These Hands.* New York: Pilgrim Press, 1986.

Magubane, Peter. *Black Child.* New York: Alfred A. Knopf, 1982.

———. *Muagubane's South Africa.* New York: Alfred A. Knopf, 1978.

———. *Soweto: The Fruit of Fear.* Trenton, N.J.: Africa World Press, 1986.

———. *Vanish Cultures of South Africa: Changing Customs in a Changing World.* New York: Rizzoli Books, 1998.

Mark, Mary Ellen. *A Cry for Help: Stories of Homelessness and Hope.* New York: Simon and Shuster, 1996.

———. *Falkland Road.* New York: Alfred A. Knopf, 1981.

———. *Indian Circus.* San Francisco: Chronicle Books, 1993.

———. *Passport.* New York: Lustrum Press, 1969.

———. *The Photo Essay.* Washington, D.C.: Smithsonian Institution Press, 1990.

———. *Photographs of Mother Teresa's Missions of Charity in Calcutta, India.* Carmel, Calif.: The Friends of Photography, 1985.

———. *Portraits.* Washington, D.C.: Smithsonian Institution Press, 1997.

———. *Streetwise.* Philadelphia: University of Pennsylvania Press, 1988.

———. *Ward 81.* New York: Simon and Schuster, 1979.

Meiselas, Susan. *Carnival Strippers.* New York: McGraw-Hill Ryerson Ltd., 1976.

———. *Kurdistan: In the Shadow of History.* New York: Random House, 1997.

———. *Nicaragua.* New York: Pantheon Books, 1981.

Mieth, Hansel. *Simple Life: Photographs from America, 1929–1979.* Stuttgart: Schmetterling Verlag, 1991.

———. *The Heart Mountain Story: Photographs by Hansel Mieth and Otto Hagel of the World War II Internment of Japanese Americans.* Los Gatos, Calif.: M. Inouye, 1997.

Miller, Wayne F. *Southside Chicago.* Berkeley: University of California Press, 2000.

———. *The World Is Young.* Japan: Fukuinkan Shoten, 1999.

Richards, Eugene. *50 Hours.* Wollaston, Mass.: Many Voices Press, 1983.

———. *Americans We.* New York: Aperture, 1994.

———. *Below the Line: Living Poor in America.* Mount Vernon, N.Y.: Consumers Union, 1987.

———. *Cocaine True, Cocaine Blue.* New York: Aperture, 1994.

———. *Dorchester Days.* Wollaston, Mass.: Many Voices Press, 1978.

———. *Exploding into Life.* New York: Aperture, 1986.

———. *Few Comforts or Surprises: The Arkansas Delta.* Cambridge, Mass.: MIT Press, 1973.

———. *The Knife and Gun Club: Scenes from an Emergency Room.* New York: Atlantic Monthly Press, 1989.

Rodriguez, Joseph. *East Side Stories: Gang Life in East LA.* New York: Power-House Books, 1998.

Rosenblum, Walter. *Lewis Hine, Ellis Island: Memories and Meditations of Walter Rosenblum on the Life and Work of an American Artist.* Toronto: Lumiere Press, 1995.

———. *Walter Rosenblum.* Dresden: Verlag der Kunst, 1990.

Singh, Dayanita. *Zakir Hussain: A Photo Essay.* New Delhi: Himalayan Books, 1987.

Salgado, Sebastião. *In Human Effort.* Tokyo: National Museum of Modern Art, 1993.

———. *Other Americas.* New York: Pantheon, 1986.

———. *Sahel, L'Homme en Detresse.* Paris: Prima Presse, 1986.

———. *Terra: Struggle of the Landless.* London: Phaidon, 1997.

————. *An Uncertain Grace*. New York: Aperture, 1990.

————. *Workers: An Archaeology of the Industrial Age*. New York: Aperture, 1993.

Sheikh, Fazal. *A Sense of Common Ground*. Zurich: Scalo, 1996.

————. *The Victor Weeps: Afghanistan*. Switzerland: Scalo Yerlag, 1998.

Vignes, Michelle. *Bay Area Blues*. San Francisco: Pomegranate, 1993.

————. *The Blues*. San Francisco: North Beach Press, 1986.

————. *Oakland Blues*. Paris: Marval, 1990.

Important Readings

PHOTOGRAPHIC BOOKS

Abbott, Berenice. *Changing New York: The Complete WPA Project.* New York: The New Press, 1997.

Adams, Ansel, et al. *Manzanar.* New York: Times Books, 1988.

Agee, James, and Walker Evans. *Let Us Now Praise Famous Men.* Boston: Houghton Mifflin Co., 1960.

Alland, Alexander, Sr. *Jacob A. Riis: Photographer and Citizen.* Millerton, N.Y.: Aperture, 1974.

Annan, Thomas. *Photographs of the Old Closes and Streets of Glasgow, 1868–1877.* New York: Dover Publications, Inc., 1977.

Badsha, Omar, ed. *South Africa: The Cordoned Heart.* Cape Town, South Africa: The Gallery Press, 1986.

Battaglia, Letizia. *Letizia Battaglia: Passion, Justice, Freedom: Photographs of Sicily.* New York: Aperture, 1999.

Beard, Peter. *The End of the Game.* New York: Doubleday and Co., 1977.

Beals, Carleton. *The Crime of Cuba.* Philadelphia and London: J. B. Lippincott Co., 1933.

Bischof, Werner. *Photography: Men and Movements.* 2d ed. Garden City, N.Y.: American Photographic Book Publishing Co., Inc., 1976.

———. *Werner Bischoff, 1916–1954.* Boston: E. P. Bulfinch Press, 1990.

Brassaï. *Brassaï: The Secret Paris of the 30s.* 1st American ed. New York: Pantheon Books, 1976.

Burrows, Larry. *Compassionate Photographer.* New York: Time-Life Books, 1972.

Caldwell, Erskine, and Margaret Bourke-White. *Say, Is This the USA.* New York: Duell, Sloan, and Pearce, 1941.

———. *You Have Seen Their Faces.* New York: Modern Age Books, Inc., 1937.

Capa, Cornell, ed. *The Concerned Photographer I.* New York: Grossman Publishers, 1968.

———. *The Concerned Photographer 2.* New York: Grossman Publishers, 1972.

Capa, Robert. *Children of War, Children of Peace.* Boston: Little, Brown, and Company, 1991.

Cartier-Bresson, Henri. *America in Passing.* 1st American ed. Boston: Bulfinch Press, 1991.

———. *The Decisive Moment.* New York: Simon and Schuster, 1952.

———. *The Early Work.* New York: Museum of Modern Art, 1987.

———. *From One China to the Other.* New York: Universe Books, 1956.

———. *Henri Cartier-Bresson: Photographer.* Boston: New York Graphics Society, 1986.

———. *Photographs by Cartier-Bresson.* New York: Grossman Publishers, 1963.

———. *The World of Henri Cartier-Bresson.* 2d ed. New York: Viking Press, 1952.

Clark, Larry. *Tulsa.* New York: Lustrum Press, 1971.

Collier, John, Jr. *The Awakening Valley.* Chicago: University of Chicago Press, 1947.

Conrat, Maisie, Richard Conrat, and Dorothea Lange. *Executive Order 9066.* Los Angeles: California Historical Society, 1972.

Davidson, Bruce. *Brooklyn Gang.* Sante Fe, N.M.: Twin Palms Publishers, 1998.

———. *East 100th Street.* 2d ed. Cambridge, Mass.: Harvard University Press, 1970.

———, et al. *Toward a Social Landscape.* New York: Horizon Press; George Eastman House, 1966.

De Carava, Roy. *Roy De Carava: Photographs.* Carmel, Calif.: The Friends of Photography, 1981.

De Carava, Roy, and Langston Hughes. *The Sweet Flypaper of Life.* 2d ed. New York: Hill and Wars, 1967.

De Keyzer, Carl. *God Inc.* Amsterdam: Uitgeverij Focus, 1992.

Duncan, David Douglas. *I Protest.* New York: Signet Books, 1968.

———. *This Is War!: A Photo-Narrative of the Korean War.* 1st ed. New York: Harper and Brothers Publishers, 1951.

———. *War without Heroes.* New York: Harper and Row, 1970.

Evans, Walker. *Many Are Called.* 1st ed. Boston: Houghton Mifflin Co., 1966.

———. *American Photographs, 1938.* New York: East River Press, 1975.

———. *First and Last.* San Francisco: Harper and Row, 1978.

———. *The Hungry Eye.* New York: Harry N. Abrams, 1993.

Faas, Horst, and Tim Page, eds. *Requiem: By the Photographers Who Died in Vietnam and Indochina.* New York: Random House, 1997.

Featherstone, David. *Doris Ulmann: American Portraits.* Albuquerque: University of New Mexico Press, 1985.

Fernandez, Benedict J. *In Opposition: Images of American Dissent in the Sixties.* New York: Da Capo Press, 1968.

Frank, Robert, and Jack Kerouac. *The Americans.* 1st ed. New York: Pantheon Books, 1958.

Freed, Leonard. *Black in White America*. New York: Grossman Publishers, 1968.

Fusco, Paul. *La Casa: The California Grape Strike*. New York: Collier Books, 1970.

Gardner, Alexander. *Gardner's Photographic Sketch Book of the Civil War*. New York: Dover Publications, Inc., 1959.

Gilden, Bruce. *Haiti*. Great Britain: Dewi Lewis Publishing, 1996.

Goldberg, Jim. *Raised by Wolves*. New York: Scalo Publishers, 1995.

Griffiths, Philip Jones. *Dark Odyssey*. New York: Aperture, 1996.

Gutman, Judith Mara. *Lewis Hine and the American Social Conscience*. New York: Walker and Co., 1967.

Hansberry, Lorraine. *The Movement: Documentary of a Struggle for Equality*. 4th ed. New York: Simon and Schuster, 1964.

Harbatt, Charles. *Travelog*. Cambridge and London: MIT Press, 1973.

Heyman, Abigail. *Growing Up Female: A Personal Photojournal*. 1st ed. New York: Holt, Rinehart, and Winston, 1974.

Hine, Lewis W. *Men at Work*. 2d ed. New York: Dover Publications, Inc., 1977.

———. *America and Lewis Hine*. Millerton, N.Y.: Aperture, 1977.

Hurley, F. Jack. *Marion Post Wolcott: A Photographic Journey*. Albuquerque: University of New Mexico Press, 1989.

In Our Time—The World as Seen by Magnum Photographers. New York: W. W. Norton and Company, Inc., 1989.

Killip, Chris. *Isle of Man: A Book about the Manx*. London: Arts Council of Great Britain, 1980.

———. *Vague à L'âme*. Paris: Nathan Image, 1989.

Koudelka, Joseph. *Gypsies*. Millerton, N.Y.: Aperture, 1975.

Lange, Dorothea. *Photographs of a Lifetime*. New York: Aperture, Inc., 1982.

Lange, Dorothea, and Paul S. Taylor. *An American Exodus: A Record of Human Erosion in the Thirties*. New Haven: Yale University Press, 1969.

Lee, Russell. *Russell Lee, Photographer*. Dobbs Ferry, N.Y.: Morgan and Morgan, Inc., 1978.

Levitt, Helen. *In the Street*. 4th ed. Durham, N.C.: Duke University Press, 1987.

———. *A Way of Seeing*. 1st ed. New York: Viking Press, 1965.

Lyon, Danny. *The Bikeriders*. New York: Macmillan Co., 1968.

———. *Conversations with the Dead*. New York: Holt, Rinehart, and Winston, 1971.

McCullin, Donald. *The Destruction Business*. London: Open Gate Books, with Macmillan London Limited, 1971.

———. *Is Anyone Taking Notice? A Book of Photographs and Comments*. Cambridge, Mass.: MIT Press, 1973.

———. *Sleeping with Ghosts: A Life's Work in Photography*. New York: Aperture, 1996.

Meltzer, Milton, and Bernard Cole. *The Eye of Conscience: Photographs and Social Change*. Chicago: Follett Publishing Co., 1974.

Minick, Roger. *Delta West: The Land and People of the Sacramento–San Joaquin Delta*. Berkeley, Calif.: Scrimshaw Press, 1969.

Minick, Roger, Leonard Sussman, and Bob Minick. *Hills of Home: The Rural Ozarks of Arkansas.* San Francisco: Scrimshaw Press, 1975.

Misrach, Richard. *Bravo 20.* Baltimore and London: John Hopkins University Press, 1990.

Mitchel, Julio. *Triptych.* New York: Parkett; Der Alltag Publishers, 1990.

Moore, Charles. *Powerful Days: The Civil Rights Photography of Charles Moore.* New York: Stewart, Tabori, and Chang, 1991.

Mora, Gilles. *Walker Evans: Havana 1933.* 1st American ed. New York: Pantheon Books, 1989.

Nachtwey, James. *Deeds of War.* New York: Thames and Hudson, 1989.

———. *Inferno.* London: Phaidon Press, Ltd., 1999.

Natali, Enrico. *New American People.* New York: Morgan and Morgan, Inc., 1972.

O'Neal, Hank, ed. *A Vision Shared.* New York: St. Martin's Press, 1976.

Owens, Bill. *Suburbia.* San Francisco: Straight Arrow Books, 1973.

Palfi, Marion. *Invisible in America.* Kansas: University of Kansas Museum of Art, 1973.

Parks, Gordon. *Half Past Autumn: A Retrospective.* Boston: Bulfinch, 1997.

Peress, Gilles. *Farewell to Bosnia.* New York: Scalo Publishers, 1994.

———. *The Silence.* New York: Scalo Publishers, 1995.

———. *Telex Iran: In the Name of Revolution.* Millerton, N.Y.: Aperture, 1983.

Riboud, Marc. *North Vietnam.* San Francisco: Holt, Rinehart, and Winston, 1970.

———. *Photographs at Home and Abroad.* New York: Abrams, 1988.

———. *Visions of China.* New York: Pantheon Books, 1981.

Riis, Jacob. *How the Other Half Lives.* 1st ed. New York: Charles Scribner's Sons, 1891.

———. *How the Other Half Lives.* New York: Dover Publications, Inc., 1971.

Rodger, George. *Humanity and Inhumanity.* London: Phaidon Press, 1994.

Rogovin, Milton. *The Forgotten Ones.* Buffalo, N.Y.: Buffalo Fine Arts Academy, 1985.

Sander, August. *Citizens of the 20th Century.* Cambridge, Mass.: MIT Press, 1986.

———. *Photographs of an Epoch.* New York: Aperture, 1980.

Sciana, Ferdinando. *To Sleep, Perchance to Dream.* London: Phaidon, 1997.

Shahn, Ben. *The Photographic Eye of Ben Shahn.* Cambridge and London: Harvard University Press, 1975.

Silverman, Jonathan. *The Life of Margaret Bourke-White.* New York: Viking Press, 1983.

Siskind, Aaron. *Harlem Document: Photographs, 1932–1940.* Providence, R.I.: Matrix Publications, 1981.

Smith, Eugene W. *Let Truth Be the Prejudice.* New York: Aperture, 1985.

———. *Minamata.* New York: Holt, Rinehart, and Winston, 1975.

———. *W. Eugene Smith: Photographs, 1934–1975.* New York: Harry N. Abrams, 1998.

Steber, Maggie. *Dancing on Fire—Photographs from Haiti.* New York: Aperture, 1991.

Stock, Dennis. *California Trip*. New York: Grossman, 1970.

Strand, Paul. *Paul Strand: A Retrospective Monograph*. New York: Aperture, 1971.

———. *Time in New England*. New York: Oxford University Press, 1950.

———. *Un Paese: Portrait of an Italian Village*. New York: Aperture, 1997.

Streit, Jindrich. *The Village Is a Global World*. Prague: Arcadia, 1993.

Ulmann, Doris. *The Appalachian Photographs*. Penland, N.C.: The Jargon Society, 1971.

———. *The Darkness and the Light*. Millerton, N.Y.: Aperture, 1974.

Vishniac, Roman. *A Vanished World*. New York: Farrar, Straus, and Giroux, 1983.

Webb, Alex. *Hot Light/Half-Made Worlds: Photographs from the Tropics*. New York: Thames and Hudson, 1986.

Weegee. *Naked City*. New York: Essential Books, 1945.

———. *Wegee's New York: Photographs, 1935–1960*. London: Schirmer Art Books, 1992.

Welty, Eudora. *Photographs*. Jackson: University of Mississippi Press, 1989.

Winningham, Geoff. *Friday Night in the Coliseum*. Houston: Westmore and Co., 1971.

Winogrand, Garry. *The Animals*. New York: The Museum of Modern Art, 1969.

———. *The Man in the Crowd: The Uneasy Streets of Garry Winogrand*. San Francisco: Fraenkel Gallery-D.A.P., 1999.

———. *Public Relations*. New York: Museum of Modern Art, 1977.

———. *Women Are Beautiful*. 1st ed. New York: Light Gallery Books, 1975.

Wright, Richard, and Edwin Rosskam. *12 Million Black Voices*. New York: Viking Press, 1941.

BIOGRAPHIES AND DOCUMENTARY TEXTS

Bourke-White, Margaret. *Portrait of Myself*. New York: Simon and Schuster, 1963.

Capa, Robert. *Slightly Out of Focus*. New York: Henry Holt and Co., 1947.

Chapnick, Howard. *Truth Needs No Ally*. Columbia: University of Missouri Press, 1994.

Coles, Robert. *Doing Documentary Work*. Oxford and New York: Oxford University Press, 1997.

Collier, John, Jr., and Malcolm Collier. *Visual Anthropology*. University of New Mexico Press, 1986.

Featherstone, David, ed. *Observations Essays: on Documentary Photography*. San Francisco: Friends of Photography, 1984.

Goldberg, Vicki. *Margaret Bourke-White: A Biography*. New York: Harper and Row Publishers, 1986.

Hughes, Jim. *Shadow and Substance: The Life and Work of an American Photographer*. New York: McGraw-Hill, 1989.

Hurley, Jack F. *Portrait of a Decade: Roy Stryker and the Development of Documentary Photography in the Thirties*. New York: Da Capo Press, 1972.

Hurn, David, and Bill Jay. *On Being a Photographer; A Practical Guide*. Portland, Oregon: LensWork Publishing Company, 1997.

Janis, Eugenia Parry, and Wendy MacNeil. *Photography within the Humanities.* Danbury, N.H.: Addison House, 1977.

McCullin, Don. *Unreasonable Behavior.* New York: Alfred A. Knopf, 1992.

Meltzer, Milton. *Dorothea Lange: A Photographer's Life.* New York: Farrar, Straus, and Giroux, 1978.

Panzer, Mary. *Mathew Brady and the Image of History.* Washington, D.C.: Smithsonian Institution Press, 1997.

Parks, Gordon. *A Choice of Weapons.* 3d ed. St. Paul: Minnesota Historical Press, 1986.

Rathbone, Belinda. *Walker Evans: A Biography.* Boston: Houghton Mifflin, 1995.

Stange, Maren. *Paul Strand: Essays on His Life and Work.* New York: Aperture, 1990.

Stott, William. *Documentary Expression and Thirties America.* New York: Oxford University Press, 1973.

Weinberg, Adam D., ed. *On the Line: The New Color Photojournalism.* Minneapolis: Walker Art Center, 1986.

Whelan, Richard. *Robert Capa: A Biography.* New York: Alfred A. Knopf, 1985.

Index